Painting INDIANA II

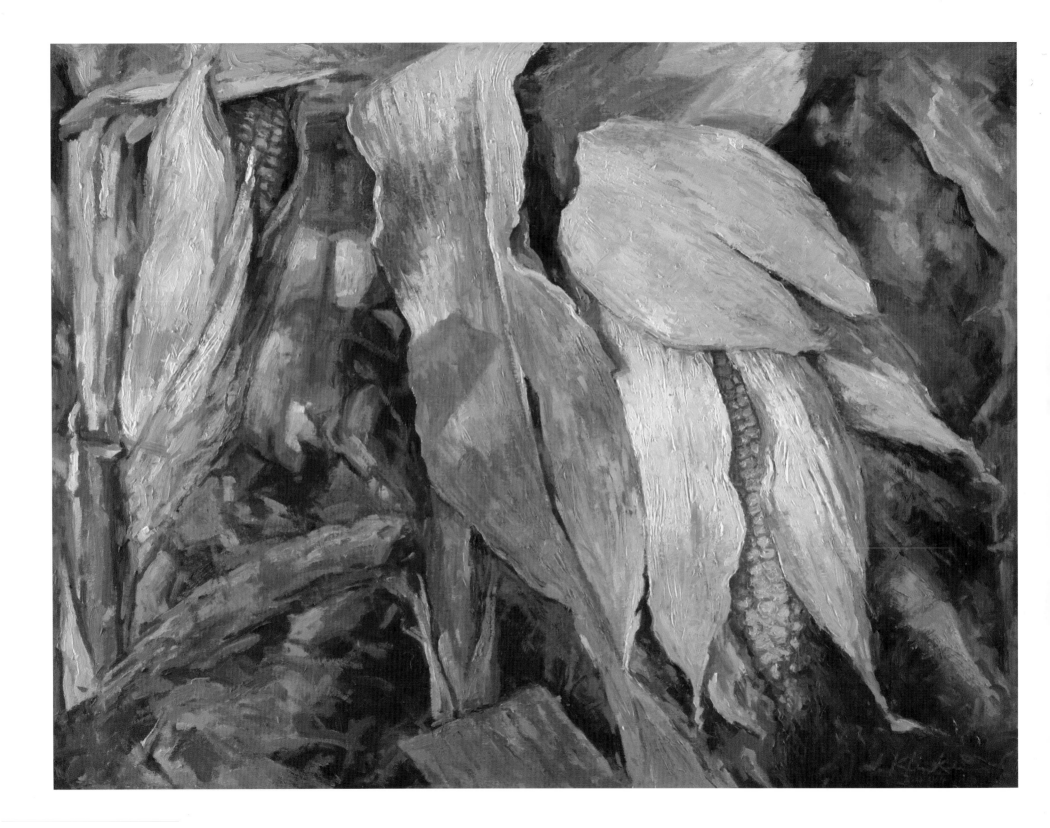

The Changing Face of Agriculture

Painting INDIANA II

Indiana Plein Air Painters Association, Inc.
Center for Agricultural Science & Heritage, Inc.

Paintings by Bill Borden, Mark Burkett, Mary Ann Davis, Lynn Dunbar, Bob Farlow, Jeff Klinker, Ron Mack, Nancy Maxwell, Carol Strock-Wasson, and Scott Sullivan

Text by Gary R. Truitt and Kathleen Stubbe Truitt
Foreword by Judy O'Bannon
Introduction by Rachel Berenson Perry

AN IMPRINT OF
INDIANA UNIVERSITY PRESS
BLOOMINGTON AND INDIANAPOLIS

This book is a publication of

Quarry Books

an imprint of

Indiana University Press

601 North Morton Street

Bloomington, IN 47404-3797 USA

http://iupress.indiana.edu

Telephone orders 800-842-6796

Fax orders 812-855-7931

Orders by e-mail iuporder@indiana.edu

Library of Congress Cataloging-in-Publication Data

Painting Indiana II : the changing face of agriculture / Indiana Plein Air Painters Association, Inc., Center for Agricultural Science & Heritage, Inc. ; paintings by Bill Borden ... [et al.] ; text by Gary R. Truitt and Kathleen Stubbe Truitt ; foreword by Judy O'Bannon ; introduction by Rachel Berenson Perry.

 p. cm.

 ISBN 0-253-34819-6 (cloth)

 1. Agriculture in art. 2. Plein air painting—Indiana. 3. Painting, American—Indiana—21st century. I. Borden, Bill. II. Truitt, Gary R. III. Truitt, Kathleen Stubbe. IV. Indiana Plein Air Painters Association. V. Center for Agricultural Science & Heritage. VI. Title. VII. Title: Painting Indiana 2. VIII. Title: Painting Indiana two. IX. Title: Changing face of agriculture.

 ND1460.A39P355 2006

 758'.509772—dc22 2006002649

 1 2 3 4 5 11 10 09 08 07 06

Frontispiece:

"What's Indiana without corn? You can find scenes like this in every part of the state, if you look close." Nationally, Indiana ranks around twentieth in number of acres in use for farming. Yet according to 2002 crop production statistics, our state provides more than 8 percent of soybeans produced and 7 percent of corn produced.

JEFF KLINKER

Corn, Montgomery County

Oil on canvas 30 × 40 inches

ABG

The Indiana Plein Air Painters Association, Inc. and the Center for Agricultural Science & Heritage, Inc. thank OneAmerica and Agri Business Group, Inc. for their generous support of the *Painting Indiana II: The Changing Face of Agriculture* project.

ONEAMERICA®

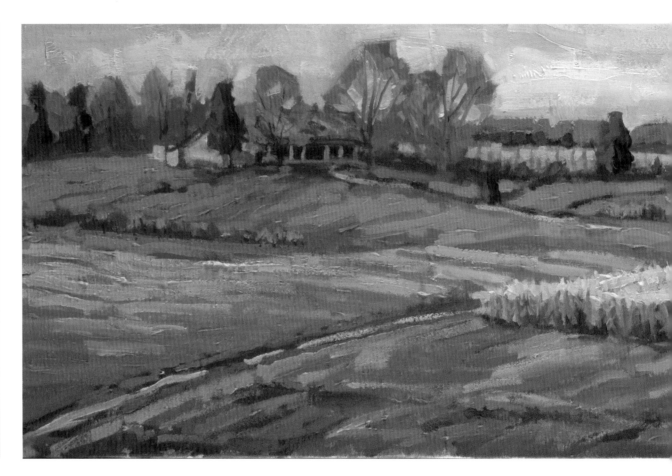

Let us never forget that the cultivation of the earth is the most important labor of man.
Daniel Webster, 1840

Hamm Brothers Seed Farm has been in Danny and Thomas Hamm's family for more than a hundred years. They used to raise beef cattle but, like most successful farmers, the scope of their business changed with the times. Today they grow various grains and hay as livestock feed. The grains are mixed with European barley and molasses, then distributed to five stores in southern Indiana.

LYNN DUNBAR
After the Harvest, Hamm Bros. Seed Farm, Memphis
Oil on canvas 12 × 46 inches

CONTENTS

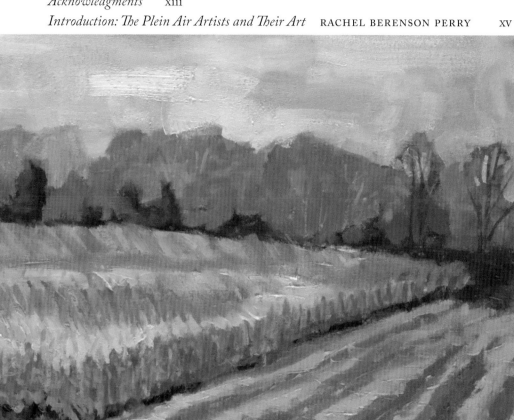

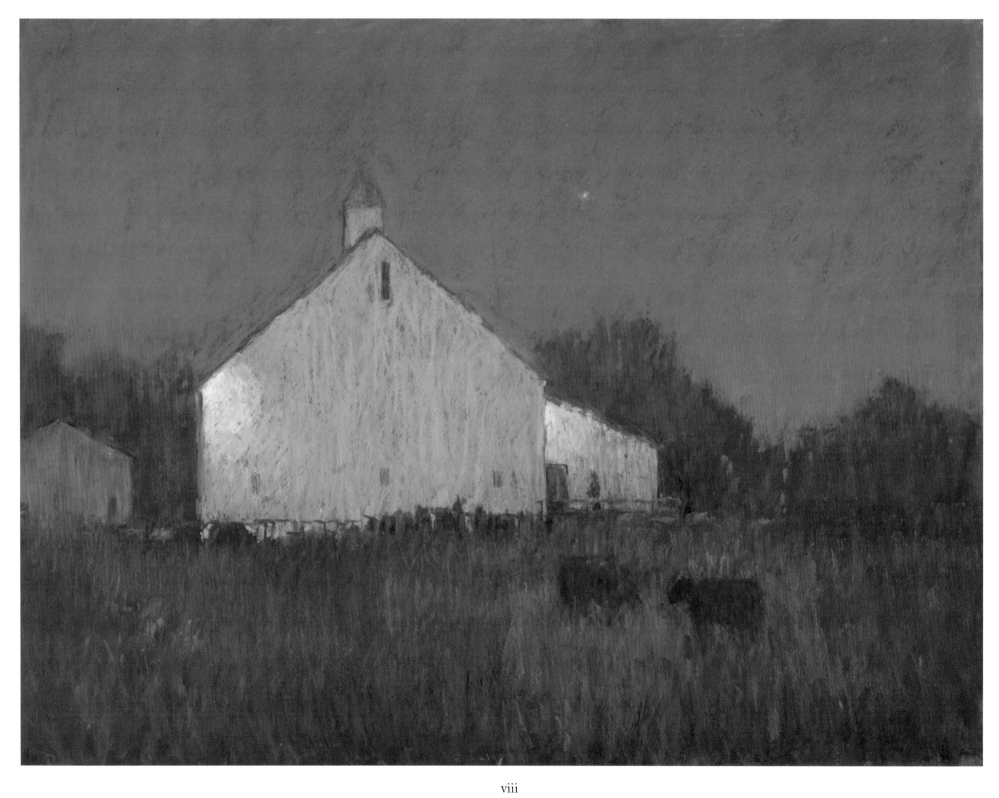

Foreword: Art and Agriculture

Judy O'Bannon

Art and agriculture. What a perfect mix not only to tell our story as Hoosiers, but also to help us open our minds to life and its meaning over this whole place we call Earth.

Both art and agriculture use the landscape of today to give us direction for the future, but the connection is not always obvious. Thus, a heart-filled thanks to the Indiana Plein Air Painters Association and the Center for Agricultural Science & Heritage, Inc. for opening our eyes to their interrelatedness.

Art and agriculture are acts of creation. As we feel our link to the awesome power of the Creator, we are ourselves drawn into the act of creation. The very nature of creation is to be always pulsating and in a state of flux. The landscape painter looks at a scene as it changes through the passing of seasons and even in the shifting of light during a single day. The farmer watches the tiniest seed sprout into a full plant and then yield a crop that feeds livestock—acts which in turn keep our bodies changing and growing. And all the while, both art and agriculture are aware of and responding to the developing social and technological conditions of the time. They operate and evolve within the context of the human condition.

Certainly the very basis of life is feeding the body so that it can grow and provide conditions for the next generation to survive and advance. Probably one of the first acts humans took to provide for basic needs was to alter the surrounding world in an attempt to catch rain water. In the thousands of years since, we have been attempting to cultivate the soil, grow crops, and raise livestock in an ever more efficient and effective manner.

Changes in agricultural lives and practices have mirrored, and in fact even caused, the broader development of civilization. When people stopped solely hunting and gathering and began to plant and harvest, they became rooted themselves, not only to nature around them but also to a specific activity and a particular place. They no longer simply responded to the forces of nature, but instead initiated and developed ways to direct them. People became creators in a world of change. They began to study, interpret, and rearrange the elements of the world around them—the landscape of their lives.

"I loved the way the electric light was striking this barn one late summer evening and was surprised that someone was still working. Like art, farming is definitely not a nine-to-five job."

CAROL STROCK-WASSON
Summer Nights, Randolph County
Pastels on board 18 × 24 inches

"With tassels apparent, the summer corn soaks up a late rain and the evening glow. It was a peaceful and quiet scene."

RON MACK
Summer, Southern Marion County
Oil on linen 16 × 20 inches

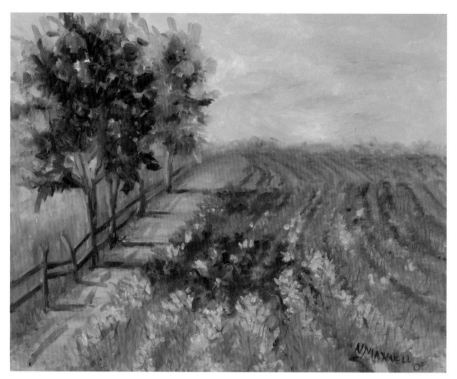

Remnants of the autumn harvest sit quietly in the snow-covered field awaiting spring-time, when they will be replaced by rows of soybeans. Crop rotation reduces the repeated planting of crops that drain the soil and, by alternating with crops that feed the soil, nutrients are replenished. "The fence reminded me of rabbit hunting and looking forward to hot coffee and a warm fire. As I painted, the sun kept breaking through to brighten and bring out beautiful colors."

RON MACK
Winter, Southern Marion County
Oil on linen 16 × 20 inches

Golden soybeans stand ready for harvest as their year in this field comes to an end. "When Ron (Mack) first painted it, it was winter and there was corn stubble showing through the snow. By late spring, it was obvious that soybeans had been planted in the same field."

NANCY MAXWELL
Four Seasons, Southern Marion County
Oil on canvas 16 × 20 inches

Webster's dictionary defines agriculture as "the science and art of farming." And indeed, farming has always been a combination of both science and art. Thus it is fitting in looking at Indiana's agricultural trends to see them through the eyes of our artists.

Plein air artists paint outside their studios, in the open air, and in doing so become a part of the world around them, absorbing the visual focus and emotions of their subjects. As each artist in his or her own unique way internalizes

what he or she perceives in the experience and translates it into an interpretation that speaks to others, we viewers gain enhanced insights and richness of meaning.

A painting can take us into an experience through which we realize the essence of a condition on a deeper level than possible with the mere reading of facts and figures.

Compare two portrayals of the act of tilling the earth: One painting shows

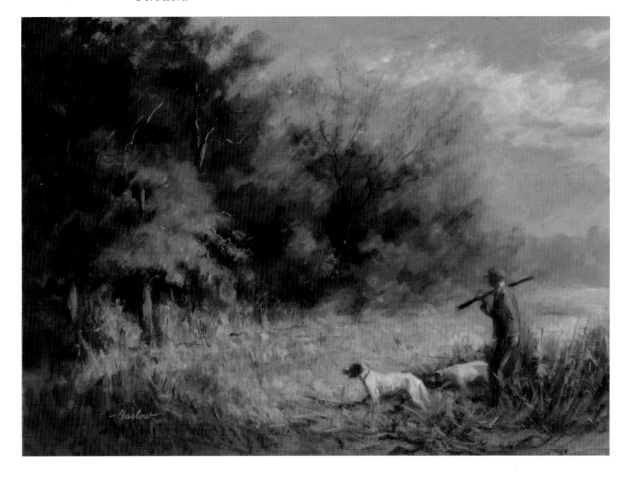

"Hunting has long been a perk for the farmer. It gives him a chance to walk the land when nature struts her colors, and view the fields without the stress of economics. The flush of game adds an adrenaline shot that increases the pleasure. As farming methods change, consideration needs to be given to the effects on the environment. If not, the hunter will find fewer flushes and the game pouch in his hunting jacket will be empty."

BOB FARLOW
Empty Game Bag, Randolph County
Oil on canvas 28 × 36 inches

a lone farmer and his horse guiding and forcing a small, hand-managed plow of yesteryear through the clay soil of southern Indiana. We feel the connection to the earth, the heat of the day, the slowness and isolation of the farming life. Contrast that image to a rendering of today's huge, high-tech tractor, with its comfortable cab, commanding the earth into new forms. No one would have to emphasize the need for advanced education and skills, the dedication of large sums of capital, and the subsequent development of larger and larger farms implied by this modern vision. We, in our viewing, put ourselves in the farmer's place and subsequently feel the situation, and thus reason its consequences.

Agriculture will always be a most basic ingredient of each life. In fact, it is perhaps the easiest way to understand the essentials of the cycle of life. At the same time, we find today's agricultural involvements represent the sharp-

est cutting-edge issues of the day environmentally, politically, and morally. In the global living room we reside in today, experiments and decisions are being made that determine the sustainability of the environment to support life. What happens in a laboratory in Indiana can directly affect world hunger, which can shift and alter whole international conditions.

There is much to observe and witness in the practices and questions posed by agriculture in Indiana. The view that Indiana is a passive rural scene of the past is too sentimental and unrealistic. This is a beautiful state, built on rich glacial till in the north and rolling hills in the south. Life here is steeped in the heritage of the past and our aggressiveness for the future. Agriculture reflects that.

This book says to all of us, "Open your eyes." Look and feel around you. Acknowledge the magic of life and the responsibility to be a part of its stew-

"I was out walking early one foggy morning, not long after we had had significant storms with powerful winds. The corn stalks were really twisted and damaged, maybe beyond possibility of harvesting. As I looked through the mist towards the barns, I saw deer quietly eating through the field and almost invisible."

NANCY MAXWELL
Silent Visitors, L&C Farm, Martinsville
Oil on canvas 16 × 20 inches

"One very popular product of the dairy industry is ice cream, which is enjoyed by all ages, maybe slightly more by the younger set. Here, some youngsters delight in the taste; the older brother invites us to join him." Indiana produces more than a hundred million gallons of ice cream annually.

BOB FARLOW
Two Delights, Winchester
Oil on canvas 24 × 30 inches

"This shows the modern way sap is gathered. I was amazed at the amount of sap it takes to make a pint of syrup."

MARY ANN DAVIS
Maple Syrup, Williams & Teague Sugar House,
 near Rockville
Oil on canvas 16 × 20 inches

ardship. Don't look with old senses, making assumptions of what is present. Awake and see anew and dream of what is to come, saving the foundations that make us vibrant today and build on them for a better tomorrow. The plein air artists help us do that.

Bring your appetite for growth, inquiry, and joy as you move through the pages of the changing agriculture in Indiana. You will never look at the world in the same way again.

"When I was young we would visit my cousins on a drive that always seemed very long, but the sight of the silo told me we had to be close to our destination. My mother's family farm in southern Indiana still has a concrete silo like this one. I like the representation of many generations; silos from my parents' time, hay and corn from my era, and diversification into a mulch operation for the next generation. When I talked to one of the owners of this property, he told me he was the sixth generation farming this land."

NANCY MAXWELL
Across the Generations, Olive Branch Road, Greenwood
Oil on canvas 12 × 24 inches

Acknowledgments

Painting Indiana II: The Changing Face of Agriculture is the result of several years of hard and thoughtful work on the part of ten talented artists, each of whom brought to it their own unique interpretation of the subject. We hope they have good memories of the experience and a new appreciation for agriculture.

Painting Indiana II also resulted from years of diligent work by the Center for Agricultural Science & Heritage, Inc. board of directors and staff. We thank them for their passion for agriculture and dedication to delivering the story through innovative methods. We hope farmers have gained a new appreciation for agriculture through this experience.

And thanks to the Indiana Plein Air Painters Association for providing artistic guidance and for keeping the art of painting outdoors alive and colorful.

Introduction: The Plein Air Artists and Their Art

Rachel Berenson Perry

The exhilarating process of gathering supplies, tramping through forest and field, and unfolding one's easel to paint an inspiring scene has engaged artists for more than a century. Ever since 1841, when paints were first marketed in portable tubes, oil painters have been leaving their studios to capture nature on location.[1]

Many artists believe that painting *en plein air*—a French phrase meaning "in the open air"—is the only way to create convincing landscapes. Using images from photographs for subject matter, they argue, results in flat and unemotional compositions. And inventing nature from memory strays from traditional art. When responding to immediate outdoor surroundings, artists can quickly interpret what they feel as well as what they see.

Holsteins are grazing peacefully in this bucolic scene with little attention to the fact that they are only minutes away from major highways and the city of Indianapolis. Even though the number of farms is decreasing, some have been in operation for generations. You don't have to drive too far on any road in Indiana before you see a sign which depicts a "100 Year Family Farm" with great pride.

RON MACK
Hillside Serenity, Zionsville
Oil on canvas 24 × 30 inches

Notable Hoosier Group artist T. C. Steele's (1847–1926) enthusiasm for plein air painting became focused under the guidance of J. Frank Currier (1843–1909), with whom Steele studied during his summers away from studies at the Royal Academy of Art in Munich. When he returned home in 1885, Steele described a sketch near Pleasant Run in Indianapolis:

The afternoon effect, the warm sunshine, the cool shadows. The sunshine having the quality that haze gives to the beams that pass through it [in] late afternoon. The gray of the distance, the light shimmering over the cornfield of the middle distance and the stubblefield until it culminates in the luminous tones upon the white cattle in the foreground. The color too becoming very pronounced until it reaches the cattle and brighter and deeper still in the sunlit grass of the foreground.[2]

Steele's illuminating description reveals a few basic fundamentals of rendering outdoor scenes—distance colors cool, foreground colors intense—that begin to create the magical depth of a well-painted

"The weeds that were flowering along this fence row fed the Goldfinch and his family. Like the farmland, he is brightly colored through the summer, turning to a muddy brown in winter."

CAROL STROCK-WASSON
Finch Food, Prairie Creek, Delaware County
Pastel on board 24 × 18 inches

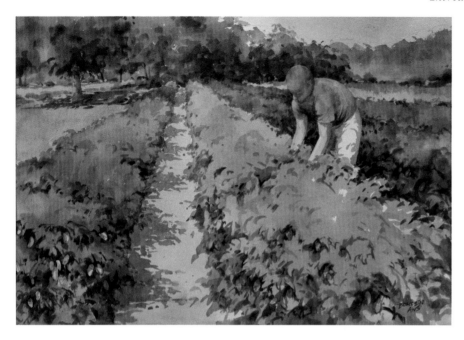

"I spent a very pleasant afternoon with Jim Campbell as he gave me a tour of his hobby field of peppers. He has another field for production peppers used to make hot sauces. I had no idea they were grown in Indiana or how many sizes, shapes, and colors of peppers existed."

BILL BORDEN
Mild to Wild Pepper & Herb Co., Franklin
Watercolor on paper 22 × 28 inches

landscape. T. C. Steele stood out among artists not only for his quality work, but also because he publicly articulated his thoughts about painting. In a lengthy article printed in *The Indianapolis News* in 1887, Steele explains,

Landscape painting is a modern art. There are comparatively no old masters in landscape, certainly none that exert any influence on the great modern school. . . . The artist does not now sit in his studio and conjure up a weak suggestion of out-of-door life. He goes at once to nature herself, not as a mere copyist, for while he holds himself rigidly to truth or effect in atmosphere and light, his trained eye broadly generalizes, his imagination works with his hand, and the result, though it may be ideal, embodies the truth of reality. In fact it is the interpretation of Nature into the more impressive language of Art.[3]

Steele was undoubtedly a catalyst for the establishment of the Brown County Art Colony and Midwest impressionism in the early 1900s. His hilltop home, named "House of the Singing Winds" and set amid 211 acres near Belmont, Indiana, also played a significant role in the recent revival of plein air painting in Indiana.

T. C. Steele's home and studio, preserved as a State Historic Site, are open to the public nine months a year. To celebrate the artist's September 11 birthday, the site sponsored the first Great Outdoor Art Contest in 1988 to encourage artists to paint on location. Several of the artists participating in the *Painting Indiana II: The Changing Face of Agriculture* project, including Jeff Klinker and Mark Burkett, admit to having their first plein air experience at one of the Steele site's outdoor art contests.

The first "paint out" in Indiana became an annual tradition and spawned similar events throughout the state. The Indiana Plein Air Painters Association (IPAPA) formed in 1998 and quickly became a clearinghouse for artists seeking outdoor painting opportunities. The organization's First Brush of Spring paint out in New Harmony now kicks off the painting season each April and attracts artists nationally.

In addition to exercising their creativity, plein air artists enjoy spontaneous and relaxed camaraderie when painting together. The challenge of visually describing nature's moods while working together at the same time, in the same place, encourages open discussion and informal critiques.

The artists who comprised the early Brown County Art Colony, many of whom were from Chicago, treasured their companionship during summer months in Nashville, Indiana. W. M. Herschell alluded in 1909 to their enviable sociability:

The artists of Peaceful Valley (Nashville) set their work aside on Sundays and indulged . . . in long hikes through the county. They were up at sunrise for a little jaunt followed by a sumptuous breakfast at the Pittman Inn and then a short rest. Now ready for a more strenuous adventure, Adolph Shulz (1869–1963) would rally the troops with, "Well, let's be off." With walking sticks in hand and headed by Shulz, the band set out on paths that took them over the hills and through the valleys on a trek that often covered fifteen miles.[4]

Participants in *Painting Indiana II: The Changing Face of Agriculture* similarly bonded with fellow artists while sharing weekends and spare hours

painting nature together. They took more than two years to travel the state, meeting farmers and discussing their paintings with experts from the Center for Agricultural Science & Heritage, Inc. to hone their subject matter. Many of the ten artists commented on the strong amity generated from their common desire to make the project successful.

The first IPAPA group project, spearheaded by artist Dan Woodson and the organization's founding president Ann Bryan Carter, recruited five of Indiana's notable plein air artists to divide the immense task of painting representative scenes from each of Indiana's ninety-two counties. Their efforts resulted in a traveling exhibition that premiered at the Indiana State Museum in 2000, a full-color book published by Indiana University Press, and a concluding sale of the artwork, all of which were received with overwhelming enthusiasm. Inspired by this remarkable success, IPAPA proclaimed that "[the project's] meaning and purpose became larger than the paintings themselves and the artists who created them. *Painting Indiana: Portraits of Indiana's 92 Counties* was in essence a portrait of Hoosier life and land."[5]

Building upon the positive reputation of the first project, IPAPA embraced a larger vision. Its ambitions now involve numerous volumes to be created over a period of decades, dedicated to artists' visual interpretation of Indiana's culture and scenery. Leaders of the group predict that "the artists' work will become the basis for video documentaries, comprehensive school curriculums, museum exhibits, and new publications, all melded to create an ongoing portrait of our state."[6]

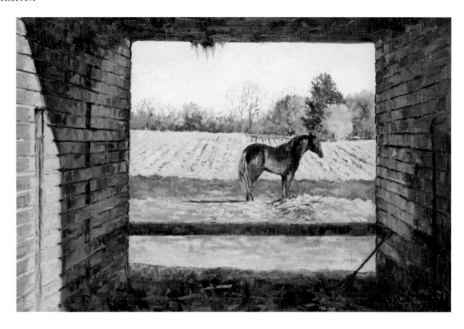

"An old friend seems restless with his lack of activity but even though his importance on the farm is now minimal, I imagine horses will always be a part of the agricultural landscape."

JEFF KLINKER
Forgotten, Idaville
Oil on canvas 24 × 36 inches

"I painted this old barn because to me it represents all the old barns left abandoned from earlier times. Barns like this have been replaced by ugly pole-barns that are easy, convenient, and more economical; but which lack character, craftsmanship, and individuality. Barns of this era are a living testament of Indiana agriculture. All operations took place in and around the barn. It was the center of family life on the farm."

NANCY MAXWELL
Winter Silence, Godsey Road, Martinsville
Oil on board 12 × 24 inches

"Purdy Materials Inc. has been supplying the surrounding area with concrete for some time. Ed Purdy, the owner, says that there will be a forty-acre lake there someday. The Purdys also own a sod farm."

JEFF KLINKER
Purdy Materials Inc., Lafayette
Oil on canvas 16 × 24 inches

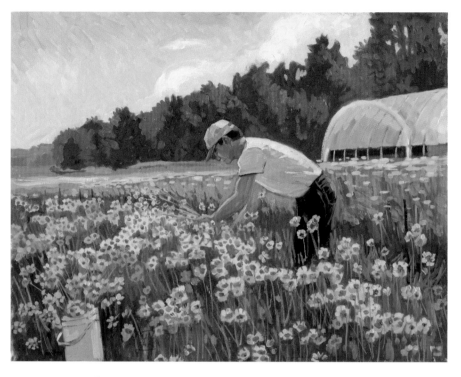

"Many flowers are imported from South America, but John and Tammy grow flowers that do not ship well and are especially known to this area. They are a high-quality product that they sell at farmers' markets and to florists."

LYNN DUNBAR
Coreopsis, Perennial Favorites, Magnet
Oil on canvas 14 × 18 inches

Partnering with the Center for Agricultural Science & Heritage, Inc., IPAPA's second project became *Painting Indiana II: The Changing Face of Agriculture.* For this endeavor, ten artists were selected from a number of applicants by *International Artist Magazine* editor Jennifer King to document contemporary and future Indiana agriculture. With a goal to produce a hundred paintings, the artists were encouraged to "explore the depth and breadth of agriculture, from current science in the field and in the laboratory to the food and fiber we consume."[7]

In response to some criticism regarding lack of artist diversity in the first project, the ten artists chosen include four women and six men. Along with eight oil painters, the group includes one watercolorist and one pastelist. The locations of the participants' homes and studios range from Winchester and Union City in the northeastern section of Indiana to Louisville, Kentucky (the artist based there paints in southern Indiana).

The backgrounds and experiences of the artists themselves reflect current trends in artist training, particularly when pursuing plein air skills. On-location painting instruction at formal American art institutes in the early 1900s took the form of summer classes in nearby rural areas, taught by academy or institute

instructors willing to lead the effort.[8] Twenty-first-century artists likewise choose from a myriad of accomplished independent artists/instructors who offer plein air workshops abroad and in picturesque locations in the United States.

Selecting suitable instructors depends upon word-of-mouth recommendations, timing, and geographical location, as well as the instructor's personal accomplishments and how the potential student views the quality of the instructor's work. Most plein air artists today take advantage of occasional on-location workshops to refresh their technical approach or improve existing skills.

Accomplished pastel artist Carol Strock-Wasson adheres to a self-imposed regime of taking at least two workshops each year with other instructors, for example. Ron Mack, the only artist to be involved in both *Painting Indiana* projects, has studied with Myron Fincham, Harold Buck, and others to improve his painting ability while earning a living as an engineer at Eli Lilly Company in Indianapolis. Scott Sullivan experienced a life-changing epiphany while taking a workshop on Monhegan Island in Maine with artist Don Stone. Jeff Klinker, in Lafayette, studied with artist Hillary Eddy, among others, in workshop environments.

Similar to the artists who populated the early Brown County art colony, several of the artists selected for *Painting Indiana II: The Changing Face of Agriculture* originally attended art schools to pursue careers in commercial art.[9] Watercolorist Bill Borden graduated from the Cleveland Institute of Art, where he earned a B.F.A. in industrial design. He spent a thirty-year career as a designer for Ford Motor Company and Research Center before retiring in Hanover. Mark Burkett received his B.F.A. in printmaking and worked for many years as an independent illustrator for interior designers and architects, and Mary Ann Davis earned her B.F.A. from the Herron School of Art with a major in lithography, eventually opening her own graphic design business. Scott Sullivan studied architectural drawing at Vincennes University

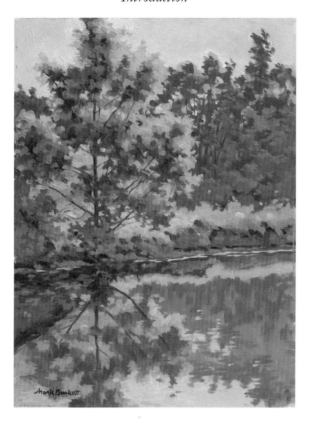

Beautiful ponds dot Indiana's agricultural landscape. They serve as a habitat and water source to wildlife and perhaps offer farmers' families a cool escape from the summer heat.

MARK BURKETT
Pond for Wildlife, New Harmony
Oil on canvas 16 × 12 inches

and pursued a career in architectural drafting prior to running his own heating and air conditioning business near Bloomington. Lynn Dunbar received her B.A. in visual design at Purdue University, utilizing her training to become an art director for publications at that school.

Participating artists who knew as undergraduates that fine art was to be their lifelong passion include Bob Farlow, who received an M.A. in fine art from Ball State University, among other degrees, and Nancy Maxwell, who earned her B.S. in fine art at Indiana University before pursuing an M.A. in education. Both Farlow and Maxwell spent many years teaching art in public schools.

For *Painting Indiana II: The Changing Face of Agriculture,* this talented group of artists tackled a broad range of subjects. Agriculture in Indiana today goes beyond the idyllic family farm with rustic outbuildings to businesses as diverse as lavender farms, lumber harvesting, and humongous automated dairy operations. Assignments were distributed to the artists to ensure that a broad range, if not all aspects, of agricultural life in Indiana would be represented in the book.

In order to understand their subjects better, the artists spent time learning about today's agricultural life. Lynn Dunbar comments, "One of the things I've liked about the project is going to a lot of places I never would have gone to, talking to people, and learning about new processes in agriculture that I didn't have any idea about."

Perhaps a bigger test for the artists was finding a way to artistically interpret subjects that aren't obviously visually attractive. "I think to be able to take any subject matter and create a good composition was probably the biggest challenge," Bob Farlow declared. "Some of the things that we are painting are not the types of things we would normally choose. And trying to keep them from being just illustrations, and to make them actually fine art, becomes a major challenge."

"Everyone's been challenged by the subject," Bill Borden admits. "In the beginning, we chose what we wanted to paint but none of us had a lot of knowledge about agriculture. Sometimes it's tough to drum up enthusiasm for some of the subjects we had no prior ties to."

One painting day in particular challenged the artists. To augment the exhibition, organizers forwarded the concept of creating a 360° "painting in

"This is a very successful and ever-expanding lavender-growing operation. They grow and sell all things lavender."

MARK BURKETT
Willowfield Lavender Farm, Mooresville
Oil on canvas 20 × 30 inches

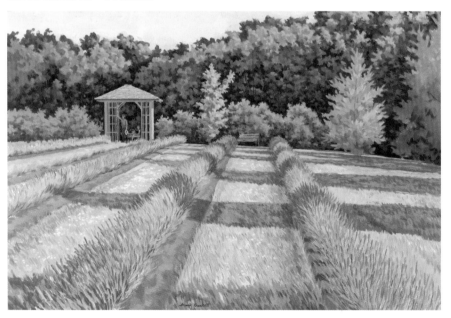

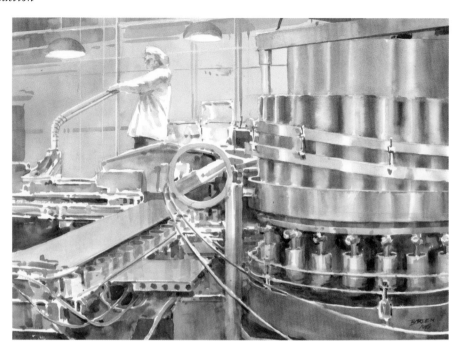

"I love mechanical subjects and there was a wealth of it here. I was given the red carpet tour but the level of efficiency and cleanliness precluded any messy painting. This one had to be done from sketches and photos. I don't think many people realize that processing is an integral step in the field-to-table journey."

BILL BORDEN
Morgan Foods, Austin
Watercolor on paper 24 × 30 inches

the round." The idea was for all ten artists to stand back-to-back in a circle, in the middle of a farm field. Each artist was to paint his or her allotted segment of the field, using the same horizon line and canvases or supports of the same dimensions. Despite much debate over how the final product would appear, the paintings are striking for their individuality yet cohesion, as they surround the viewer with the illusion of an open field in late spring.

That cohesion may stem in part from the fact that several artists in the project share similar philosophies about their work. Says Lynn Dunbar, "I look at a subject and I look at the light and how it hits the shapes—and the colors and the feeling of the day—how it affects me. Maybe it's the fresh air or being

out in the farm fields in the different seasons. I want to express that feeling so that people can have the same feeling I had when I did the painting." Mark Burkett agrees. "The older I get, the more I'm aware of and impressed by the fact that you're trying to create a mood," he says. "If you're trying to recreate a scene, the best you can hope for as an artist and a painter is to try to recreate the sense that you felt when you looked at it, so another person can experience that same thing."

Artists attracted to plein air subjects paint predominantly in a modified American impressionist style. Their interest in remaining true to their own response to the immediate environment is generally balanced by the desire to create visually appealing compositions. Unlike the Social Realists of the 1930s and '40s, they tend to avoid painting industrial images or the darker side of humanity. Being encouraged to paint images of meat packing plants or to include cell phone towers in their landscapes, as was required by this project, was sometimes disconcerting to artists who look for and recreate beauty with their art.

Despite the intrinsic differences between plein air art and a project requiring visual representations of agri-business technology in the twenty-first century, the ten artists in the project worked to achieve successful results. They learned to look at and to think about agriculture. "I see agriculture in two different ways," Scott Sullivan says. "I see it going toward technology and science. There are marvelous things they can do,

but at the same time what's happening to the quality of our food and what's happening to our environment? . . . And then there's the other side. People are going to farmers' markets because they want to buy food with no additives."

"Going to the Fair Oaks Dairy (a 70,000-head modern dairy farm in Fair Oaks, Indiana) was an education. I had no idea that existed," Bill Borden remarks, adding, "I think this project has a lot of value. It's a service to the community."

The marriage of plein air art with the documentation of Indiana's agri-business has been a bit more discordant than initially predicted. After all, what's more picturesque than cows in a shaded pasture? Brown County author Henry Swain wrote, "I am glad that artists have historically found beauty in the pastoral landscape and recorded it for us. Not only was beauty recorded, but a history of the progression of agriculture. . . ."[10] The agricultural experts involved in *Painting Indiana II*, however, discouraged purely nostalgic renderings of farms and instead emphasized educational accuracy. A painting of a two-story farm house with a truss-roofed barn does not represent a working farm, even historically, because a myriad of functional outbuildings would have surrounded the homestead.

Artistically interpreting the changing face of agriculture in Indiana has been a learning experience for all involved. In some ways, the project's goals have transformed contemporary traditional plein air impressionists into rural realists. The results comprise an intriguing body of work.

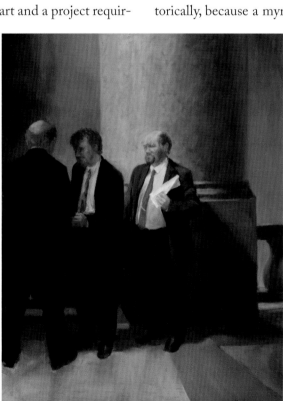

"Increasingly, government is playing a role in the farm equation. Special interest groups press legislators for action or change and agribusiness is no exception. This painting contrasts the ideal of government as the vertical marble columns with the reality of government or the protagonist in black, forming the horizontal."

BOB FARLOW
The Lobbyist, State Capitol Building, Indianapolis
Oil on canvas 36 × 28 inches

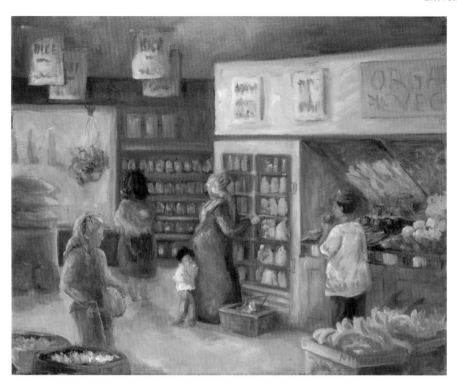

"I love the colors, sounds, smells, and textures of this ethnic market. It tells the old story of market, where product meets consumer. It also shows the growing diversity of both product and consumer in Indiana."

NANCY MAXWELL
Something for Everyone, Bloomington
Oil on canvas 14 × 18 inches

NOTES

1. William James Williams, introduction to *Impressionism and Post-Impressionism* (New York: ParkLane, 1989), p. 10. "In 1841, the American scientist-artist John Rand patented folding tubes to hold spoilable oil paints. . . . Rand's paint tubes permitted an entire studio to fit into a briefcase and be carried outdoors conveniently."

2. Theodore Clement Steele journal entry August 18, 1885, quoted in Selma N. Steele, Theodore L. Steele, and Wilbur D. Peat, *The House of the Singing Winds* (Indianapolis: Indiana Historical Society, 1966), p. 34.

3. "The Artist Steele," *Indianapolis News*, February 19, 1887.

4. W. M. Hershell, "The Art Invasion of Peaceful Valley," *Indianapolis News*, August 7, 1909.

5. Brochure, *Painting Indiana: The Changing Face of Agriculture, Volume Two in the Painting Indiana Series*, IPAPA 2004.

6. Ibid.

7. Ibid.

8. At the Art Institute of Chicago, instructors John Vanderpoel and Charles Boutwood led a band of merry students to Delavan, Wisconsin, each summer in the 1890s for outdoor sketching, and famed William Merritt Chase reigned over classes at his Shinnecock Summer Art School from 1891 to 1903 for artists who studied predominantly at the Art Students League in New York.

9. "Members of the Brown County group, like many American artists in all eras, had at times supported themselves as sign painters, commercial artists and illustrators." Rachel Perry, introduction to *The Artists of Brown County* (Bloomington: Indiana University Press, 1994), p. xxiii.

10. Henry Swain, "Haystacks," *Our Brown County* magazine, Helmsburg, Indiana, October 2004, p. 46.

The artists of Painting Indiana II: The Changing Face of Agriculture *were challenged to paint a 360° panorama. Facing outward in a circle at the Lamar Farm in Zionsville on April 29, 2005, they painted the same horizon line using the same size canvases. The scene was typical of much of Indiana farmland on any given cloudy day. Old barns, new buildings, traditional equipment, modern machines, wooded areas, fields, and a cell tower were part of the view. The artists' (initial) places in the panorama are indicated by the 36° slices pictured at right.*

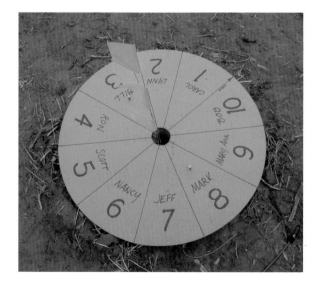

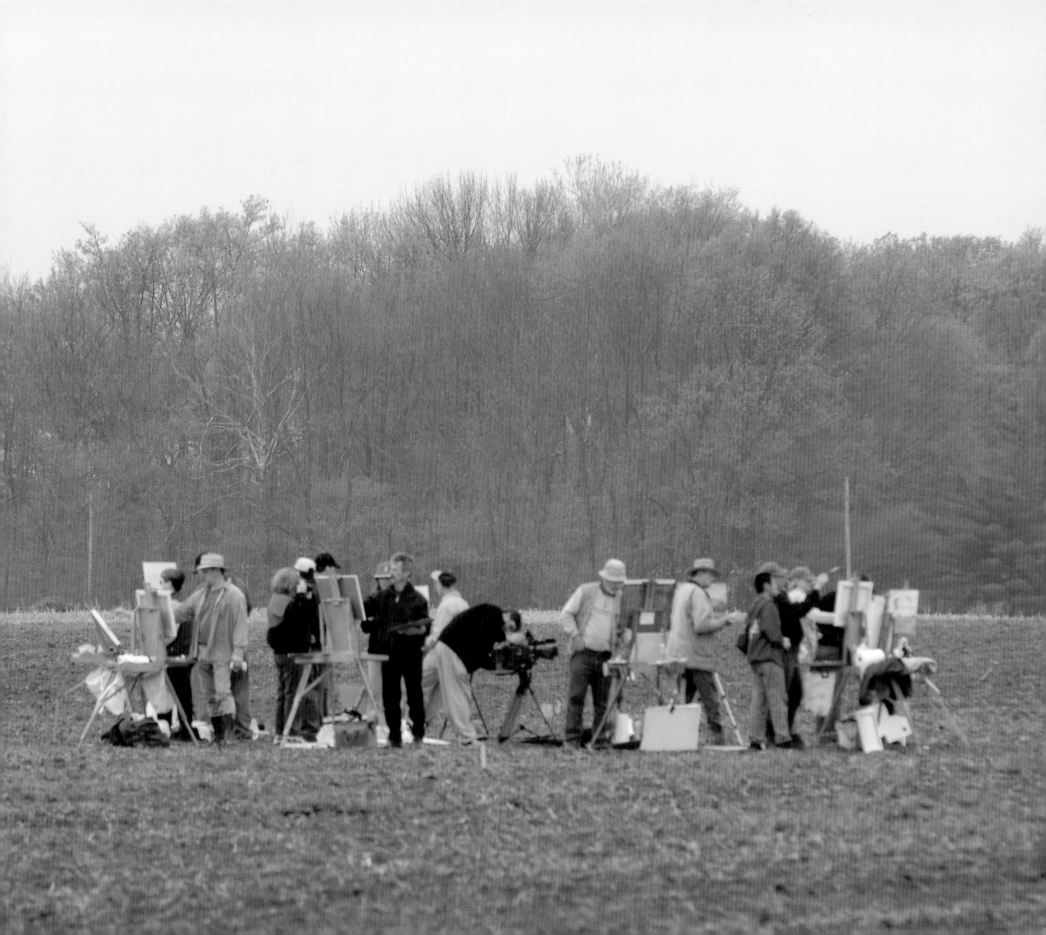

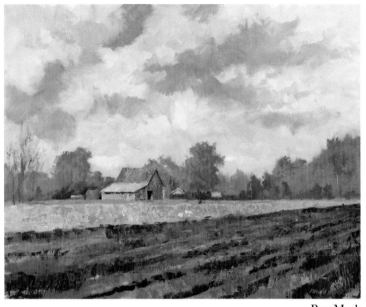

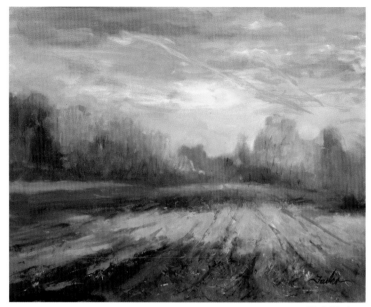

Ron Mack

Bob Farlow

Pastels, oils, and watercolors, placed side by side, form a total 360° perspective of the Lamar Farm.
Each painting is 16 × 20 inches.

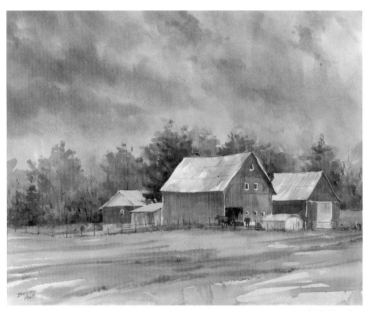

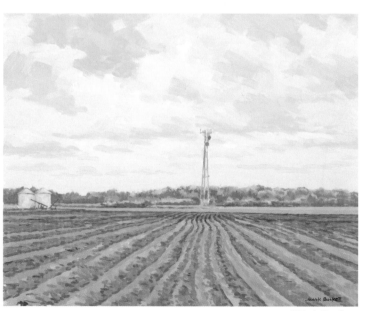

Bill Borden

Mark Burkett

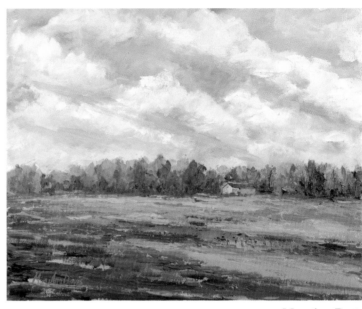

Lynn Dunbar

Carol Strock-Wasson

Mary Ann Davis

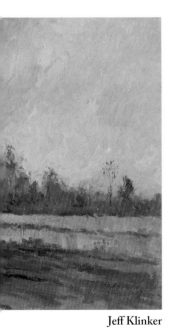

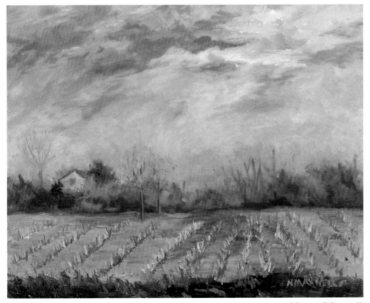

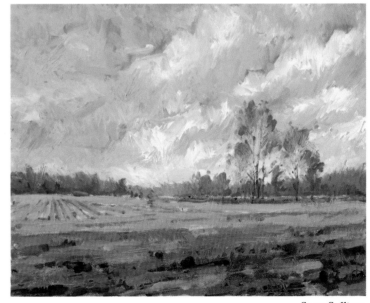

Jeff Klinker

Nancy Maxwell

Scott Sullivan

"This painting shows springtime on a sheep farm. Some sheep are already sheared, clean and white, and out in the pasture. Others, long-haired and dirty, are waiting in line. The man doing the shearing is well-known in this area. He is a very large, strong man, but he handles the sheep very gently and with care. I helped with skirting and weighing the fleece."

NANCY MAXWELL
A Sure Sign of Spring, Morgantown
Oil on canvas 24 × 28 inches

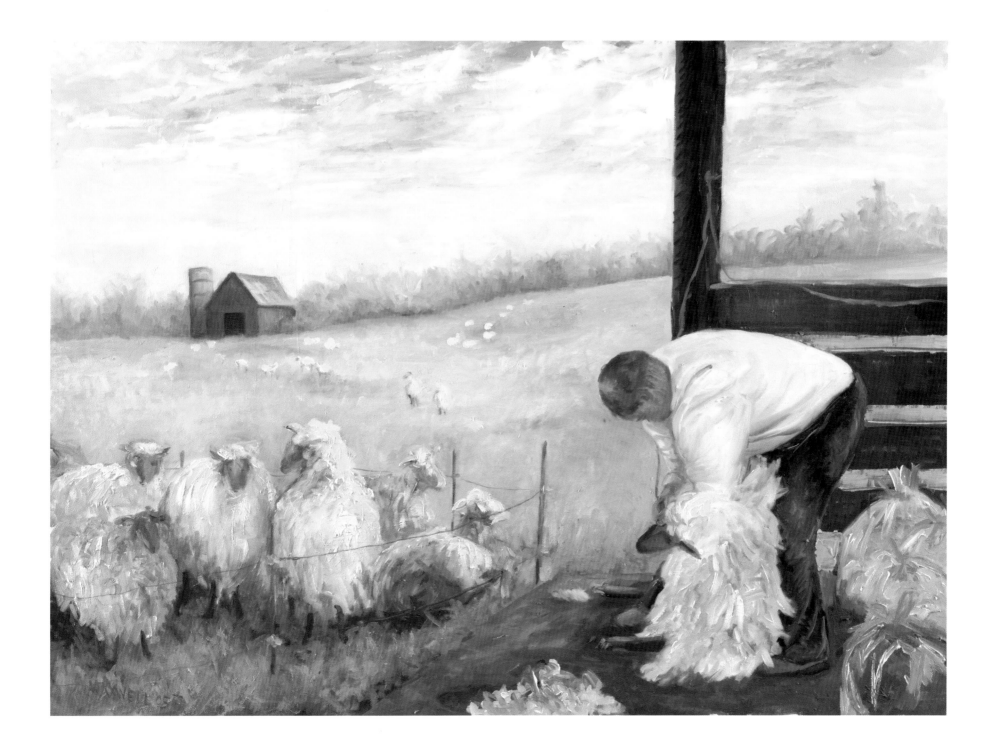

xxvii

"Even though bison or buffalo haven't been exactly domesticated, there are more than a few buffalo farms along the Indiana landscape. Their lean and especially flavorful meat is steadily growing in popularity."

MARY ANN DAVIS
Watching His Women, English Buffalo Farm,
Bainbridge
Oil on canvas 20 × 24 inches

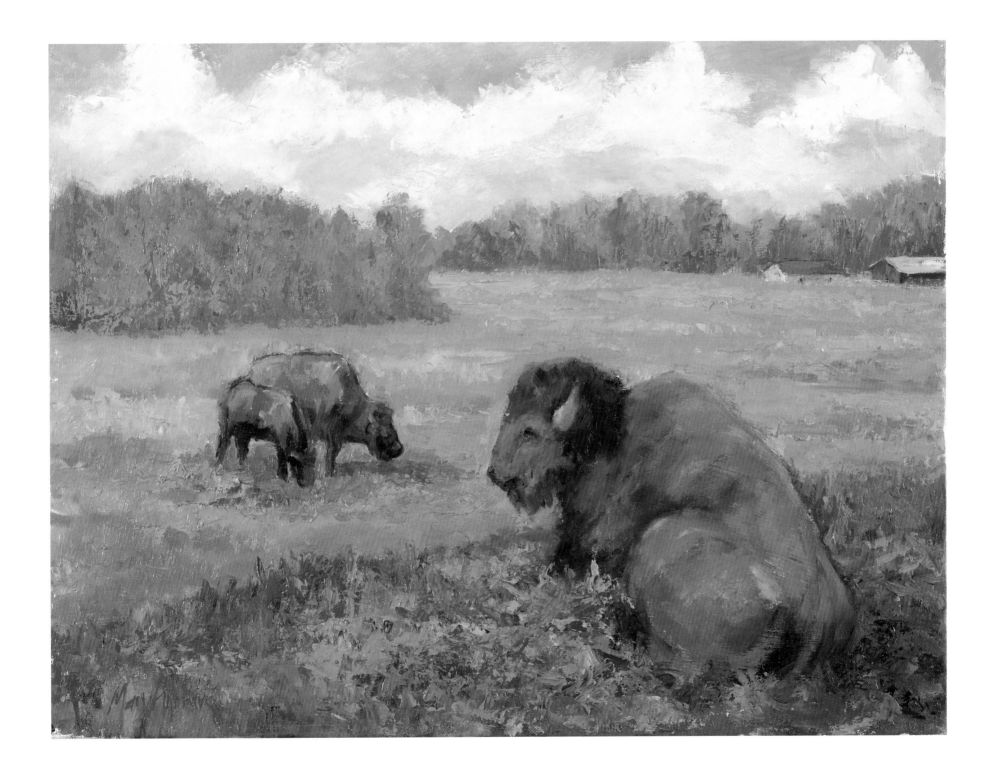

Using a special paint box and easel, Lynn captured the Ohio River on canvas from the jump seat of a small Cessna airplane. "I wanted to paint the river because it plays an important role in agriculture. The large barges were floating the last of the season's grain down river toward Cincinnati. The flooding of the river after the winter's thaw will leave rich organic materials behind, making the farm land fertile for the new season."

LYNN DUNBAR
Winter View, Ohio River, Evans Landing,
near Corydon
Oil on canvas 20 × 24 inches

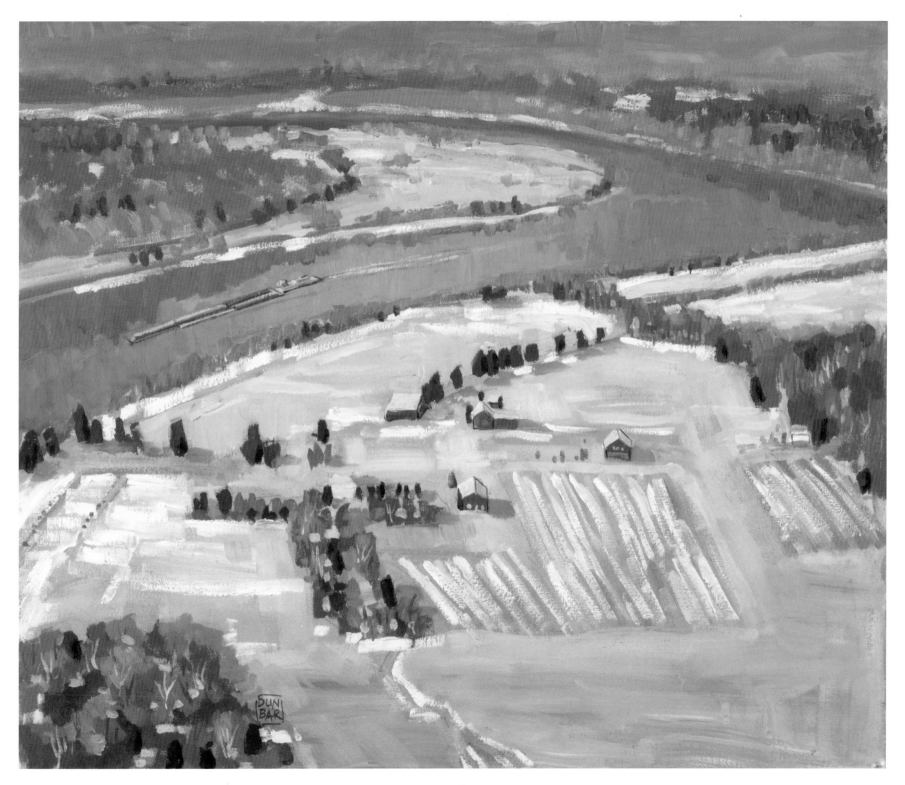

*"Dream Acres Farm boards and rehabilitates race horses,
as well as growing some of their own hay."*

JEFF KLINKER
Straw Raker, Dream Acres Farm, Lafayette
Oil on linen 24 × 30 inches

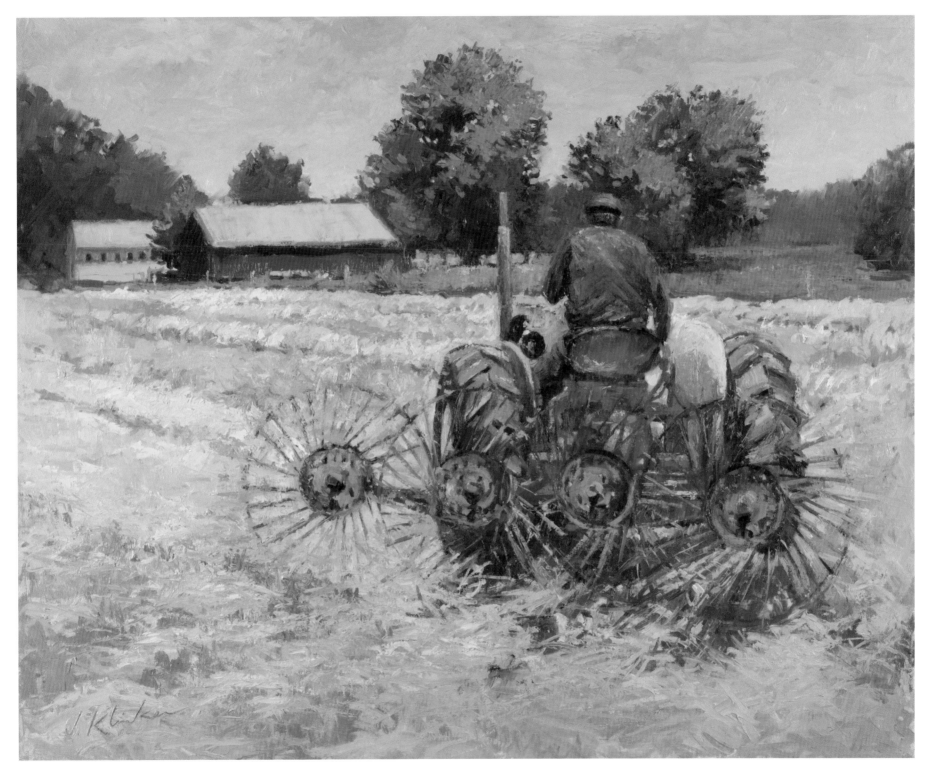

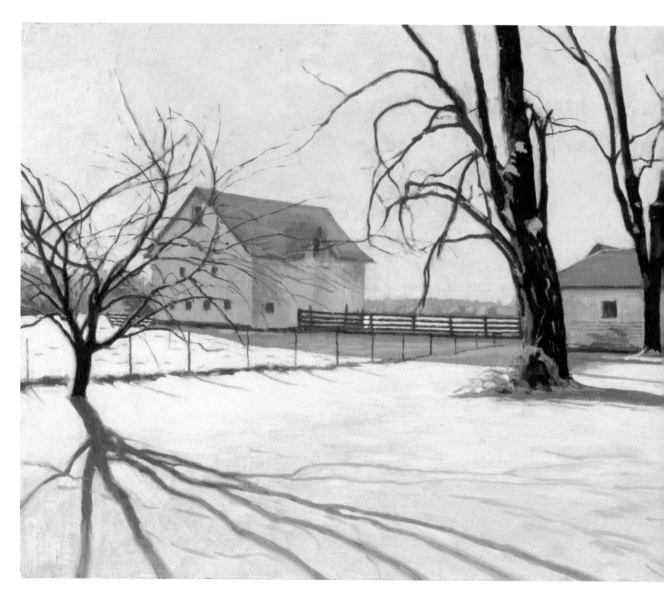

"*This farm had been in the same family for over 150 years and plans are underway to turn it into a living history museum. The old house, barn, and other outbuildings whisper of quieter and simpler days.*"

MARK BURKETT
Maple Lawn Farmstead, Zionsville
Oil on canvas 10 × 30 inches

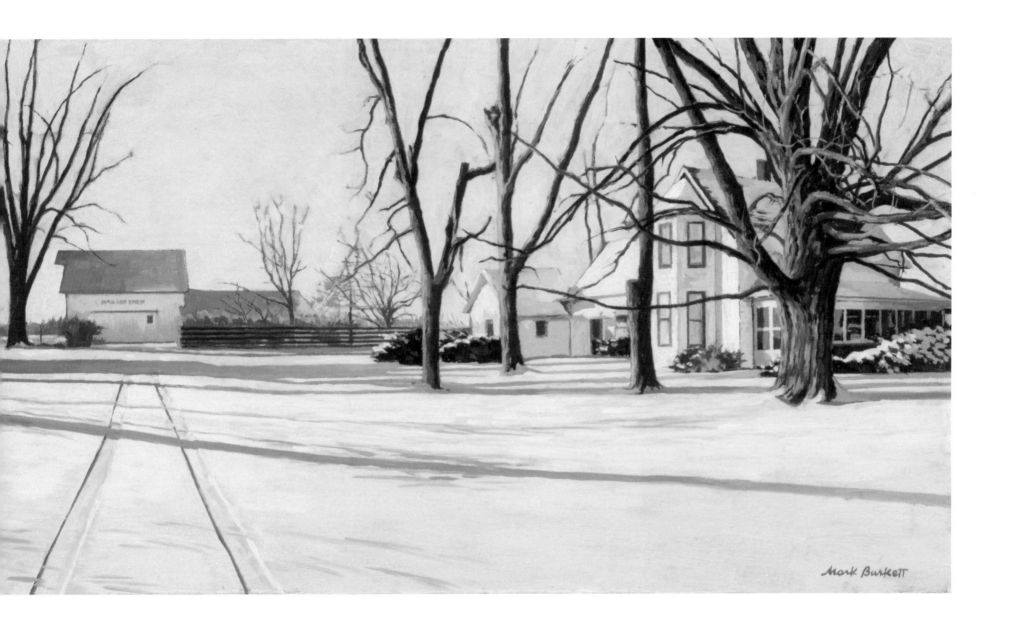

Painting INDIANA II

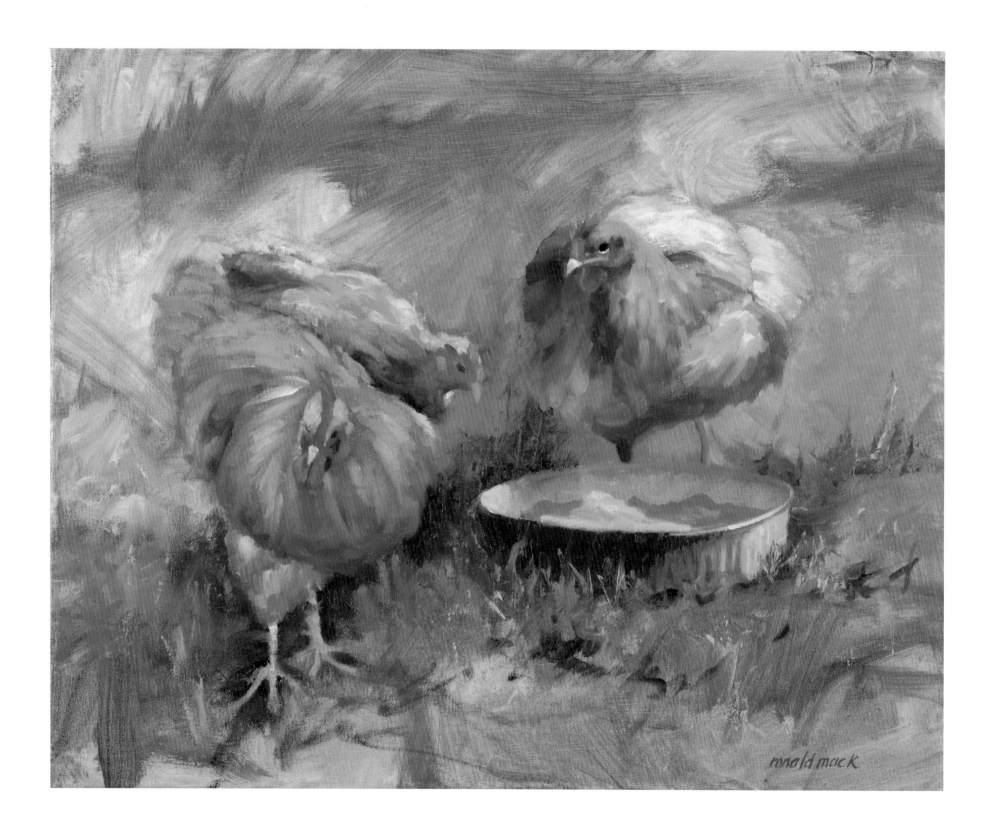

1. The Changing Face of Indiana Agriculture

When the frost is on the punkin and the fodder's in the shock,
And you hear the kyouck and gobble of the struttin' turkey-cock,
And the clackin' of the guineys, and the cluckin' of the hens,
And the rooster's hallylooyer as he tiptoes on the fence;
O, it's then's the times a feller is a-feelin' at his best,
With the risin' sun to greet him from a night of peaceful rest,
As he leaves the house, bareheaded, and goes out to feed the stock,
When the frost is on the punkin and the fodder's in the shock.

JAMES WHITCOMB RILEY

When Hoosier poet James Whitcomb Riley penned those words in 1882, most of his readers were personally familiar with the sounds, images, and dialect he used. The majority of Indiana residents lived on farms or had done so at some time. Most Hoosiers had recently heard the clucking of chickens and had personally ventured out into a raw fall morning to feed the livestock.

Today, most Hoosiers are generations removed from the farm, and the closest most people get to chickens, cows, or pigs is the meat section of the grocery store. Over the past hundred years, Indiana agriculture has evolved from subsistence farming, which did not change much for hundreds of years, to a global industry using biotechnology and satellite positioning.

Painting Indiana II: The Changing Face of Agriculture tells the story of that amazing transformation, the forces that brought it about, and the impact it has had on the people, the culture, and the economy of our state. Painting in the plein air tradition, on location, ten Indiana artists have interpreted the past, present, and future of Indiana agriculture and rural life.

Paintings in this book combine fine art and natural beauty. They capture the colors and textures, the contours and contrasts, and the patterns and perspectives that mark the rural landscape. In addition, they show the people who are at the heart of agricultural industry.

To make Indiana agriculture come alive in their paintings, the artists who contributed to *Painting Indiana II* went into fields, barns, and processing plants. They met farmers, their families, and, in some cases, their animals to better understand the complexity and diversity of the Indiana agricultural community. The end result is a beautiful collection of artwork that tells the story of the changing face of Indiana agriculture.

"The fowl of the field were making their presence known, pecking and clucking in the dirt and pen. They became very interesting subjects as they paraded around on their turf, shapes of red and gold with a blue pan." These free-range chickens are integral to Traders Point Creamery's organic dairy.

RON MACK
Lunch Is Served, Traders Point Creamery, Zionsville
Oil on canvas 16 × 20 inches

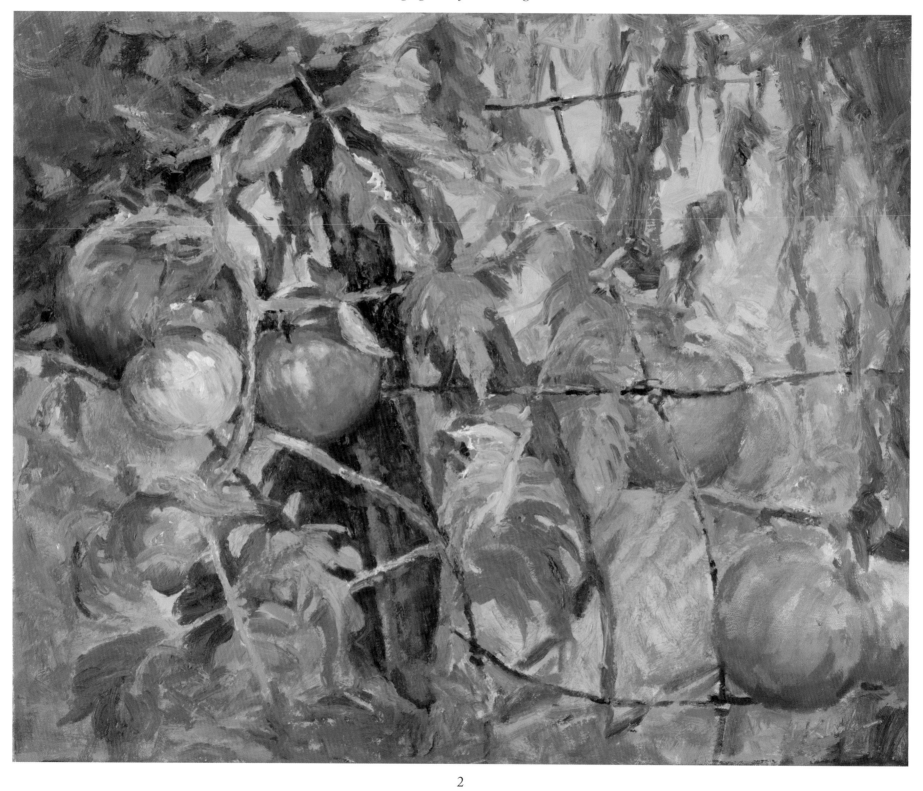

Agriculture and art have a special connection involving patterns, colors, contrast, texture, perspective, emotion, and creation. But the artists also found in this project an opportunity to preserve the images of agriculture for future generations. "I believe it is important to preserve the heritage of Indiana agriculture," declares artist Nancy Maxwell.

The face of agriculture is changing rapidly. Through these paintings, we see the past and the present and get a glimpse of the exciting future that awaits Indiana agriculture in the next hundred years.

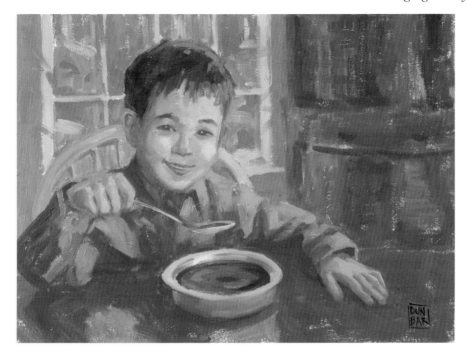

"My son was enjoying a bowl of tomato soup. It made me think about consumption, the best part of the agricultural process!"

LYNN DUNBAR
Tomato Soup, Louisville, Kentucky
Oil on canvas 10 × 12 inches

For some of the artists, including Bob Farlow, Mark Burkett, and Jeff Klinker, this project was a return to their pasts, as they were raised on farms in rural Indiana. Other artists, including Lynn Dunbar and Mary Ann Davis, had little previous exposure to farming and rural life and found themselves immersed in a new and fascinating world.

"My neighbor plants her tomatoes with the post and wire just like my mother used to do. No matter how high-tech farming gets, nothing will ever beat a home-grown tomato."

JEFF KLINKER
Tomatoes, Hoosier Backyard
Oil on canvas 16 × 20 inches

"I spent an afternoon in the field with Alan Small and his associates during harvest. The combine did all the steps of snapping and shelling the kernel from the cob and transferring it to the weigh wagon. The corn was then augured into the transfer truck, which would take it to a bin for drying and storage."

RON MACK
Corn Harvesting, Alan Small Farm, Jasper
Oil on canvas 20 × 30 inches

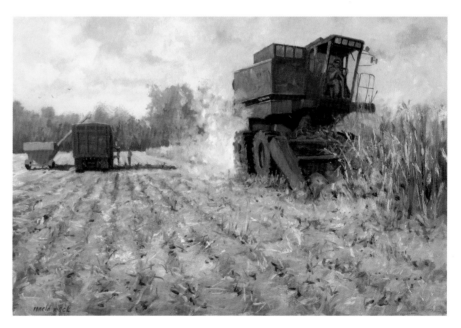

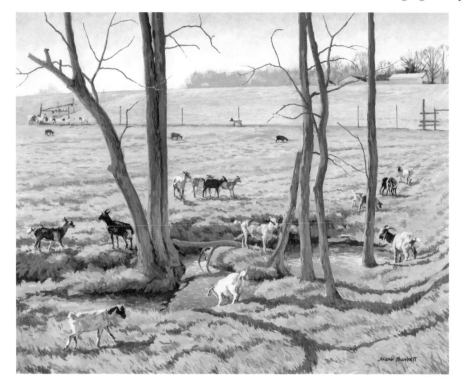

"Prince's Goat Farm has the only slaughterhouse in the state where people may slaughter their own animals. It is patronized by a growing number of immigrants from the Middle East, Africa, and Latin America. The goats were very curious and will attempt to eat paintings if given a chance."

MARK BURKETT
Prince's Goat Farm, Hazelwood
Oil on canvas 16 × 20 inches

Three Revolutions

Agriculture has always been an industry driven by technology. With each technological advance, farmers have become more productive, efficient, and fewer in number. The twentieth century saw three revolutions that dramatically changed American agriculture in general and Indiana agriculture in particular: mechanization, hybridization, and biotechnology.

At the beginning of the nineteenth century, a farmer had to work 344 hours to produce 100 bushels of corn. An average yield was 25 bushels per acre. By 1850, 90 hours of labor were required to produce 100 bushels of corn, and average yields were 40 bushels per acre.

Several technological advances during the 1800s laid the groundwork for the transformation of farming in the twentieth century. Cyrus McCormick invented the grain reaper (1831), John Deere began making steel plows (1837), and the first gasoline tractor was invented (1892). By 1900, only 40 hours of work were required for a farmer to produce 100 bushels of corn.

"I had talked to several farmers who use dogs to herd and guard their flocks of sheep. They said there has been a resurgence in using dogs as a farming tool. Shepherds and Border Collies herd the sheep, and Great Pyrenees are often raised with the sheep flock to serve as watch dogs. The title 'Down, Come By to Me' is a command the farmer used frequently to instruct the dog to bring the sheep around."

NANCY MAXWELL
Down, Come By to Me, Morgantown
Oil on canvas 15 × 30 inches

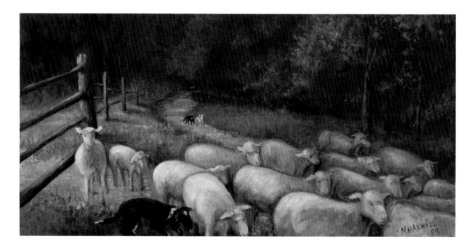

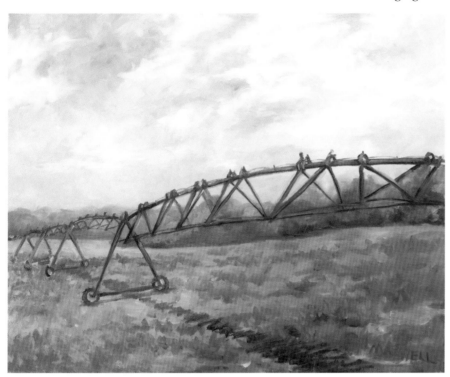

"This is a typical soybean field with above-ground irrigation. I love the look of these structures; they are beautiful sculptures that go on and on across many Indiana fields."

NANCY MAXWELL
Across a Country Mile, Hwy. 37, north of Martinsville
Oil on canvas 16 × 20 inches

"Semi trailers lining the roadside mark the beginning of the field-to-table journey for this farmer's crop."

JEFF KLINKER
Harvest, Montgomery County
Oil on canvas 30 × 24 inches

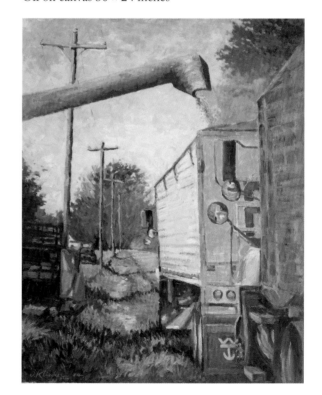

The mechanical revolution was slow to come to Indiana, however, and farmers used horses for many farm chores well into the 1930s. Early steam-powered farm equipment was large, heavy, expensive, and took several men to operate, which limited its use by most farmers. The first gasoline-powered machine on many farms was Henry Ford's Model T. Introduced in 1908, the Model T was priced for the average citizen, and farmers quickly adapted its use for hauling produce and livestock around the farm and to market.

Ford introduced his first farm tractor, the Fordson, in 1916, and by 1923, it was common on many Indiana farms. In 1923, John Deere began producing a two-cylinder farm tractor; in 1924, International Harvester Co. introduced the Farmall tractor, which was billed as the first all-purpose farm tractor.

After World War II, agricultural production in the Midwest focused on row crops (mainly corn and soybeans), which led to the development of specialized pieces of equipment such as multi-row planters and self-propelled combines. By the 1950s, the tasks of planting, cultivating, harvesting, husking, and shell-

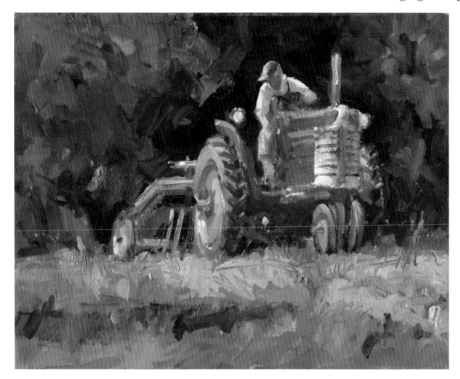

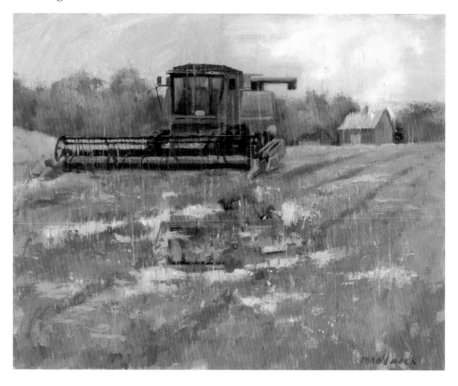

"While technology continues to advance, making farm equipment more efficient and economical, there will always be a place for an antique tractor in the barn."

SCOTT SULLIVAN
Stiff Neck, Bloomington
Oil on linen 16 × 20 inches

Even with cutting-edge technology, Mother Nature is still in charge.

RON MACK
Rain Delay, Hancock County
Oil on linen 16 × 20 inches

ing, which had been performed by hand or horsepower in the past, were done by machines.

Over the past fifty years, farm equipment has become larger, more sophisticated, and more expensive. Today, a farmer can plant up to twenty-four rows of corn at a time. Tractors offer amenities such as air conditioning, radio, television, and on-board computers. Combines have monitors that show farmers their yields as they move across a field. New auto-steer technology, which integrates on-board computers and global positioning satellites (GPS), lets farmers take their hands off the wheel and allow the computer to drive the equipment.

The mechanical revolution not only increased farmers' productivity and efficiency but also wrought changes in their farms, families, and communities. By 2004, producing 100 bushels of corn required two hours of labor and one acre of land. As machines took over more and more jobs once done by horses, the horse disappeared from the farmstead. Acres of oats that had been used to feed the horses were replaced by soybeans and other cash crops.

In 1900, Indiana had 216,000 farms. By 1960, the number had decreased to 134,000 farms; in 2003, to just 59,500. And as fewer hands were needed for the work of the farm, the number of people directly involved in production agriculture declined steadily. At the beginning of the twentieth century, one third of the population was involved in agriculture. By the end of the century,

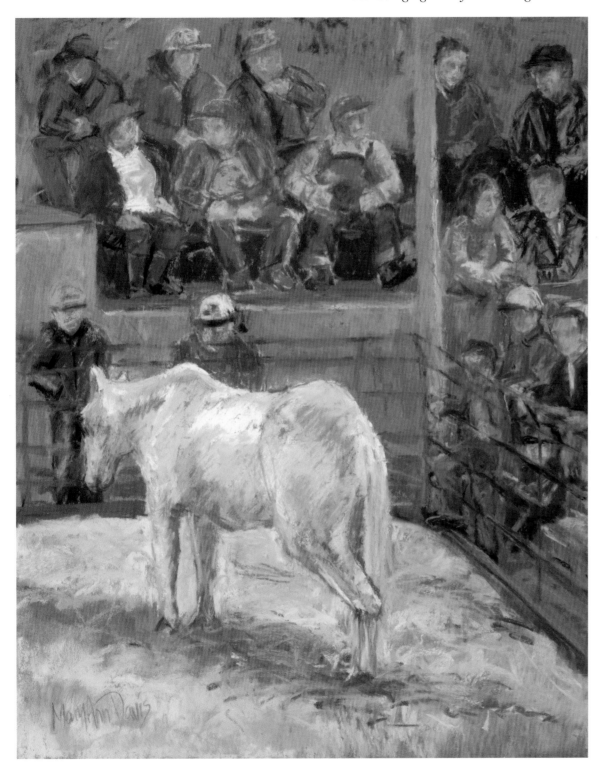

Once depended upon for transportation and power in the fields, the horse on the modern-day farm rarely has duties beyond being family pet. This old mare sold for $35.00 at the Rockville Livestock Auction.

MARY ANN DAVIS
Horse Auction, Rockville
Pastel on board 20 × 16 inches

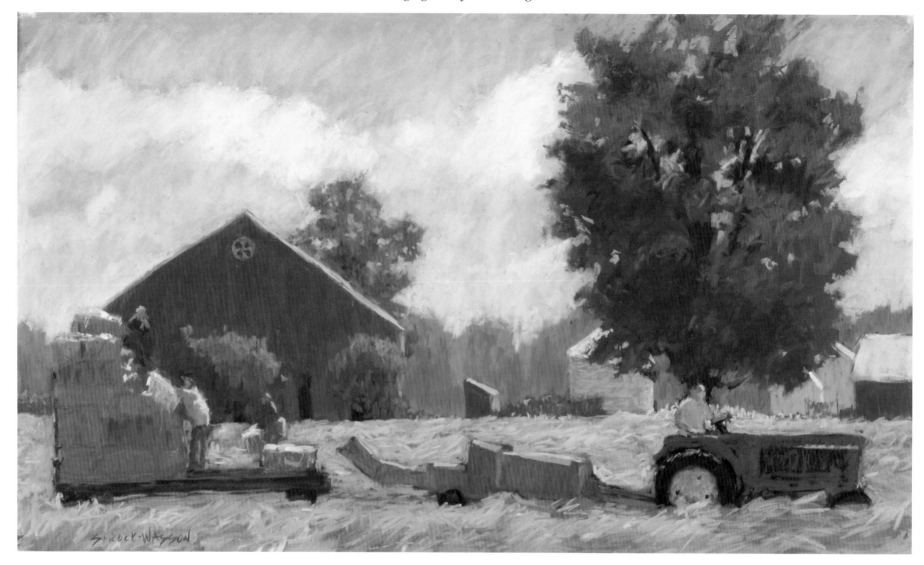

"I just happened to be passing by when they were baling straw. I noticed that the labor-ers were high-school boys. I imagine they are the only ones who can stand the sweltering heat." Often the children of farmers work right alongside their parents. They are a vital part of the family's success.

CAROL STROCK-WASSON
Baling the Straw, Road 800 E, Randolph County
Pastel on wallis paper 16 × 27 inches

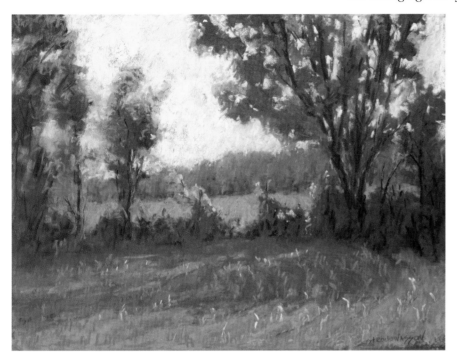

"I think every farmer, no matter how confident, breaths a small sigh of relief or maybe just gasps in reverence when they gaze upon their new seedlings in the field."

CAROL STROCK-WASSON
Corn Emerging in the Fields, 950 N, Randolph County
Pastel on board 18 × 24 inches

Much of this increased productivity was due to commercially produced hybrid seeds. Plant breeders were able to cross many different varieties to produce crops that were particularly suited for certain areas. Today, farmers can choose seeds that are specially designed for the weather and soil type on their farms.

New fertilizers also contributed to increased productivity during the latter half of the twentieth century. During World War II, munitions plants in the United States produced a by-product called anhydrous ammonia. Farmers found that this chemical made an outstanding fertilizer. It is still in wide use today and allows for a more intensive use of farmland. In addition, new crop protection chemicals became available in the 1950s, allowing farmers to more effectively control weeds and insects. Although these chemical tools were costly, the increase in yields they provided offset the cost.

Concerns over the environmental effects of these first farm chemicals gave rise to a new generation of chemicals that produced the same results but at a much lower rate of use. Today, farmers apply ounces rather than gallons to a field.

The third revolution in agriculture, biotechnology, has just begun to make its impact. By manipulating plant genes in a laboratory, scientists are now able to produce crops with a variety of characteristics. Crops can be developed with a built-in resistance to specific diseases and to insects, for example, thus eliminating the need for toxic insecticides. Crops also can be designed with special characteristics to make them ideal for specific use—for example, corn can be engineered to offer high oil or starch content or with special nutrients to benefit livestock. Fruits and vegetables can be designed with added vitamins to improve human diets. This technology allows for new varieties to be developed and brought to market more quickly.

The most popular use of biotechnology by Indiana farmers at the end of the twentieth century was to create herbicide resistance. For example, a soybean crop was created with a built-in resistance to the glyfosate herbicide, commonly known as Roundup®. Farmers could then spray an entire field with the herbicide to eliminate all other plants except the soybeans. This technology reduces the use of many other chemicals while maintaining high yields.

Biotechnology has also changed the look of our corn fields. The old saying "knee high by the 4th of July" just does not measure up any more. Improved plant genetics have given us faster-growing and taller corn. In Indiana, most corn is at least shoulder high by July 4.

that number shrank to just 2 percent of the population. Farming used to be a community activity, bringing together families, neighbors, and whole communities to do the work, but today, very few people have on-farm experience.

The second revolution that shaped the face of modern farming was hybridization. Crop yields increased very little during the nineteenth century, but the twentieth century saw a rapid increase in yields. Indiana farmers had average corn yields in 1900 of about 41 bushels per acre (BPA). Seventy years later, yields had increased to 68 BPA, and, in 2004, Hoosier farmers enjoyed record yields of 134 BPA. Soybean yields likewise increased from 9 BPA in 1924 to 49 BPA in 2001.

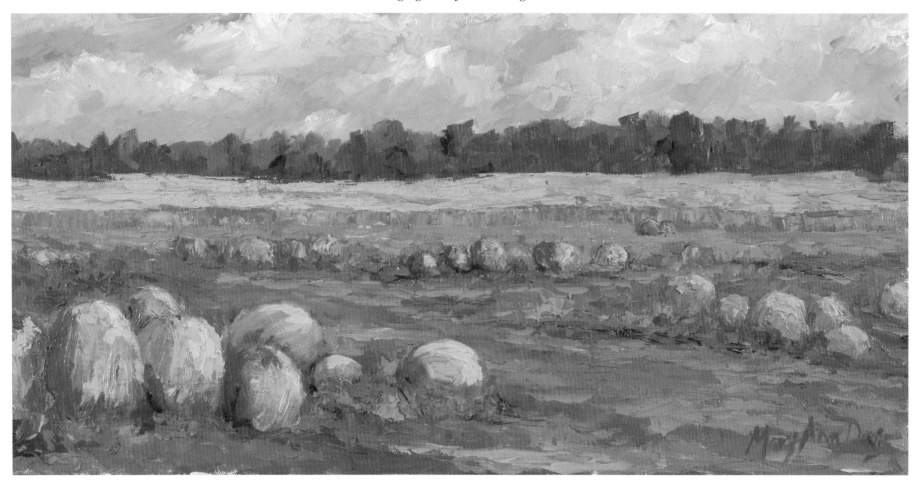

Test farms like this one scientifically evaluate hybridized and engineered crops—their practical application, their effects on the environment, and the overall benefit they may provide to the farmer.

MARY ANN DAVIS
Pumpkins at Purdue, Lafayette
Oil on canvas 12 × 24 inches

Planters capable of seeding twenty-four rows at once are not an uncommon sight on Hoosier farms. Together with biotechnology, they are making crop production more efficient and reliable.

LYNN DUNBAR
Plowing Fields in Spring, Fellows Farm, Nabb
Oil on canvas 16 × 20 inches

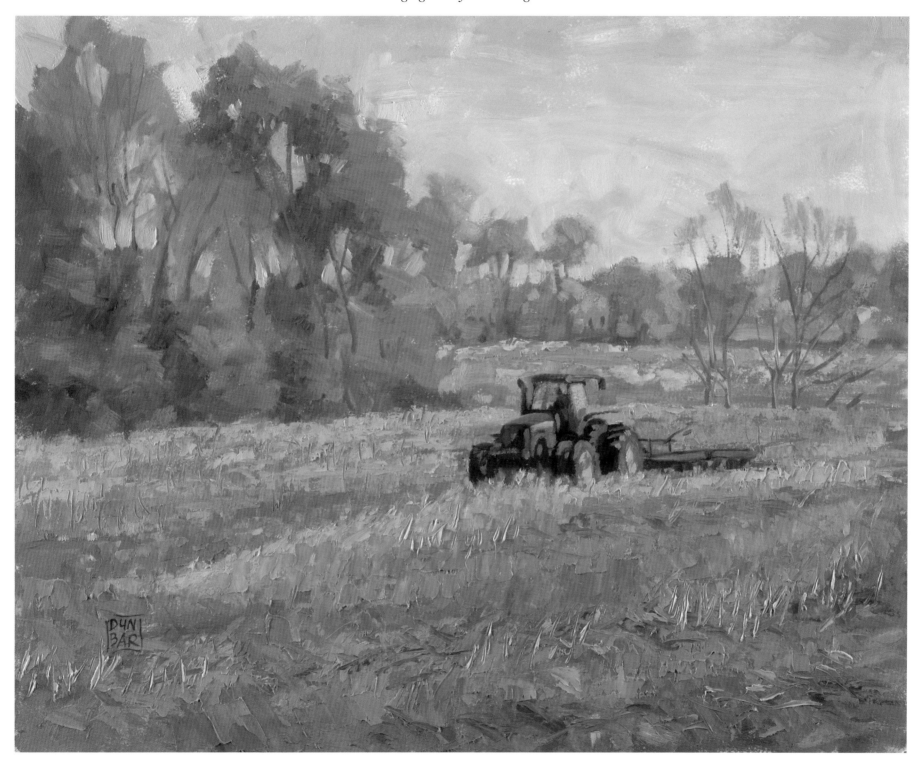

Efficiency and higher yields are not the only objectives of technology. Sustainability and conservation of our natural resources are also priorities.

CAROL STROCK-WASSON
Hurley Drilling the Soybeans, Greenville Pike and 500 S, Randolph County
Pastel on board 18 × 24 inches

The Two Futures of Indiana Agriculture

Indiana agriculture is moving in two divergent directions. It is getting larger and smaller at the same time. These trends will reshape the rural landscape in two very different ways. *The 2002 Census of Agriculture* revealed a trend of larger farms getting larger. From 1997 to 2002, Indiana saw a 3.5 percent increase in large farms (1,000 to 1,999 acres) and a 39 percent increase in farms with more than 2,000 acres. During this same period, the number of small farms (10 to 49 acres) increased 4 percent. Meanwhile, the number of medium-size farms (50 to 999 acres), once in the majority, decreased by more than 18,000 farms.

Larger farms can take advantage of large-scale efficiencies and produce bulk commodities at a low price for the world market. Modern, integrated, confined-livestock feeding and dairy operations can raise animals quickly, safely, and at very low per-pound cost.

Although Indiana may be known for its sprawling corn fields, there is a rich diversity to Indiana agriculture. Many farm families are today growing a variety of other products, from fruits and vegetables to Christmas trees, mint,

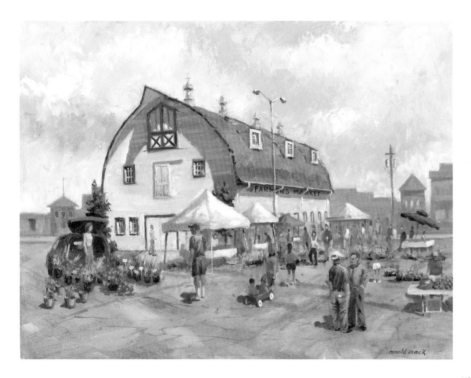

"The home of the Center for Agricultural Science & Heritage, Inc. is an impressive-looking barn of the past with a modern interior and a colorful outdoor farm market in summer in the middle of Indianapolis."

RON MACK
Center for Agricultural Science & Heritage, Indianapolis
Oil on canvas 18 × 24 inches

hot peppers, flowers, honey, popcorn, and fish. The growing popularity of ethnic foods provides an opportunity for farmers to produce specialty crops not available in supermarkets.

In addition, Indiana's wine industry is recapturing some of the glory it enjoyed at the turn of the twentieth century. Prohibition dealt a blow to the state's wine industry in 1919, but since 1989, the Indiana wine and grape industry has expanded by more than 300 percent. The key has been the development of wine grapes that can survive the often harsh Indiana winters.

Small farmers are finding success in producing these specialized products for niche markets as well as marketing products directly to consumers. According to the 2002 census, national direct-to-consumer marketing by farmers totaled $812 million, an increase of $200 million from 1997. Both farmers and consumers are rediscovering the benefits of farmers' markets. Urban consumers can now find fresh, high quality fruits, vegetables, and meats at an increasing number of markets across Indiana.

With today's consumer many generations removed from the farm, some small farms are finding an opportunity for a new venture: tourism. Agritourism is a growing industry in Indiana. From farm bed-and-breakfasts to corn mazes and U-pick opportunities, farmers are finding that farm life is an experience marketable to the modern urbanite.

The face of agriculture is being shaped by two powerful forces, technology and economics. As it has in the past, technology continues to provide farmers with new levels of production and efficiency, offering new and better crops to grow, better ways to grow them, and safer and more efficient ways to plant and harvest. The economics of this technology has forced some farmers to get bigger, some to get smaller, and some to get out of farming altogether. As explored in the following pages, these forces have also changed the land and the people who live on it. And just as the developments of the past century have shaped the food and fiber of our new century, the agriculture of today will shape the land and the people of tomorrow.

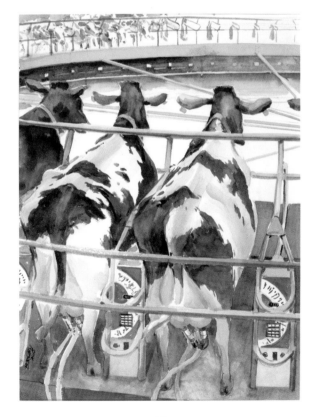

The romantic imagery may have disappeared from many modern-day farms, but they provide an economic, secure, and reliable product to our growing population. "Fair Oaks is very careful to avoid any possible contamination of their cows or milk, so we toured the facilities by bus. To view the milking parlor, we were driven into a large garage area and allowed to leave the bus only after the garage door was closed. We were then directed to an elevated observation room which was small and dimly lit. I was left behind and allowed to paint from this location but had to move my easel out of the way as each successive tour passed through."

BILL BORDEN
Fair Oaks Dairy, Fair Oaks
Watercolor on paper 24 × 20 inches

"Jenner's Tree Farm's main building sits up on a hill with a view of a beautiful valley planted in Christmas trees. My family has been cutting trees there for many Christmases. The scene has always appealed to me, especially when it's snowing. It is all green and white with just a few bright flecks of color that catch your eye. These are the jackets, scarves, and mittens of tree shoppers."

NANCY MAXWELL
Holiday Harvest, Jenner's Tree Farm, Ellettsville
Oil on canvas 20 × 30 inches

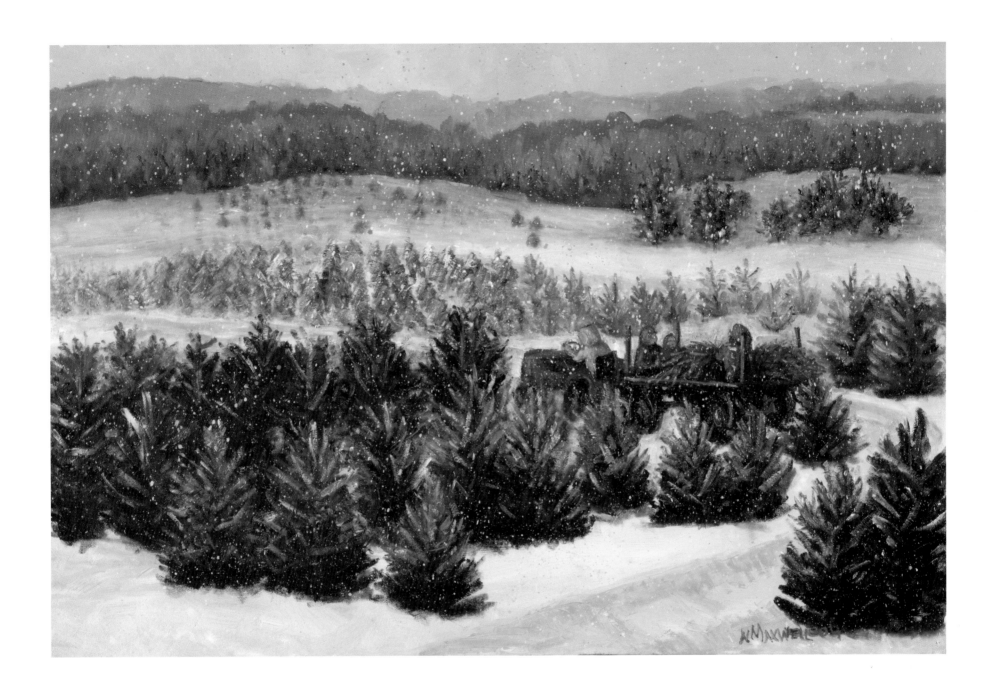

15

"We've known the Thomas family since moving to the Madison area. They're great supporters of the arts and host art shows at their tasting room and also provide live Celtic and other musical performances on weekends and for special events. The day of crushing was a flurry of activity and I got involved in hauling and dumping crates of grapes as well as painting and sketching."

BILL BORDEN
Thomas Family Winery, Madison
Watercolor on paper 22 × 28 inches

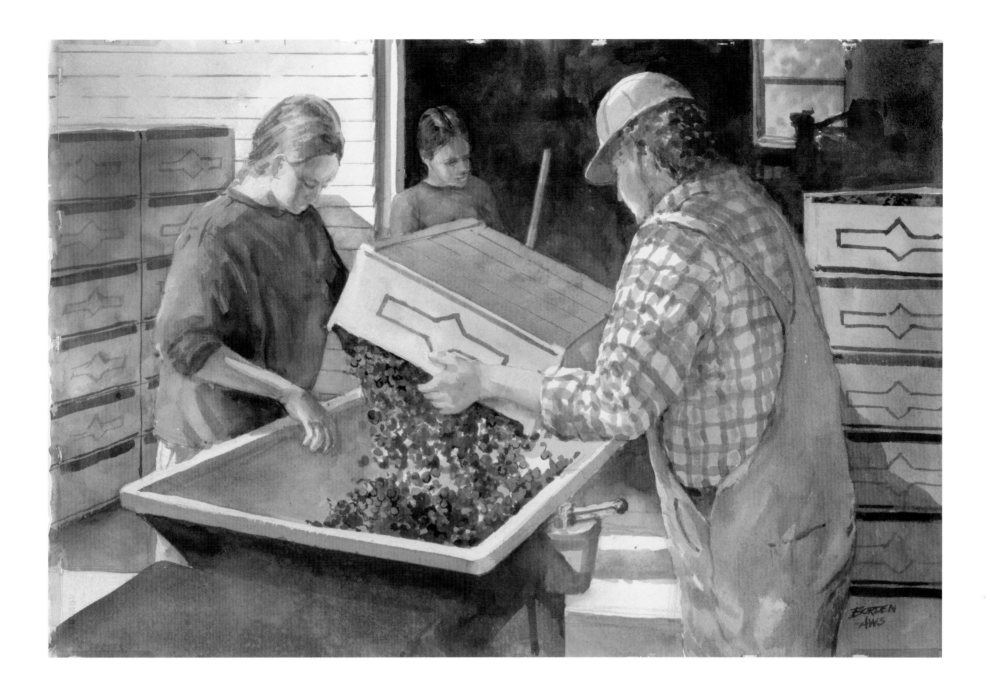

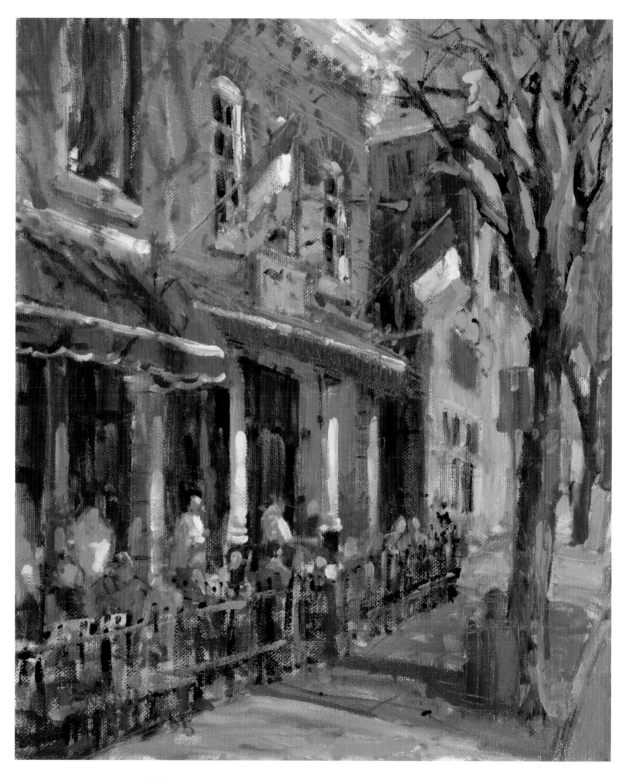

The Irish Lion is one of many well-patronized, locally owned restaurants in Bloomington that retains a small-town ambience.

SCOTT SULLIVAN
Irish Spring, Irish Lion, Bloomington
Oil on canvas 24 × 20 inches

2. The Land

Thomas Jefferson said, "We shape the land, and the land shapes us," and that certainly can be said for the land we call Indiana. Encompassing 36,205 square miles of land and 309 square miles of water, the state is divided into three main regions: the upper third, with sandy soils and many lakes; the central third, with flat landscapes and heavy clay soils; and the southern third, with rolling hills and a thin covering of soil over limestone.

The glaciers of the ice age left Indiana rich in natural resources and perfect for agricultural endeavors. Land elevation ranges from 324 feet above sea level at the mouth of the Wabash River to 1,257 feet in east central Indiana. The

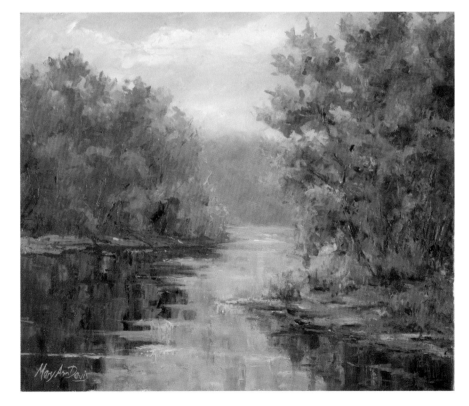

Rivers will always be a vital part of the agricultural process. Modern farming practices, such as no-till planting, ensure that clean and sustainable waterways are maintained.

MARY ANN DAVIS
White River Dawn, Indianapolis
Oil on canvas 20 × 24 inches

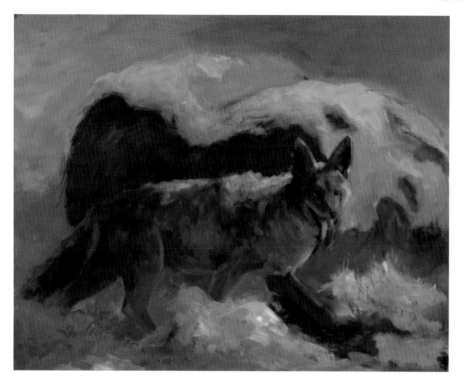

"The coyote and round bales are newcomers to the Indiana farm. For the composition, I chose for the motif of the coyote's ears and the circle of the bales to play against each other. The bales heighten the alertness seen in the sharpness of the coyote's face."

BOB FARLOW
The Coyote, Randolph County
Oil on canvas 24 × 30 inches

Saving Indiana Soil

Farmers today use a variety of methods to conserve and enrich our soil and to protect the Hoosier environment. Many Indiana farms have been in the same family for generations, and those who work the farms view themselves as stewards and caretakers of the land for the next generation.

The first Indiana settlers adopted the farming techniques of the Native Americans, planting their crops in mounds. With the coming of the plow, farmers began to plant their crops in long furrows. Mechanization added speed to the plowing and planting process but did not significantly change it.

In 1943, in his book *Plowman's Folly*, Edward H. Faulkner released some of the first research on no-till farming—the revolutionary idea that farmers could improve soil quality and lessen soil erosion by leaving crop residue on the soil surface. Individual Indiana farmers started experimenting with no-till in the 1960s, and Purdue University began research trials in the 1970s.

In 1985, federal farm policy began requiring farmers to adopt conservation methods. The invention of Roundup®-ready soybeans in the early 1990s allowed farmers to control weeds without cultivation. During the next decade, no-till farming jumped from being used in fewer than 20 percent of soybean fields to more than 60 percent. Today, that figure has climbed to more than 80 percent.

No-till corn has been slower to develop. However, recent advances in biotechnology have increased the number of corn fields using conservation tillage. By the year 2000, about 20 percent of Indiana corn was produced with conservation tillage. This number is expected to continue to grow in the coming years. The widespread acceptance of no-till and other forms of conservation tillage have reduced soil erosion by as much as 40 percent in Indiana.

No-till technology has benefits for those not involved in agriculture as well. Less soil erosion means cleaner water in our lakes and rivers, which benefits everyone, as we all depend on safe water to drink.

In 1937, Vanderburgh County was the first in the state to form a conservation district to direct local efforts to control flooding and protect the environment. Since then, soil and water conservation districts have been established in every county.

climate provides adequate annual precipitation and four distinct seasons with wide variations in temperatures.

When settlers first came to Indiana, much of the northwestern part of the state was swampland. Over time, this land was drained by the creation of a sophisticated series of canals. Today this land is some of the most productive farmland in the state. But the northwest is by no means the state's only fertile ground: about 75 percent of Indiana's land is involved in agricultural production. In 2003, more than 15 million acres were classified as farmland.

Over the past several decades, Indiana farmers and conservation officials have been busy planting grass filter strips, buffer strips, and millions of trees. Many of these plantings were placed as windbreaks at the edges of fields, which helps prevent soil loss from wind erosion.

Many producers have also planted forests on hillsides to hold the soil in place. This forestland provides clean air as well as a renewable cash crop of hardwood lumber. Indiana now has more than 4.4 million acres of hardwood forests. Hoosier forestland has grown by more than 440,000 acres since 1967. The forest products industry is the fifth largest industry in the state.

Today's soil and water conservation efforts are a partnership between federal, state, and local agencies and organizations. In recent years, increases in government funding have allowed many conservation improvements to be made to Indiana farmland and watersheds. Not only do these improvements help to provide clean water for all Hoosiers but also to increase wildlife habitats and restore wetlands. Farmers and rural residents care about the land and are working hard to protect and improve our state's soil and water.

Vanishing Acres

The biggest threat to Indiana farmland is urban sprawl. As Hoosier cities grow, they take over more and more farmland. Fields that once produced crops and were home to livestock now sprout housing developments, strip malls, and office parks.

Some communities, having recognized the importance of maintaining a balance of farmland and urban land, have adopted a policy known as smart

growth. This policy designates certain areas of a community for agricultural use and others for business and residential development. This approach takes a long-term view that plans for the needs of a community decades into the future while protecting the valuable natural resources of the area. Although technology will continue to affect agriculture in the future, Indiana agriculture will always depend on a stable supply of fertile land as the foundation for our food and fiber system.

The Crossroads of America

In addition to its natural resources, Indiana's location makes it a great place for a thriving agricultural industry. Indiana is located within twenty-four hours by truck or train from 60 percent of the population of the United States. The state boasts interstate highways, airport facilities, a thriving railway service, and a river and port system that together give farmers access to the world market.

Indiana has three major ports: two on Lake Michigan and one on the Ohio River. More than seventy million tons of cargo move in and out of Indiana by

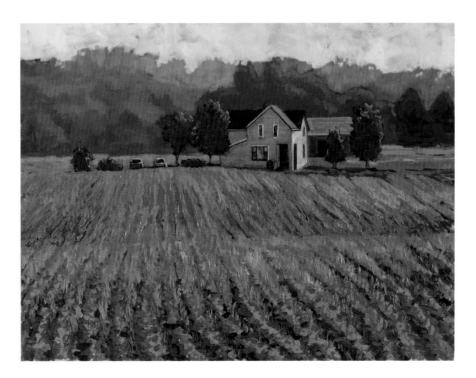

Double cropping results in higher productivity per acre. While crop yield likely will not increase, two crops are harvested from the same acreage in one season, such as wheat followed by soybeans. "I pulled over one late afternoon and had to paint this field; it seemed to glow."

LYNN DUNBAR
No-till Soybeans, Johnson County
Oil on canvas 18 × 24 inches

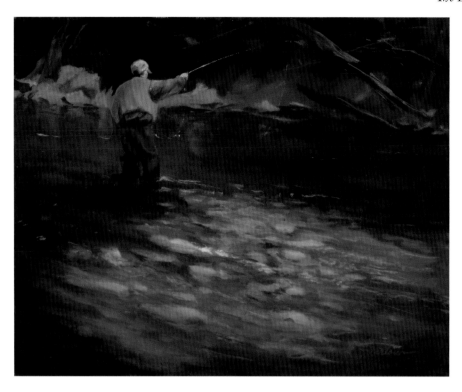

"The incredible cycle of water that flows to the oceans to be returned by the rain sustains life. The nutrients of the soil would be worthless without water to carry them to the leaves. Unfortunately, water also carries toxins that may be transferred to plants and animals. This is why clean water is so essential to agriculture as well as to fish and other aquatic life." Programs like the Indiana River Friendly Farmer Program help protect and improve the state's soil and water resources. It is a program jointly sponsored by agricultural organizations and governmental agencies to recognize and reward farmers who manage their farms in an economically and environmentally sound way.

BOB FARLOW
The Fisherman, Brookville
Oil on canvas 24 × 30 inches

water. Grain is exported from Indiana farms to the world market through our ports, while fertilizer needed by Indiana farmers is shipped in on the state's waterway system.

Indiana's railroads, which have a long and illustrious history, have also played a vital role in the development of our state's economy and agriculture. By 1850, Indianapolis was the hub for seven different railroads. The first Union Station in the nation was built in Indianapolis in 1853 and soon serviced more than a hundred trains a day. (The well-known American folk song "The Wabash Cannonball" celebrates Indiana's rail heritage.) Today, 40 percent of all intercity freight in the state moves by rail. Farm products comprise 17 percent of that freight, and food products account for 7 percent. The railways transport 40 percent of all grain and 20 percent of all farm chemicals into the state, and outward bound to destinations around the country and the world.

Indiana's transportation infrastructure, combined with an abundant agricultural production base, has made the state attractive to food processing companies. Indiana is the leading ice-cream-producing state in the nation, for example. Our strong dairy industry, central location, and access to transportation make Indiana an ideal home base from which to produce and ship the frozen delight to a hungry nation.

The U.S. Fish and Wildlife Service buys farmland to turn back into natural wetlands as well as forest for migrating birds and water fowl. Some of the land is farmed to grow grain which is not harvested, thereby ensuring a steady supply of food for wildlife.

LYNN DUNBAR
Into the Trees, Muskatatuck National Wildlife Refuge, Seymour
Oil on canvas 30 × 34 inches

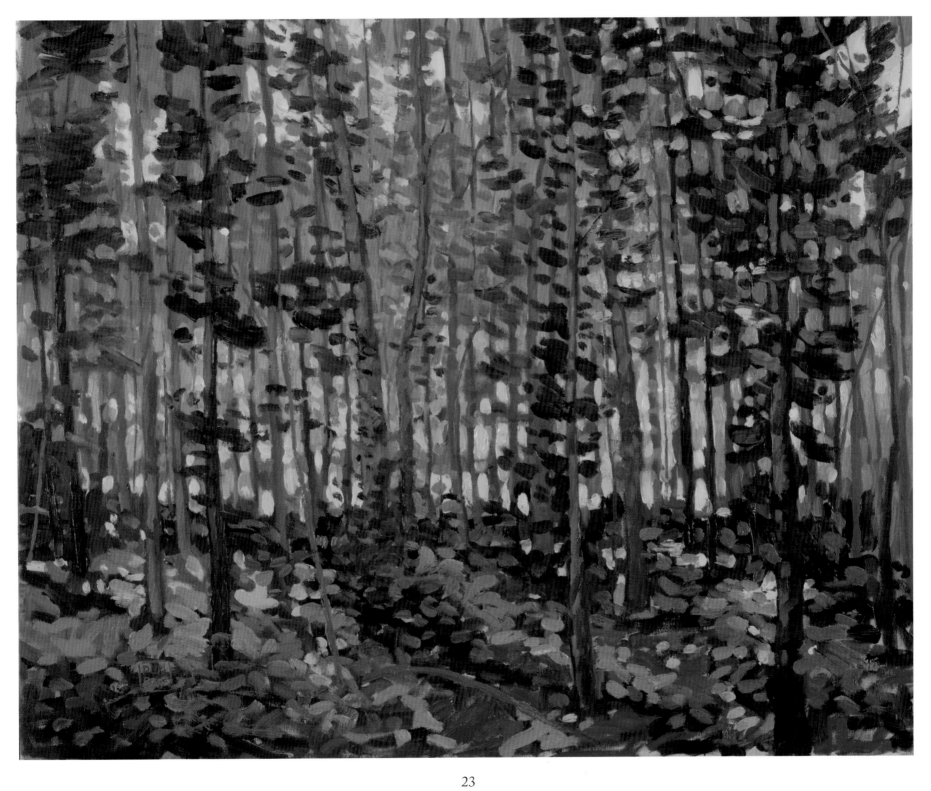

A corn crib of yesteryear once was surrounded by fields of corn and now stands watch
over fields of houses.

RON MACK
Advancing Suburbia, 126th Street and Hazel Dell Parkway, Carmel
Oil on linen 16 × 20 inches

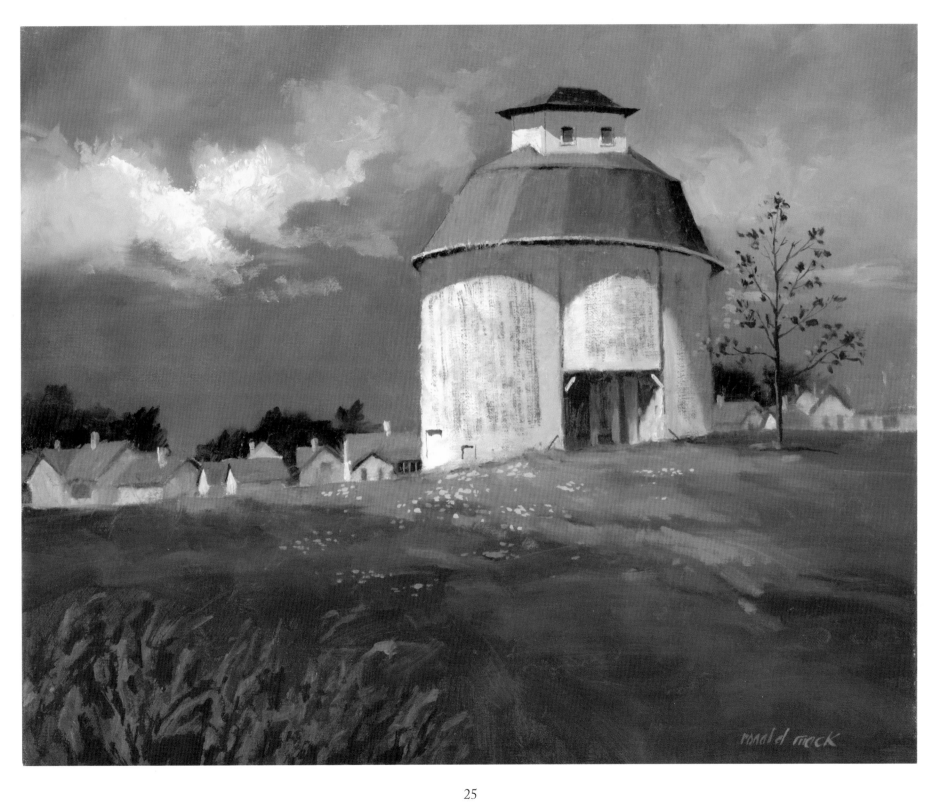

The Louisville Slugger is widely known, but few think of it as an agricultural product. The timber industry produces more than paper and plywood. The Slugger baseball bats are made of ash, one variety of tree grown in Indiana for its wood.

LYNN DUNBAR
Dipping Bats, Hillerich & Bradsby Co., Louisville, Kentucky
Oil on canvas 16 × 20 inches

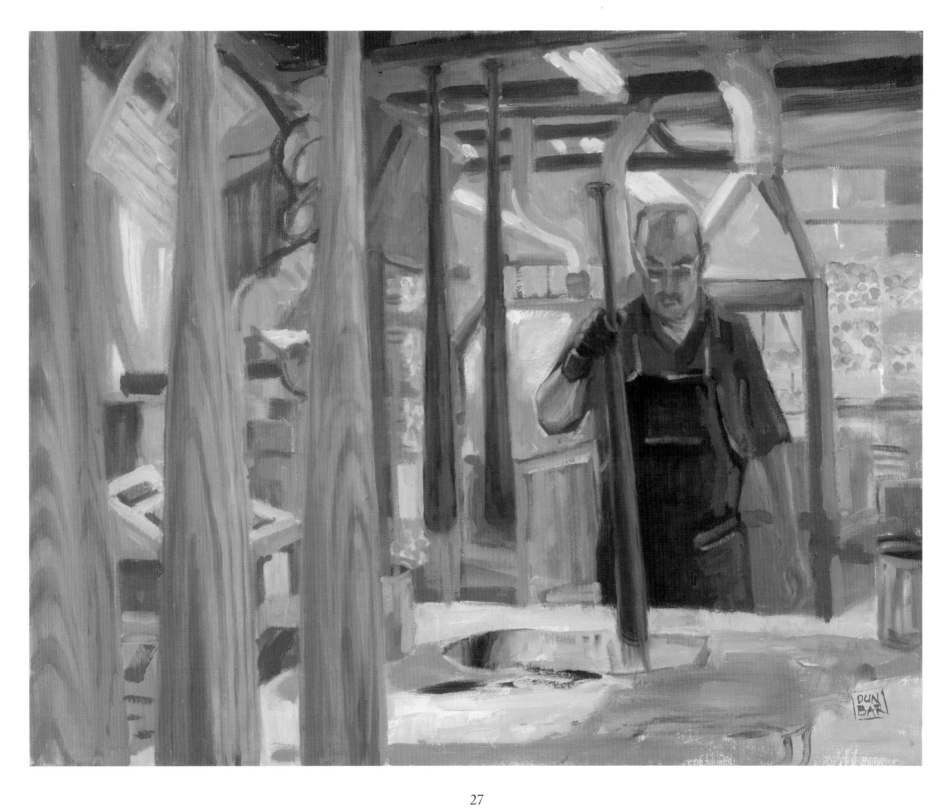

27

"Out of the fields and en route to the table. The distribution of Indiana agricultural products may take place on land or by sea or air. Hoosier agriculture may be found in all corners of the globe . . . and space."

BILL BORDEN
Consolidated Grain and Barge, Madison
Watercolor on paper 22 × 28 inches

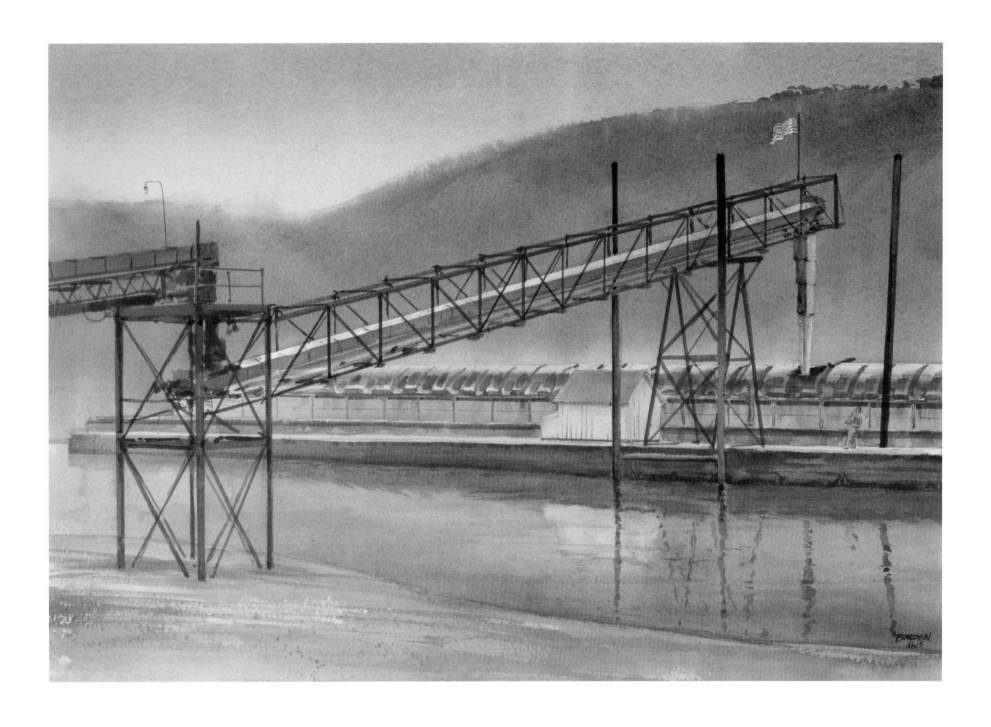

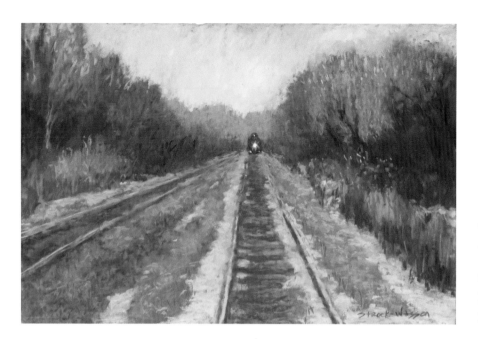

"These old rails may play a greatly expanded role in the future. The advent of super-conductors and high-speed trains coupled with rising petroleum costs could bring the train into another golden age."

CAROL STROCK-WASSON
Inbound Train, Muncie
Pastel on board 18 × 24 inches

"Even in winter, Red Gold is on the move and agriculture is constantly changing and growing. I also wanted to show the contrast between technology in the trucks and highway system versus the river and nature. There must be a balance between the two. Otherwise growth and development will cease."

CAROL STROCK-WASSON
Red Gold on the Move, Highway 69, Randolph County
Pastel on board 18 × 24 inches

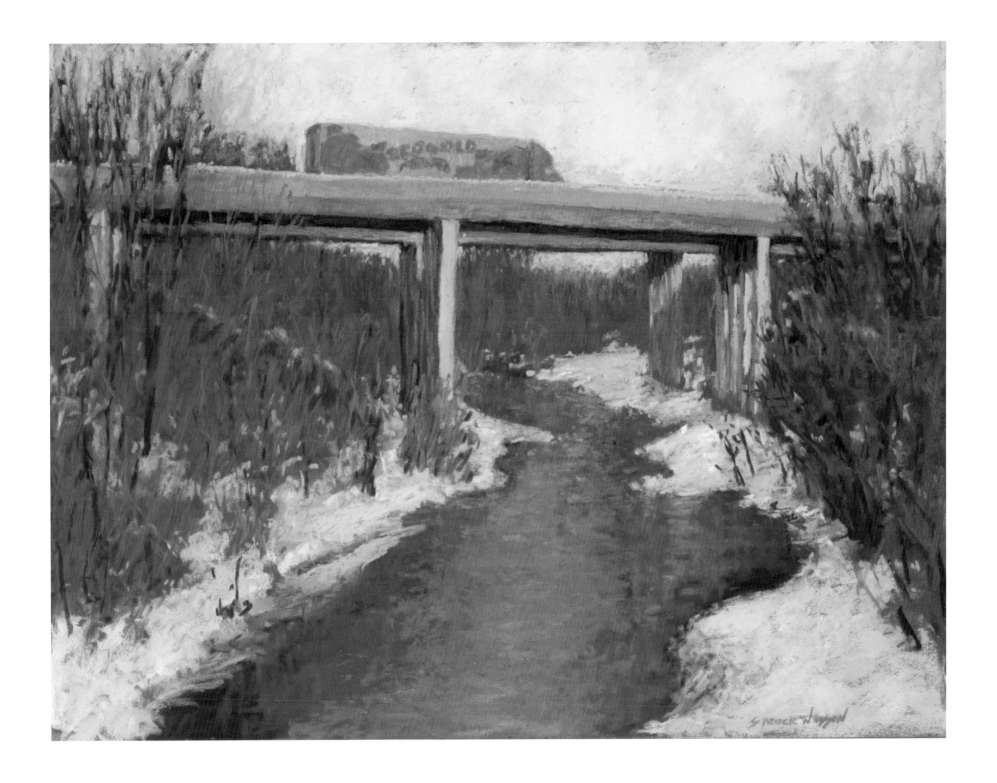

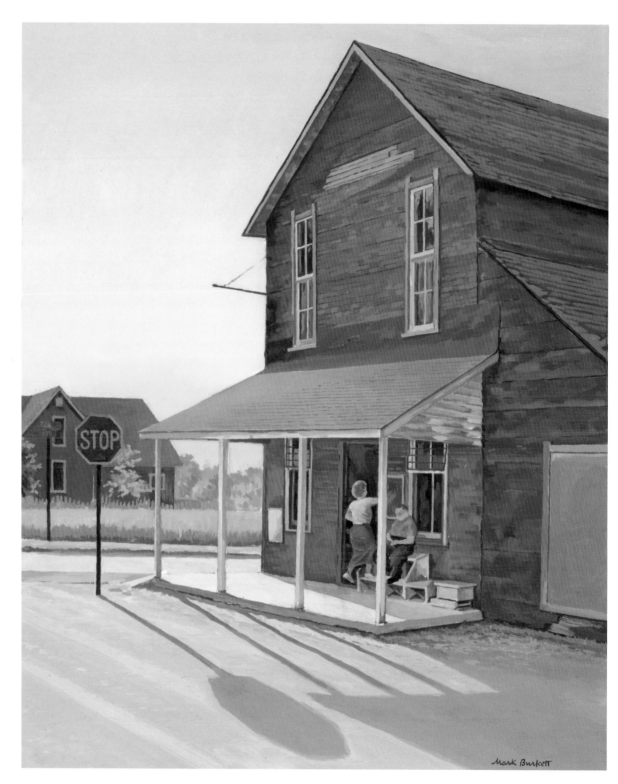

"The Banta General Store stands at the crossroads of a small town that is nearly gone. Still, folks will stop in for a quick snack, but it's its unique role as a beekeeping-equipment supplier that keeps the place running."

MARK BURKETT
Banta General Store, Banta
Oil on canvas 20 × 16 inches

3. The People

I live in the small town of Young America, Indiana. Our town is so small the only heavy industry we have is our 300-pound Avon lady.

CAPTAIN STUBBY

"Chuck and Joseph are my second and third cousins and I've enjoyed getting to know them better since my return to Indiana. Chuck is a dedicated farmer like his father and grandfather and has a day job to support his farming. Joseph is a bundle of energy and a dedicated future farmer as well as a budding artist. Maybe he'll be a contributor when this book is revised in twenty years. It's great to watch the two of them working together and to feel this connection to farming that is prevalent in our family but that I was never able to experience directly."

BILL BORDEN
Lamar Farm, Brownsburg
Watercolor on paper 22 × 28 inches

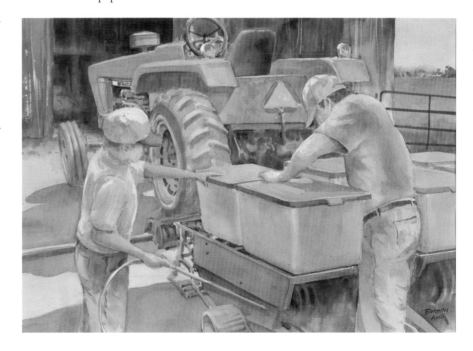

You can't talk about the family farm without talking about the farm family. The story of Indiana agriculture is as much about the people as the technology. Just as machines and computers changed life on the farm, they changed the life of the farm family.

Although the farm remains the centerpiece of the farm family, it no longer requires the full-time involvement of every family member. Today, at least one member of most farm families works off the farm. *The 2002 Census of Agriculture* indicated that 61 percent of Indiana farms had at least one source of non-farm income.

Many farmhouses have satellite television and a growing number have high-speed Internet access. Most farm kids are bussed to large consolidated county schools that look very much like large consolidated schools in the city. Despite all these changes, however, farm families maintain a connection to the land and an appreciation of nature that their counterparts in the city do not have.

The late Governor Frank O'Bannon once said, "Indiana is like one big small town." He was referring to the sense of community for which Hoosier towns

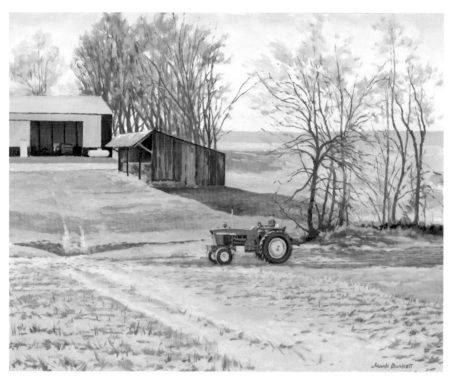

An old John Deere, past its prime, awaits the farmer's return from the spring fields in his modern global positioning–guided machine.

MARK BURKETT
Early Spring, Stegemoller Farm, Danville
Oil on canvas 16 × 20 inches

effect on small towns. Consolidation in the agribusiness sector has meant fewer local businesses serving fewer farmers. Large chain and franchise businesses have come to many small towns, displacing locally owned retail businesses. The once thriving courthouse square, the heart of a county seat, is often no longer the hub of a town's commerce.

Lack of educational and employment opportunities in rural communities have forced many young people to leave home, adding to the population decline that has plagued many small towns. Some towns, however, are seeing an influx of new residents. Located close to larger urban areas, these communities

are famous. Most Indiana towns started as a grouping of farmsteads. They grew into communities to support the local farms. They were places where people came together to do business, go to school, and attend church. They were communities where people shared common values, a common history, and often a common ethnic heritage. Many of the values that are woven into the fabric of our society came from these rural communities.

The changes that have come to agriculture, along with the social and economic changes that have occurred in the world at large, have had a profound

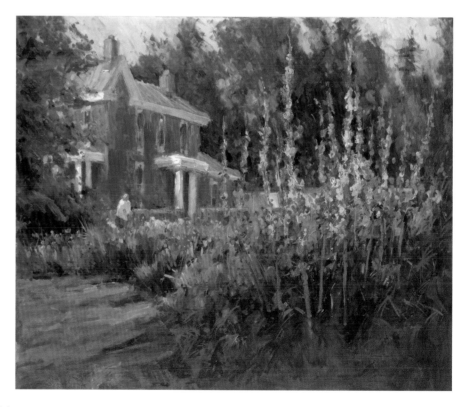

Mary Hardle working in her garden late in the day, creating a view that brings pleasure to passersby.

SCOTT SULLIVAN
Flower Garden, 1800s House, Bloomington
Oil on linen 30 × 36 inches

are experiencing growth as urban residents move further away from the city, perhaps seeking what they imagine will be "the country life."

Developers are buying up large tracts of farmland, at highly inflated prices, and building large developments of single-family homes. This growth is straining local roads and resources. And because new residents may not share the heritage or values of the community, they often find themselves at odds with their farming neighbors.

The Changing Face of the American Farmer

The Grant Wood painting *American Gothic* presents the image that many people have of the American farmer. Today's farmers, however, wear suits almost as often as jeans. They have college educations, with degrees in subjects such as agricultural economics or animal science. They may be specially trained and licensed in the use of dangerous and toxic chemicals. They typically own at least one computer and regularly use the Internet to gather agricultural news and market information. They negotiate with bankers for loans that often top six figures, and they buy equipment that costs hundreds of thousands of dollars. They get up early, usually work late, and are always thinking about how they can make their farms just a little bit better.

In a typical day, an Indiana farmer might assist with the birth of a calf, mend a broken fence, talk market strategy with a commodity broker, e-mail a member of Congress in support of trade legislation, help a child with a 4-H project, sift through about two dozen pieces of farm-related junk mail, talk to a seed salesman, and attend a local zoning meeting.

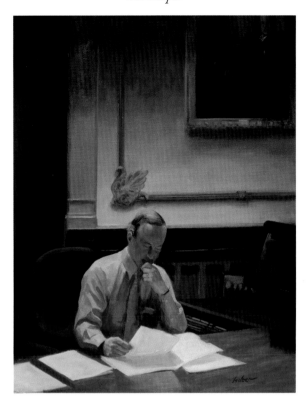

"Governor Daniels has pressed for and established a Department of Agriculture. He has stated that this will be the most favorable administration to agriculture ever."

BOB FARLOW
He Came to Work, Governor's Office, Indianapolis
Oil on canvas 36 × 28 inches

Careers in Agriculture

Although opportunities to work on a farm are fewer today, opportunities to work in agriculture-related industries are increasing. The School of Agriculture at Purdue University reports that its graduates with degrees in agriculture-related fields enjoy a higher job-placement rate than any other school at the university. Careers as diverse as food science, golf course management, finance, sociology, law, software design, and aerospace all have ties to the School of Agriculture, and the farming industry is one of the largest employers in the state.

Agriculture is also a major driver of the state's economy, and as a result, state leaders carefully monitor policies to ensure growth in the farm sector. In 2005, the Indiana General Assembly established Indiana's first stand-alone Department of Agriculture. Farm organizations and lobbyists represent farmers' interests at the state and federal level.

The Farmer as Steward of Land and Livestock

Modern farming practices are sometimes criticized as being harmful to land and animals. The reality is that farmers are strong stewards of the land and careful and compassionate caretakers of their livestock.

Farming, in fact, is one of the most heavily regulated industries in the nation. Although homeowners and gardeners can apply fertilizers and insecticides by the carload with no particular training, farmers must undergo special training and be licensed for the application of many of today's crop-protection products. Many livestock operations undergo a rigorous permitting, licensing,

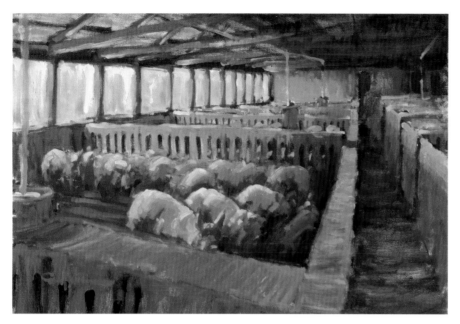

and monitoring process to ensure the protection of the air, water, and animals. Confined animal–feeding operations are routinely inspected by the Indiana Department of Environmental Management (IDEM) to ensure compliance with environmental regulations and procedures.

More than 90 percent of Indiana corn is treated with herbicides and over half is treated with insecticides. Yet farmers also use a variety of non-chemical measures to control weeds and insects. For example, rotating the type of crops that are planted in a field every year helps reduce the need for herbicides and reduces insect populations. Another non-chemical method, called integrated pest management, uses beneficial insects to control unwanted pests. And a growing number of farmers perform field mapping, made possible with Global

In a cloud of dust on the evening horizon, this farmer is still hard at work harvesting his beans. Dawn-to-dusk hours are every day during harvest.

MARY ANN DAVIS
Soybean Field at Harvest, New Harmony
Oil on canvas 16 × 20 inches

Confined animal-feeding operations allow for large numbers of animals to be raised in sterile environments. Consumers are demanding leaner meats and less fat, more white meat and more nutrients. The technology in agriculture allows for the identification of feeds, for example, that help raise livestock to meet customer demand.

SCOTT SULLIVAN
Hog Heaven, South of Loogootee
Oil on linen 24 × 36 inches

Positioning Satellites (GPS), to isolate certain areas of a field and then treat only those sections that need special help.

Four major livestock species are raised in Indiana: hogs, cattle, sheep, and poultry. Many small livestock producers still exist, but the trend is toward larger, confined operations.

This shift to fewer and larger operations is most notable in the dairy sector, where 3 percent of Indiana dairy farmers account for over a third of the state's

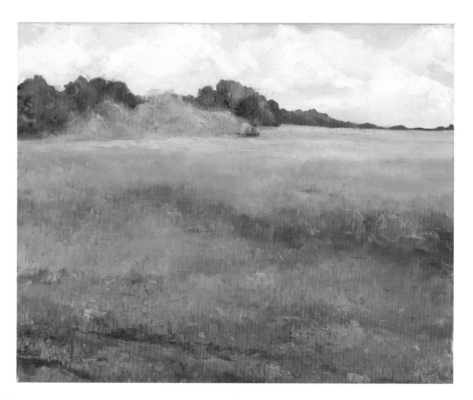

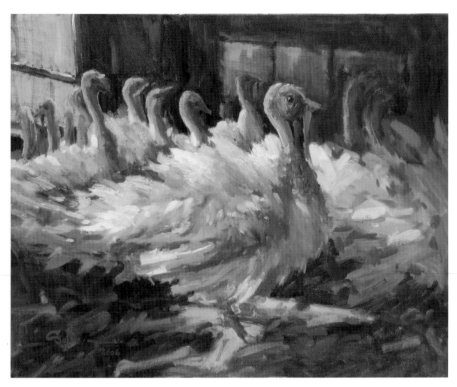

dairy cows and close to half of the state's milk production. Although 65 percent of Hoosier hog farms have fewer than 500 head, more than 70 percent of the state's swine are raised on farms with more than 2,000 head. Poultry production continues to increase in Indiana as growing numbers of farmers contract with chicken and turkey companies to produce birds.

Animals raised in the controlled atmosphere of confined feeding have a safe and abundant food supply and regular health monitoring. The meat produced meets both government standards and consumer demand.

The Hoosier horse industry is another significant part of Indiana agriculture, with more than 160,000 horses living on 34,000 farms. The horse program is the second-largest 4-H livestock project in the state. Once the backbone of Indiana agriculture, providing the power to pull farm equipment, the horse is kept mainly for sport or leisure today.

Turkeys often are raised in confined feeding operations. Housed in large pole barns, these turkeys were free to wander back and forth across the cement floor.

SCOTT SULLIVAN
Turkey Farm, Loogootee
Oil on linen 36 × 48 inches

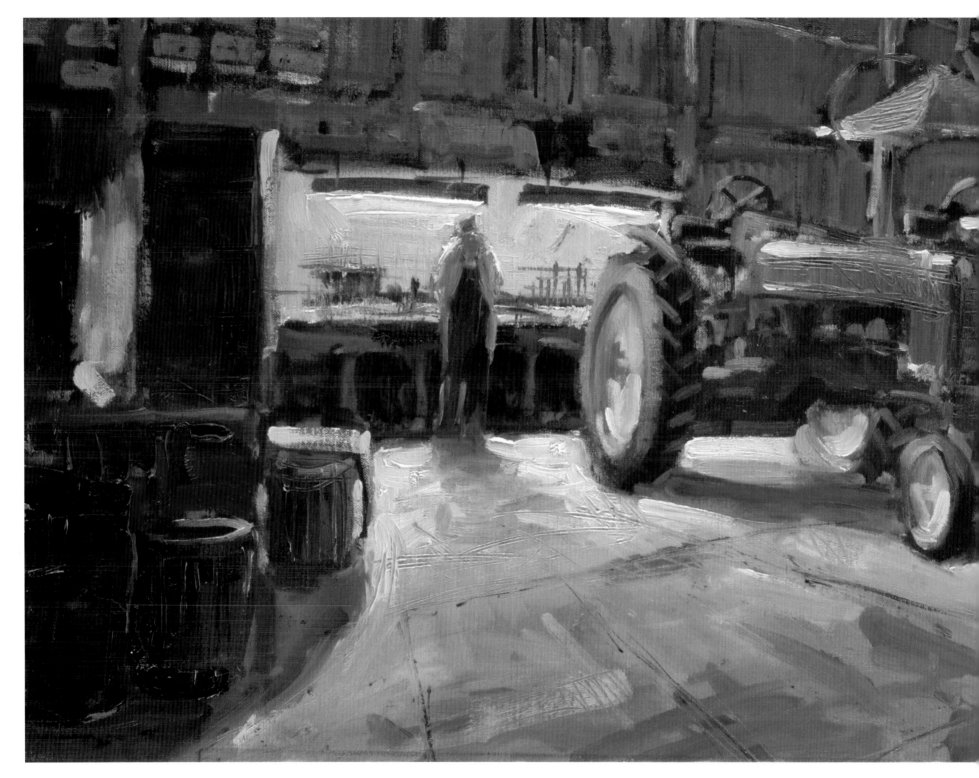

A farmer's work is never done. With the completion of harvest and arrival of hard frosts, a farmer turns to equipment maintenance and business planning in preparation for the next growing season.

SCOTT SULLIVAN
Long Day, Peden Farm, Bloomington
Oil on linen 18 × 36 inches

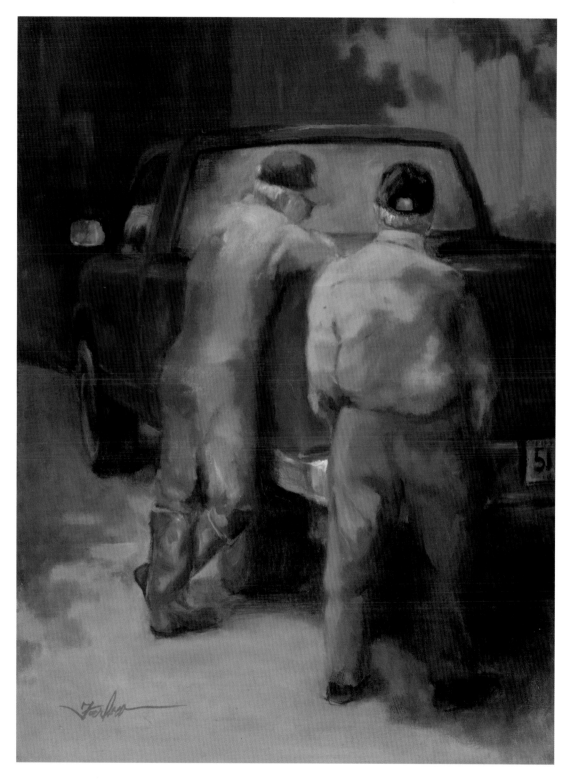

"Farmers are sociable people, among themselves. Does that sound like a contradiction in terms? By nature, farming tends to be a solitary profession, but among farmers, there is a kindred spirit. Few occupations are as dependent upon the fickle variants of the weather as farming. Farmers understand other farmers. Whenever you find two or more farmers and a pickup truck, you will find the bed of the trunk being studied during intense conversation, and an occasional exaggeration of the truth."

BOB FARLOW
Planning Session, Alley's Farm, Delaware County
Oil on canvas 24 × 18 inches

"The four-wheeler is now used for transportation all over the farm. It can haul, pull, and even be used to round up livestock. A modern-day horse, I suppose."

RON MACK
Cattle Moving Day, Jasper
Oil on linen 24 × 30 inches

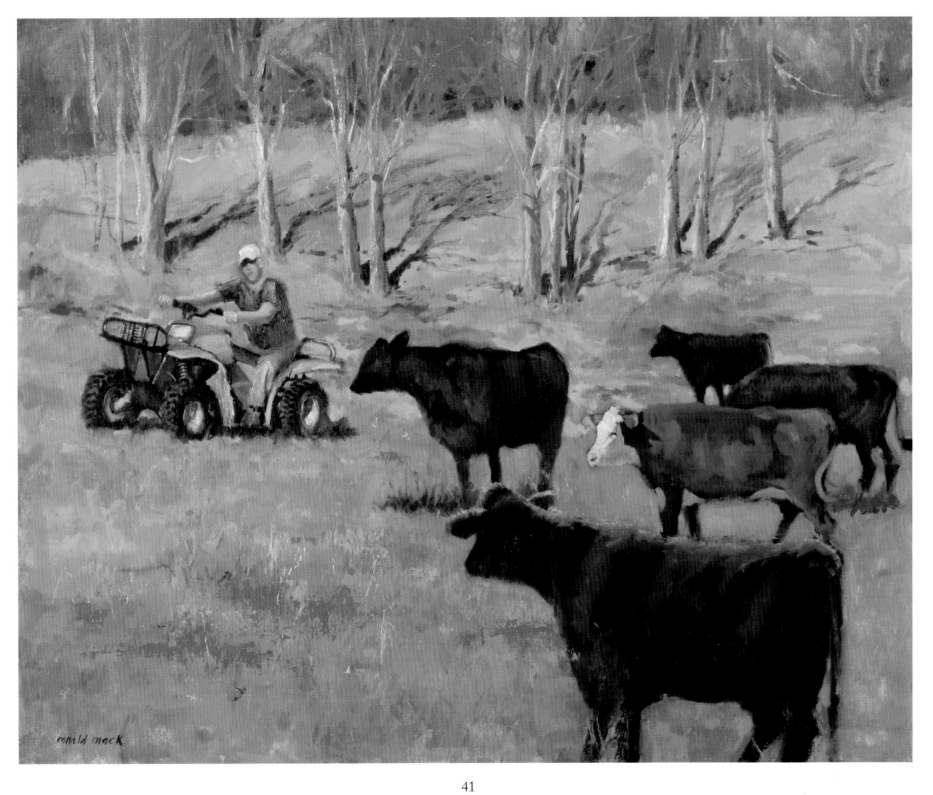

ronald mack

41

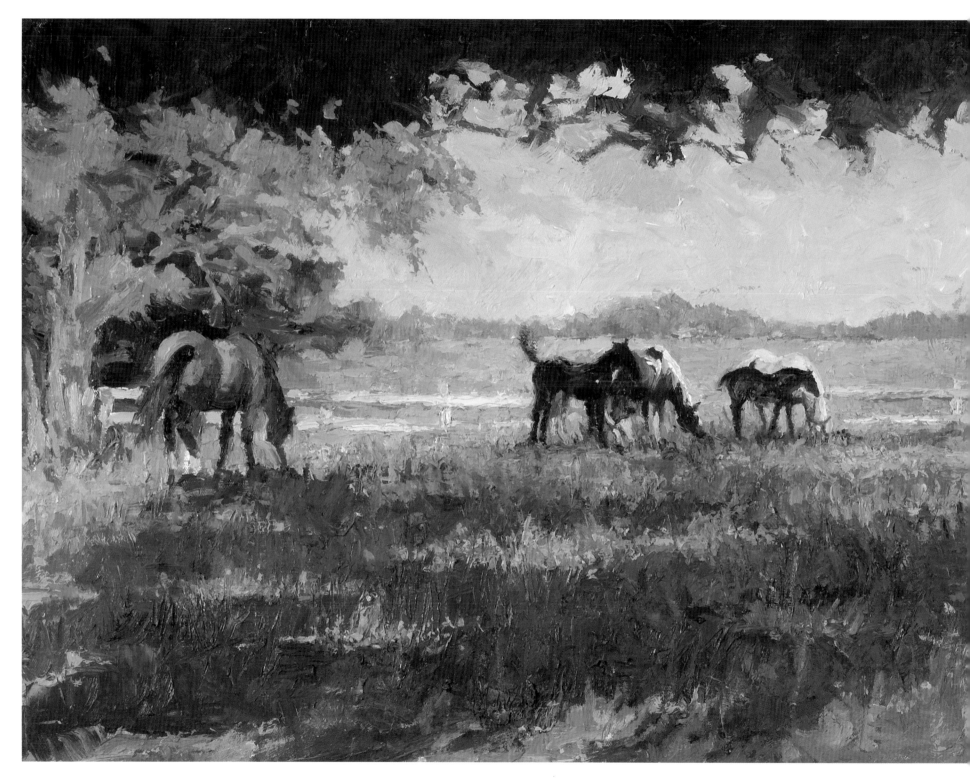

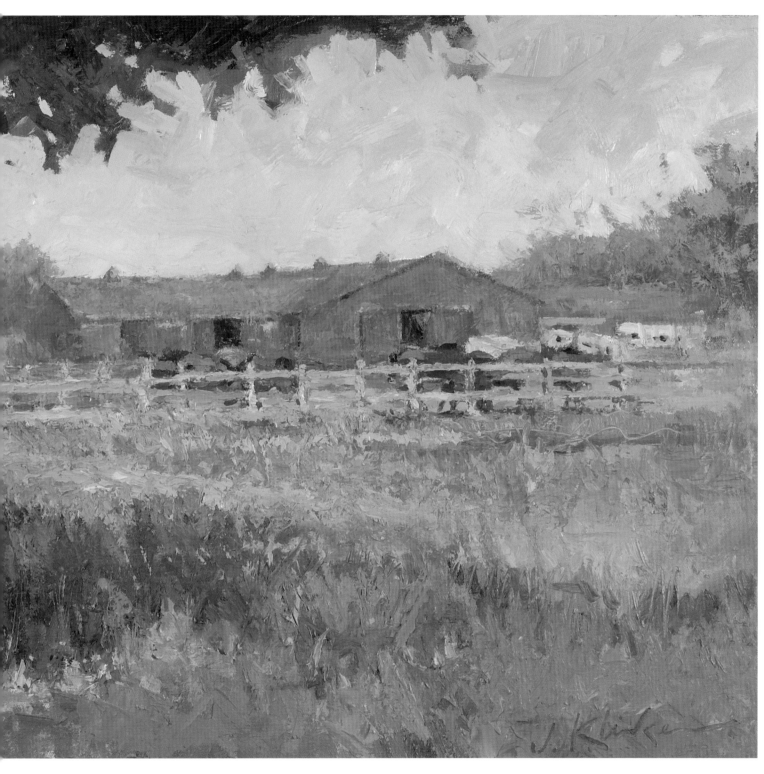

"This was an awesome sight to behold, and it was only minutes away from my home. Forrest Hill Farm boards and trains horses to dance! It was a fun painting to do."

JEFF KLINKER
Dressage Farm, Forrest Hill
Farm, north of Lafayette
Oil on canvas 14 × 34 inches

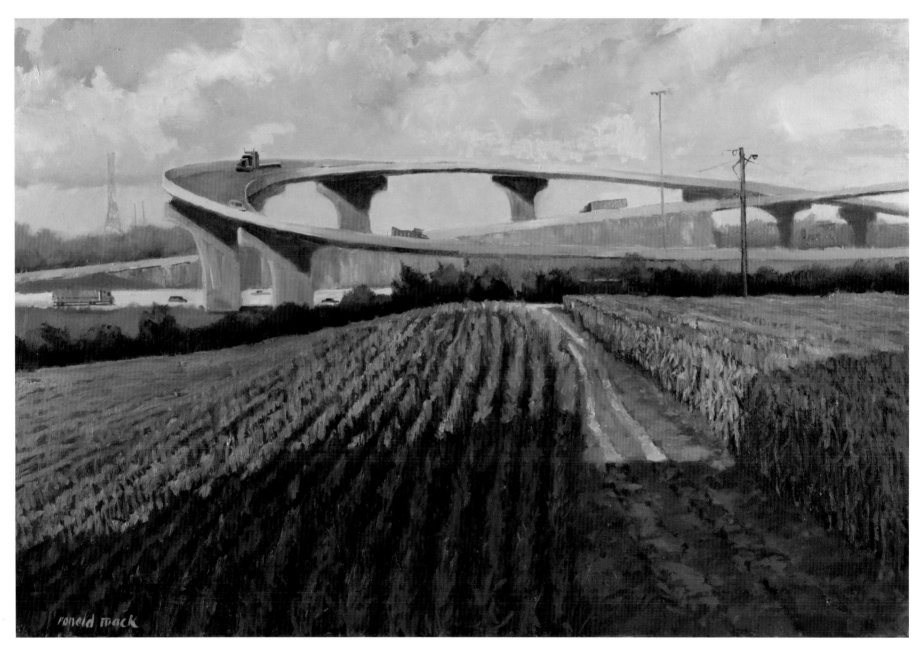

"The changing face of agriculture—corn fields have to make way for the modern expansion of massive highways and population explosion, yet these highways deliver the products that the expanding populations purchase. It is a delicate and dynamic balance that will continue to challenge modern man."

RON MACK

Farmland vs. Transportation, Highways 465 and 74, Indianapolis

Oil on canvas 20 × 30 inches

4. The Technology

Bringing electricity to the farm was the most important technological advancement in agriculture in the last hundred years. It changed the way we farm, the way we live; it changed everything.

MAURI WILLIAMSON,
FARMER, WEST LAFAYETTE, INDIANA

In 1731, Englishman Jethro Tull invented the horse-drawn cultivator and seed drill. In 1784, James Small invented the iron plow. Since then, farmers have continually invented and adopted new technology to meet their needs. Just five years ago, putting crop protection chemicals in the seed or driving farm equipment by satellite would have seemed like science fiction; today, these practices are common in Indiana agriculture.

Advances in agricultural technology have led to more efficient equipment and also to the development of new foods, new non-food uses for crops, and even changes at the molecular level of seeds and livestock.

Inventing New Markets for Traditional Crops

Farmers, through their commodity organizations, have invested millions of dollars in research to create new foods and non-food uses for their crops. The soybean has been one of the most prolific plants in this regard. Soy protein is used to produce not only livestock feed and human foodstuffs, but also many non-food items, such as candles, crayons, and health and beauty products.

Soybeans may even be the key to our energy independence and sustainability. Soy biodiesel fuel is made by combining soy methyl ester, derived from soybean oil, with petroleum diesel fuel. The resulting fuel produces fewer sulfur emissions, creates less particulate matter, and offers improved lubricity.

Indiana is one of the nation's leading states in the consumption of soy biodiesel. Farmers use the fuel in their farm equipment, and school districts and other public entities are adopting soy biodiesel for buses and other vehicles as an environmentally friendly alternative to other fuels.

Research being conducted at Purdue University is opening the door for other energy uses for soybeans. Jet airplane fuel can now be made using soybeans, and Purdue researcher Bernie Tao has developed an airplane de-icer made from soy. Tao believes that soon there may be bio-refineries that produce a host of energy-related products from soybeans.

Corn, too, has become a source of many new food and non-food products. Processing plants have been turning Indiana corn into corn sweetener, used in human and animal food as well as pharmaceutical and industrial applications, for decades. In addition, a variety of new plastics and resins are being made

"This image comes to mind when I think of my younger days on the farm. The Indiana State Fair was the place of origin. A couple of artist friends and I went wagon hopping that night. The soft warm light can be felt coming from the heat lamp nearby."

JEFF KLINKER
Sow with Piglets, Indiana State Fair, Indianapolis
Oil on canvas 20 × 30 inches

from corn. Ethanol, derived from corn, is growing in popularity as a gasoline additive. As large cities strive to improve the quality of their air and America works to reduce its dependence on imported oil, ethanol will continue to play an important role in our fuel supply. More ethanol plants are being built to meet this growing demand, benefiting corn-producing states such as Indiana. These plants provide a local market for Indiana corn and jobs for the rural communities in which they are located.

Advances at the Molecular Level

In addition to creating new products from traditional crops, technology is improving the performance of the crops themselves. Yield, along with disease and insect resistance, has been improved for most of our major crops.

In the past few years, technology also has produced entire new varieties of apples, tomatoes, and many other crops. For example, when researchers discovered that trans fats in soybean oil caused health problems for consumers, they developed a new variety of soybean that has little or no trans fat. This new variety is now being grown to produce a healthier vegetable oil.

Production agriculture also takes advantage of technology from other life sciences. Ultrasound and other imaging technology is regularly used to determine the leanness of hog carcasses. And some ranchers routinely take blood samples from young calves and analyze their DNA to determine which animals will produce high-quality, well-marbled meat. These calves are fed a special diet and bring a higher market price because of the top-quality steaks they will yield.

Science is helping farmers produce healthier animals as well. Sophisticated breeding and improved pharmaceutical products have virtually eliminated many livestock diseases. With more livestock raised indoors today, the animals are better fed and better protected than ever before.

Help from Above

Global Positioning Satellite (GPS) technology is having a big impact on agriculture. With GPS, farmers can map their fields down to the square foot and then allow computers to drive tractors and combines with only minimal human intervention. GPS also provides enhanced weather forecasting models that take a little of the guesswork out of predicting the weather.

Farmers can now get high-speed Internet access in the barn and satellite television in the house. GPS has brought the information age to the farm, and market prices and other timely information can be delivered right to the cab of the tractor.

Just as rural electrification revolutionized life on the farm in the last century, a similar revolution is underway to bring broadband technology to all rural areas. This development will give farmers greater access to online resources and help rural communities attract industries that depend on high-speed connectivity. Cellular phone and wireless technology, once only available in large cities, is becoming more common in rural communities as well.

"As I was working on this painting, the farmer, Gary Post, came over to see if I needed help. He lives in Fort Recovery, Ohio, but owns ground and farms in Indiana. Better ground in Indiana, he says." As agricultural technology advances and the world market shrinks, it isn't necessary for the farmer to live on site.

CAROL STROCK-WASSON
Spring Plowing, Post Farm, 500 N, Randolph County
Pastel on Lacarte paper 18 × 24 inches

"The methods of raising livestock are changing, but the respect of the farmer for his animals is the same. There is always that special hog, cow, sheep, or horse that the farmer enjoys and gives a little extra attention. Even though agriculture is becoming a more mechanized enterprise, there is still a respect for those charges under the farmer's care."

BOB FARLOW
Eldon and Queenie, Randolph County
Oil on canvas 28 × 36 inches

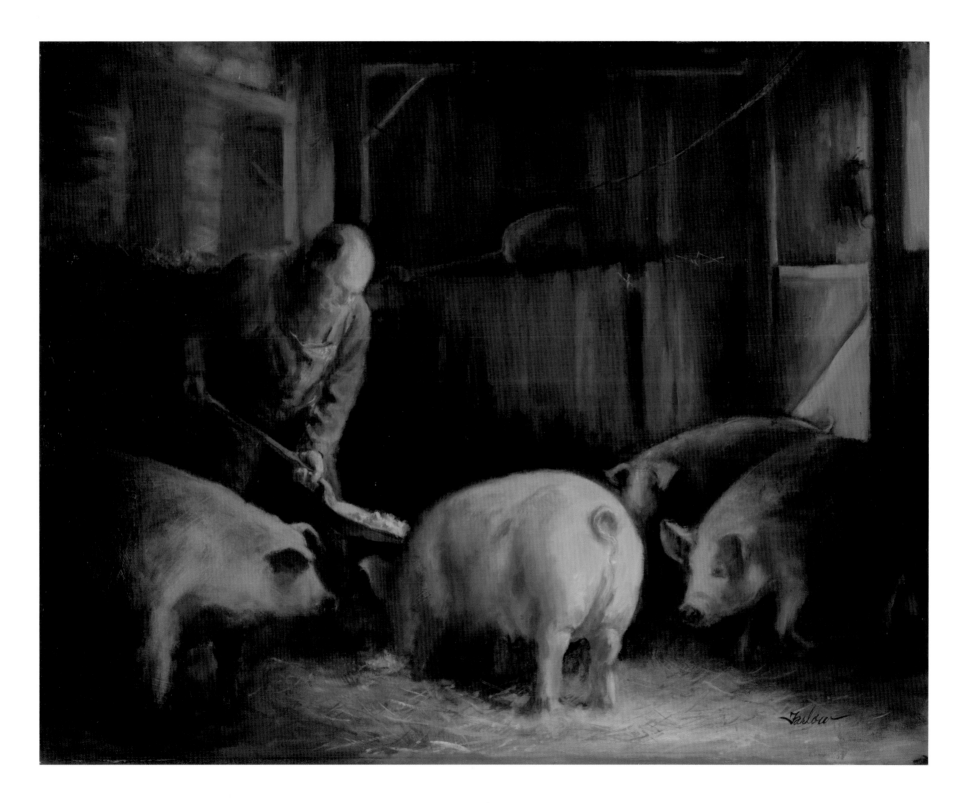

"This was a tough one. Joyce Villwock and Jason Misiniec gave me a complete tour of their extensive farm, including a ride through the fields in a very modern tractor. I finally worked from sketches and photos to look over Jason's shoulder as he planted seed using computer and satellite controls in the tractor's cab."

BILL BORDEN
Villwock Farms, Edwardsport
Watercolor on paper 20 × 24 inches

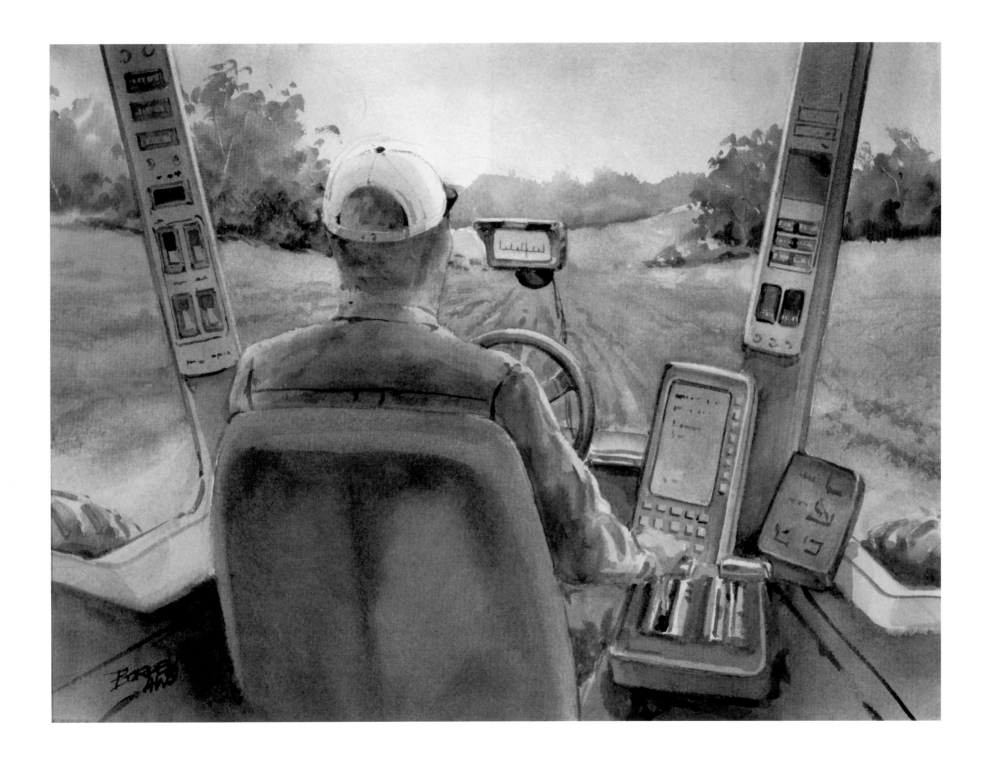

"As a past employee of eighteen years, I had to paint this. The bright lights give it a whole new image. Tate & Lyle processes corn into sugars and starches. This company has processing facilities in Lafayette and other places around the world. It is a global leader in the production of sugars."

JEFF KLINKER
Corn Processing Plant, Tate & Lyle, Lafayette
Oil on canvas 18 × 24 inches

Apples are Indiana's fourteenth-largest cash crop. Besides supplying the state with home-grown apples, these orchards also provide jobs with good pay that are often filled by recent immigrants to Indiana.

MARK BURKETT
Anderson Orchard, Mooresville
Oil on canvas 16 × 20 inches

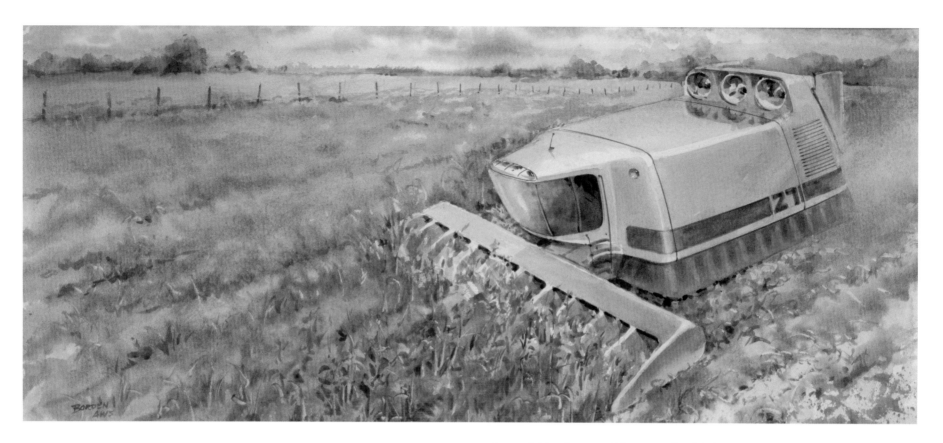

A crystal-blue sky over a Martian-colored field inspired this vision of the future. "After thirty years of designing cars, it's not too hard to make the shift to farming equipment. So I let my imagination run wild as I painted this field, twenty-five years from now."

BILL BORDEN
Future Combine, Imagined
Watercolor on paper 22 × 38 inches

5. The Future

The strength of American agriculture is the development and
implementation of innovative technology. Agricultural research
is the engine that drives that machine.

RANDY WOODSON,
DEAN OF AGRICULTURE, PURDUE UNIVERSITY

Just as farmers in 1900 could not have imagined the changes that would come to agriculture over the twentieth century, we at the beginning of the twenty-first century cannot imagine how agriculture will change in the next hundred years. Yet many of the advances and innovations of the 1900s will determine the future of agriculture. Based on some of the trends and technologies just now taking shape, we can start to form a vision of what agriculture may be like in upcoming years.

The Mechanical Revolution Continues

Machinery changed everything about farming in the last century. As farms continue to increase in size, machines might continue to increase in scale. Planters, cultivators, and sprayers might continue to grow to cover more ground. Larger, more powerful tractors might be needed to pull this equipment. Soil compaction could result from such changes. One solution, as envisioned by artist Bill Borden, could be a future trend for farm machinery: a hovercraft.

Machinery will certainly continue to become more sophisticated and au-
tomated. The integration of computers and Global Positioning Satellites will likely take over much of the operation of the equipment, and farmers will be provided with more monitoring and analytical abilities. Today, there are still many crops that must be harvested by human hands, but in the future, more and more of this work will probably be done by machines.

As crop production becomes more specialized, farm equipment will evolve to meet the needs that emerge. Combines and harvesters might have to harvest two different crops at the same time and keep each separate. Produce from specific areas of a field might need to be separated and its identity preserved. Some new crops might have special handling and storage characteristics.

The mechanical revolution of the past changed the architecture of the farm. Wood-frame barns, once used to store feed and livestock, have to a great extent been replaced by large metal buildings used to store and repair costly farm equipment. The barns of the future will continue to reflect the technology that will dominate production. They might more closely resemble airplane hangers, with large, open work areas filled with computer technology. (But, being in Indiana, barns will still have a basketball hoop on the side!)

"I saw buffalo entering a slaughterhouse at Memphis Meats. I was in awe of them and couldn't believe I was standing only three feet away from a 1,500-pound animal. I was somewhat unnerved, but the respect the folks at Memphis Meats show for these animals is tremendous. They use all of bison. Skulls are used for decoration and tools that are shipped to Indian reservations; skins are used for leather, and the entrails and other by-products are used for cosmetics."

LYNN DUNBAR
The Meat We Eat, Memphis Meat Packing, Memphis
Oil on canvas 20 × 16 inches

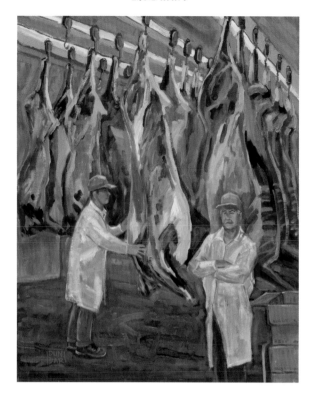

High-Tech Husbandry

Technology will play a bigger role in livestock production in the twenty-first century than it did in the twentieth century. For example, a nationwide animal identification and tracking system might become reality within the first decade of the new century, driven by biosecurity concerns.

With this system in place, every farm animal could be identified and tracked. Their movements, what they eat, their health, and their genealogy would be listed in a database and accessible at the touch of a button. At processing, the meat from specific animals would be identified and tracked. An electronic trail would stretch from the pen to the plate. This system would help keep our food supply safe and could virtually eliminate the spread of contagious diseases such as "mad cow disease," for example. Livestock producers will be as skilled in database management as they are in animal husbandry. The branding iron will be replaced by the hand-held scanner, and the ear tag will be replaced by the radio frequency chip.

Livestock breeding has been as much an art as a science, but advancements in genetic engineering and cloning will give producers the ability to breed animals in a whole new way. Technology will give us the ability to design and clone livestock with particular traits on a mass scale. This development does,

however, raise serious ethical concerns, and our society will need to deal with these issues in the coming years.

Biopharming

We have already seen how farming is beginning to produce raw materials for the industry and energy sectors of our economy. The future will see that trend continuing, with Indiana playing a leading role in the production and distribution of biofuels.

Just on the horizon is biopharming, which is the growing of plants that synthesize therapeutically active proteins or pharmaceuticals. Plant-made pharmaceuticals (PMRs) are in the early stages of development but represent a tremendous potential for agriculture. Researchers predict that by the year 2010, biopharmaceuticals will make up 35 percent of the market and generate more than $20 billion in revenue.

These drug-producing plants might be grown in special greenhouses for more precise climate control and isolation from other crops. At one end of these long greenhouses, a special grain storage bin could store up to 250 million doses of a flu vaccine, for example.

Drug production using biopharming will be considerably cheaper than traditional methods, and the active ingredient can be stored in the seed until it is needed. Currently, 360 different drugs have been identified as candidates for production using biopharming. Indiana's leading role in life science research and technology will help move the state's agricultural community into this new and promising industry.

The Future of the Forest

Indiana once had more forests than fields. Due to an increase in row-crop agriculture and city development over the last century, forests no longer dominate the landscape. Yet since 1967, Indiana forestland has increased by 450,000 acres.

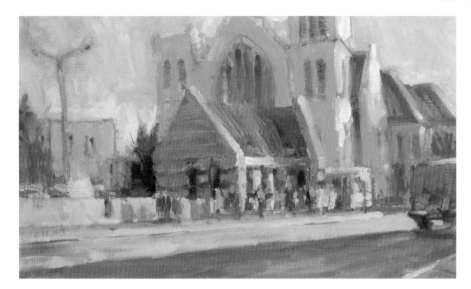

For many, each morning commute starts at the bus stop. Pictured here is Bloomington Transit's first bus to run on soy bio diesel. Now all of BT's buses, as well as all of IU-Bloomington's buses, do!

SCOTT SULLIVAN
Bus Stop, Bloomington
Oil on linen 12 × 24 inches

The 2005 Bio-Crossroads Report identified the Hoosier lumber industry as an underdeveloped industry that holds great potential for the future.

New tree varieties yield up to fifteen times more lumber than older species, and improved forest management has increased the number of trees per acre. In the future, trees will be X-rayed and then analyzed with the aid of computers to determine the most productive way to cut the logs. Computerized sawmills will process the trees to exact specifications. Like other renewable resources, Indiana trees, properly managed, will produce income for farmers, off-the-farm jobs for rural communities, and a sustainable supply of high-quality wood and paper products for the world.

Greenhouses not only extend the growing season, they provide a controlled environment where innovations, theories, and processes may be tested. "I took a tour of Dow facilities and scheduled a time to paint. It was evening when I arrived and the campus seemed deserted when I finally started painting one of the greenhouses. I felt like I was actually in the future!"

JEFF KLINKER
Greenhouse at Dow AgroSciences, Zionsville
Oil on canvas 16 × 20 inches

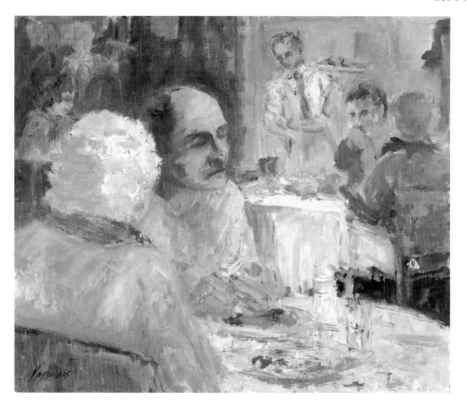

Finally, it is at the table where customers mark a glorious journey's end for Indiana farmers' crops.

MARY ANN DAVIS
Dinner Time at MCL Cafeteria, Indianapolis
Oil on canvas 20 × 24 inches

Dr. Mitchell also has been involved with a project that is growing crops underground. In a sixty-acre abandoned mine in southern Indiana, crops such as corn, tomatoes, and tobacco have been produced in a controlled environment. Indications are that plants grow faster and produce better yields in this underground facility. Such underground farms could yield two or three crops per year, rather than a single one. Increased biosecurity is another possible advantage.

What Is Old Is New Again

At the beginning of the twentieth century, roadside stands featuring fresh farm produce were common. People made regular trips to the countryside to buy fresh eggs from local farmers. This trend is finding new life in the new century. Urban consumers, due in part to where they live, to lifestyle choices, and to limited access, have become distanced from the farm. The "super center" grocery store has further lessened the connection with local agriculture. Yet for many urban dwellers, there is a desire for some connection, if only for access to fresh produce. Farmers' markets and on-farm stores are growing in popularity. Farmers unable or unwilling to compete on a large scale are finding a niche market in direct sales to consumers via such venues and Internet sales, for example.

In addition, many farm families have discovered that farm life can be entertainment to those who are generations removed from it. Agritourism is a growing industry in Indiana. Trips to a farmers' market will once again become more common. On-farm entertainment venues that trace our heritage or food production will dot the Indiana countryside. The more technical and processed our food system becomes, the more there will be a yearning for the natural connection to the land and the people who work it. The local farmer and the small-scale farmstead will continue to have a valuable place in the new century.

Farming without Dirt

Purdue University, with funding from the space agency NASA, has for several years been conducting research focused on growing an expanded variety of food products hydroponically—that is, without dirt, in nutrient-fortified water. NASA hopes that this effort will lead to a system that will allow future astronauts on long voyages to grow their own food in space. But the research may also have implications for those of us here on Earth.

Dr. Cary Mitchell, Director of Advanced Life Support Research at Purdue, envisions hydroponic food production on an industrial scale. Large, windowless warehouses in the midst of industrial parks would contain thousands of square feet of plants growing hydroponically in a climate-controlled atmosphere, with computer-controlled lighting. These food factories would produce a variety of products year-round. Products such as bananas, oranges, and pineapples that cannot currently be grown in Indiana could be produced here hydroponically.

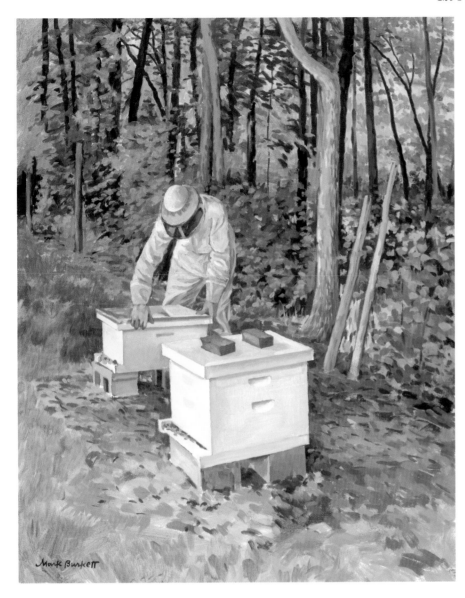

The Indiana Beekeepers Association is a very passionate and surprisingly large group. There is even a State Honey Queen! Many, like Shane Williams, pictured here, keep hives as a hobby.

MARK BURKETT
Tending the Hives, Williams Farm, Mooresville
Oil on canvas 20 × 16 inches

Is There a Future for Small-Town Indiana?

As Indiana cities continue to expand, and as new interstate highways snake across the landscape, small towns and rural communities will come under increasing pressure. Once relatively autonomous, today's rural communities are more dependent on the state as a whole. Likewise, the state needs the natural and human resources rural communities offer in order to grow and prosper. Only with policies and programs that foster this mutually beneficial relationship between urban and rural will small-town Indiana thrive.

The successful small town of tomorrow will be one that plans for economic growth but includes local agriculture as part of that plan. It will be in a county that protects its farmland but provides for new development. It will be a community that has a balance of locally owned businesses and franchise chains. It will be a mix of old and new residents who value the past but embrace progress. Rural communities cannot rely solely on agriculture to support them. They must plan and work toward economic interdependence rather than independence.

The Future Farmer of Indiana

Farmers of the future will need knowledge and skills not conceived of today. They will find themselves affected as much by political forces and economic conditions as the weather. The farmer will be in the energy business and the life sciences industry, as well as in food and fiber production. Some farmers will be involved in the global market. Some will even operate farms in several different countries. Others will produce for a local farmers' market and interact with their customers face to face. Some will use cutting-edge technology to produce their crops, while others will shun all such measures and go organic.

All of them, however, will share a powerful link with the farmers of the past centuries. They will need a love of the land and a respect for nature, a dogged practicality and an eternal optimism, a love of family, a willingness to work hard, a readiness to help a neighbor, and, underlying it all, a burning passion to pass on the farm and its heritage to a new generation.

Fruit stands, like farmers' markets, are a growing trend in the city. People value the fresh, local produce and the opportunity to deal directly with the farmer or grower.

MARY ANN DAVIS
Fruit Stand, 62nd and Allisonville Rd., Indianapolis
Oil on canvas 16 × 20 inches

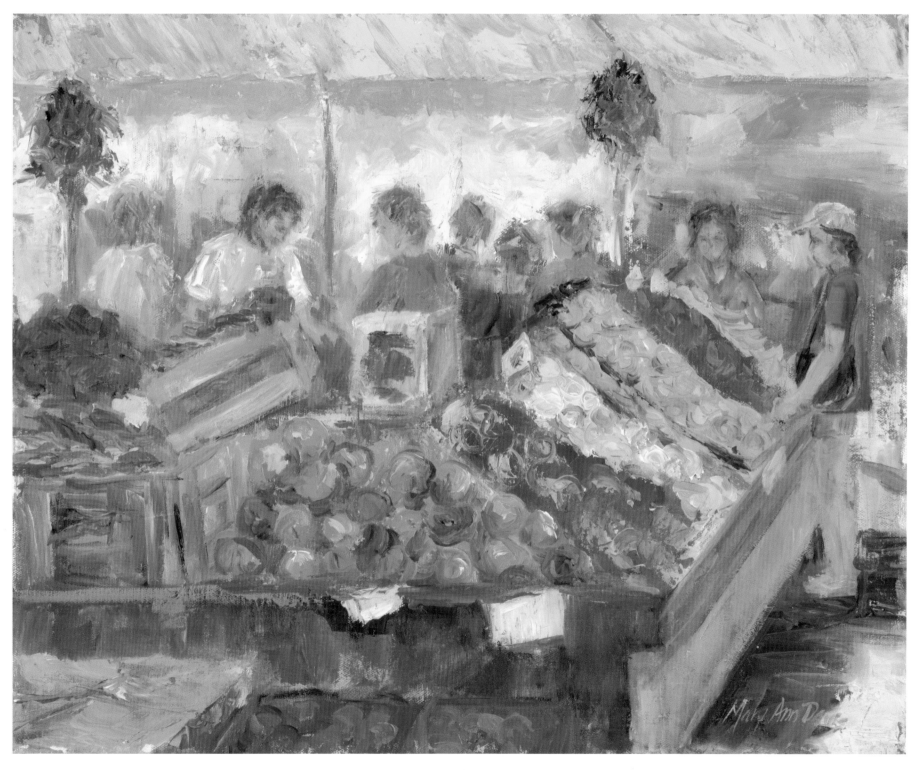

Agriculture is a dynamic and progressive industry; however, it is important to the understanding of our culture to ensure the old ways are not forgotten. Mennonite and Amish communities continue to preserve our heritage by eschewing technology. "Watching the five-team hitch, I saw incredible harmony between driver and team, among the horses themselves, and between the farmer and the land. There was harmony of sound with the stretching of leather harnesses and the soft sound of the disks in the humus-rich soil. It was a symphony and I watched, entranced, for hours."

BOB FARLOW
Disking Amish Style, Walter Swartz Farm, Berne
Oil on burlap 24 × 30 inches

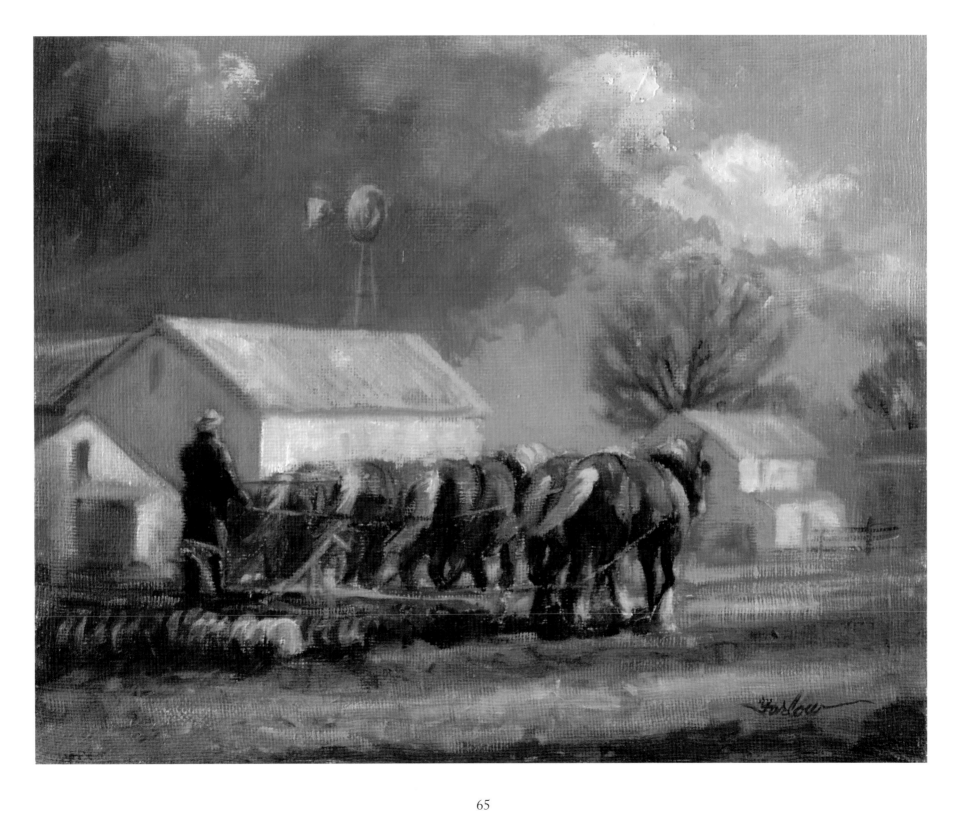

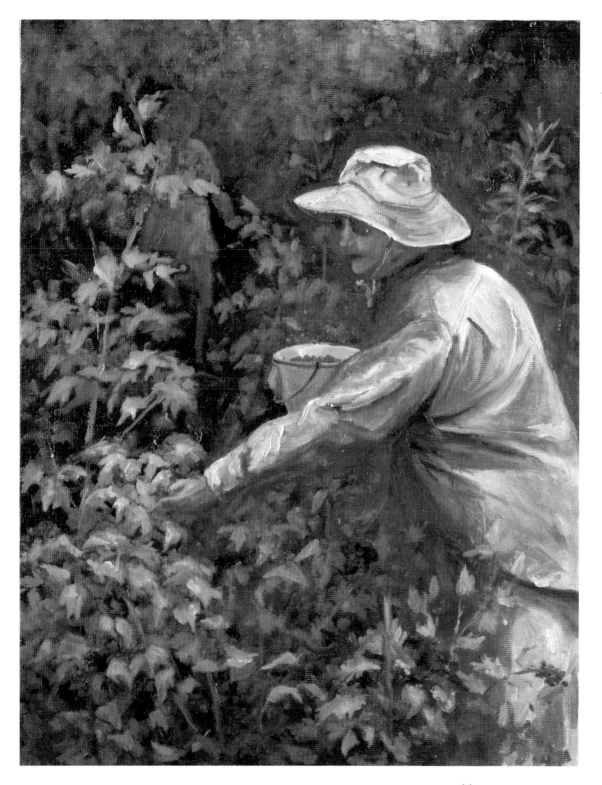

"There are a wide variety of U-pick crops in southern Indiana. Farmers grow strawberries, blueberries, raspberries, and blackberries, among other produce. People are allowed to pick for themselves. I was picking berries with my daughter on this day but the farm was so beautiful with strong lights and darks that I turned in my berry bucket and got out my paints."

NANCY MAXWELL
The Possibility of Pie, Martinsville
Oil on canvas 14 × 11 inches

"Dr. Ted Grayson spent most of a morning explaining the operation of their swine seed stock facility. The silos use computer technology to mix feed according to the needs of the growing pigs and disperse it to their respective barns. I didn't see a slop bucket the whole tour, but I did see Dr. Grayson's intense love and dedication to raising quality breeding stock."

BILL BORDEN
Somerset Farm, Kirklin
Watercolor on paper 22 × 28 inches

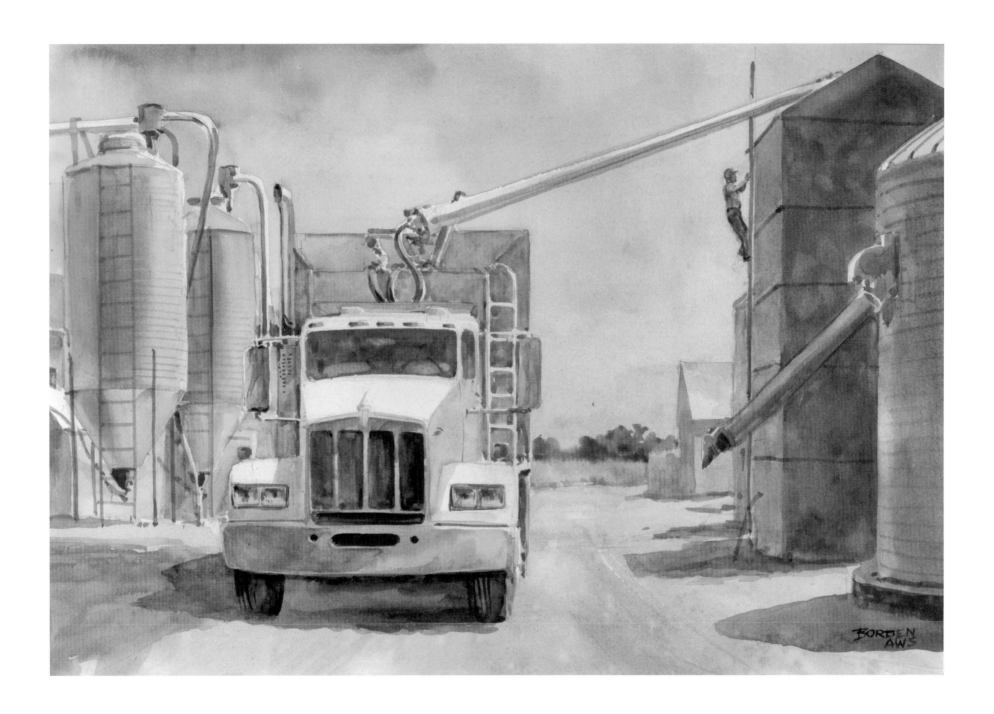

The old is not always replaced by the new in agriculture. This feed lot utilizes its old silos alongside the new to store adequate feed for the growing herd.

SCOTT SULLIVAN
Inquisitive, Baynes Farm, Bloomington
Oil on linen 30 × 36 inches

The processing of timber is an important business for Indiana. Hoosier forests, both public and private, combine to make nearly ten million dollars annually in cash receipts.

SCOTT SULLIVAN
Knight's Corner Lumber, Nashville
Oil on linen 24 × 36 inches

Forestry is a wonderful example of sustainable practices improving environmental conservation, while increasing the profitability of a given crop. The lumber industry in Indiana is playing an ever-increasing role in the state's economy.

MARY ANN DAVIS
Cutting Timber, Arbortera, Lizton
Oil on canvas 14 × 28 inches

73

The journey of field to table for this crop may end as ketchup. Red Gold processes and distributes Indiana-grown tomatoes and chilies throughout the Midwest.

CAROL STROCK-WASSON
Red Gold Tomato Field, Hurley Farms, County Road 500
Pastel on board 12 × 16 inches

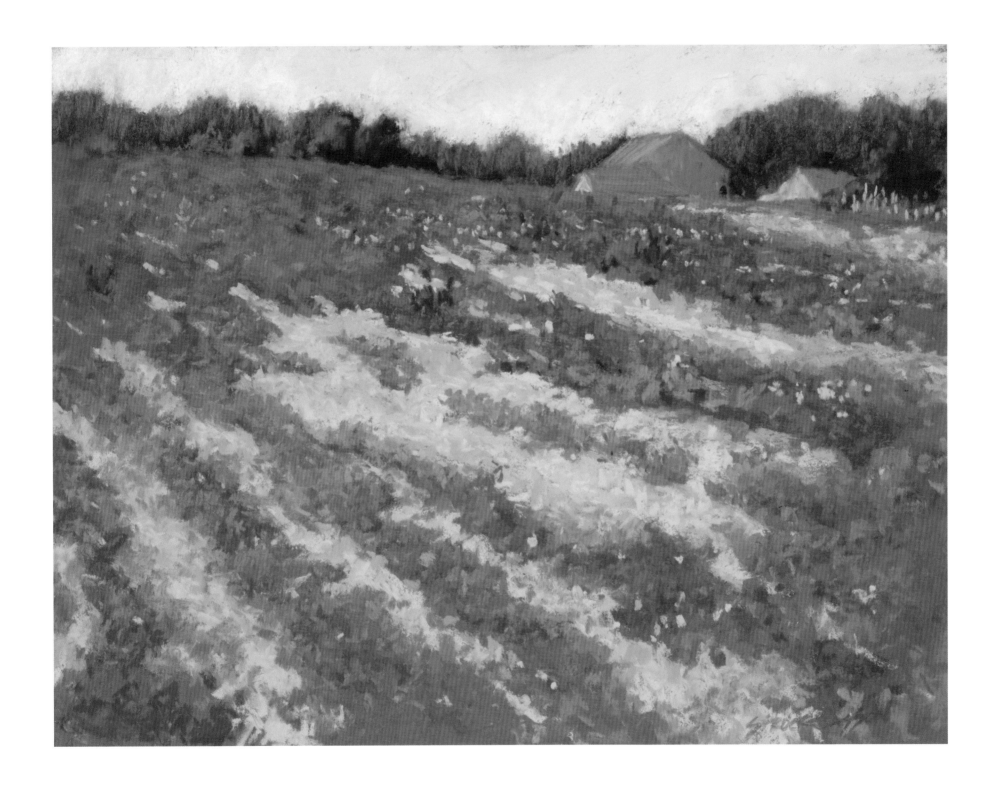

Traders Point Creamery is Indiana's only organic dairy. The livestock roam freely in beautifully cultivated pastures. Traders Point Creamery's success is evidence of the growing consumer demand for organic products. While they are generally more expensive, consumers are willing to pay the extra premium for a product produced by a more environmentally conscious process.

SCOTT SULLIVAN
Traders Point Creamery, Zionsville
Oil on linen 24 × 30 inches

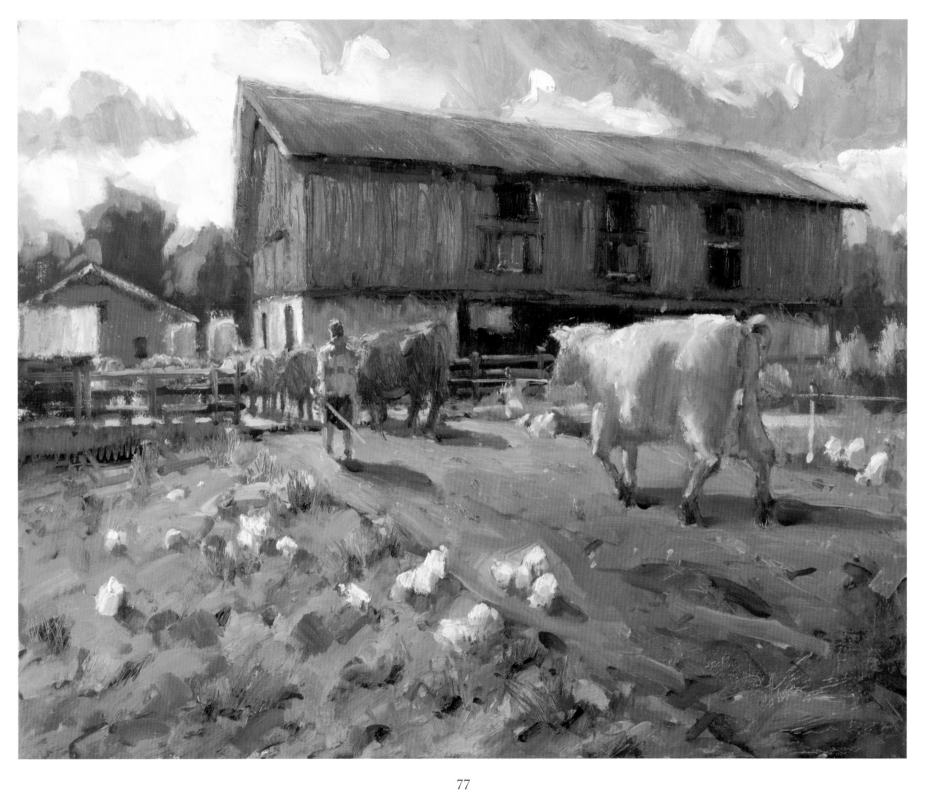

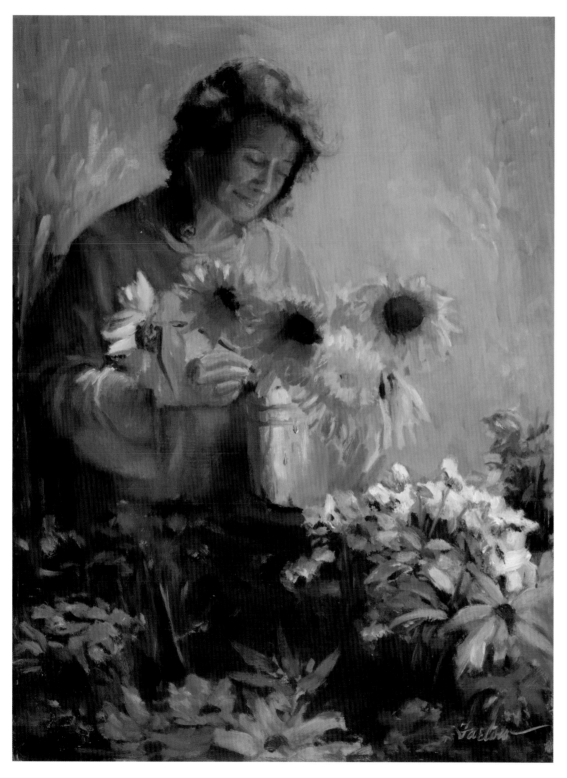

"*Farmers' markets have long been a source of income providing extras for the family. The direct marketing provides a higher percentage of the profits and in many cases has become the primary income. Flowers create a product outside the food chain and add a touch of beauty to the homestead.*"

BOB FARLOW
Flower Vendor, Farmers' Market, Culver
Oil on canvas 24 × 18 inches

Kincaid's Market has been a family-owned business for three generations and they know their customers by name. Meats are still butchered by hand here. Kincaid's often buys the prize-winning steer at the Indiana State Fair.

LYNN DUNBAR
Kincaid's Meat Market, Indianapolis
Oil on canvas 16 × 20 inches

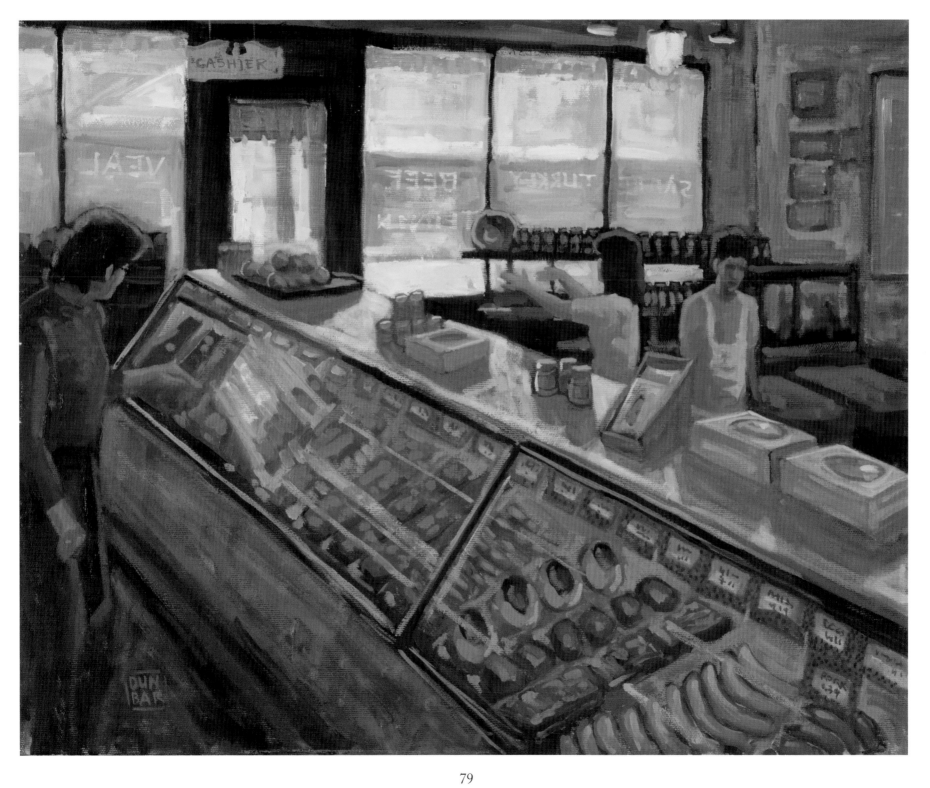

79

The big city doesn't have the market cornered on Indiana's growing ethnic diversity. Mooresville is home to Zydeco's Cajun Restaurant. Chef Carter Hutchinson relocated from the heart of Cajun country, New Orleans, to bring his authentic cuisine to Hoosiers. As ethnic diversity increases, so does the diversity of consumer demand which ultimately determines the specific bounty of our farms.

MARK BURKETT
Zydeco's Cajun Restaurant, Mooresville
Oil on canvas 14 × 18 inches

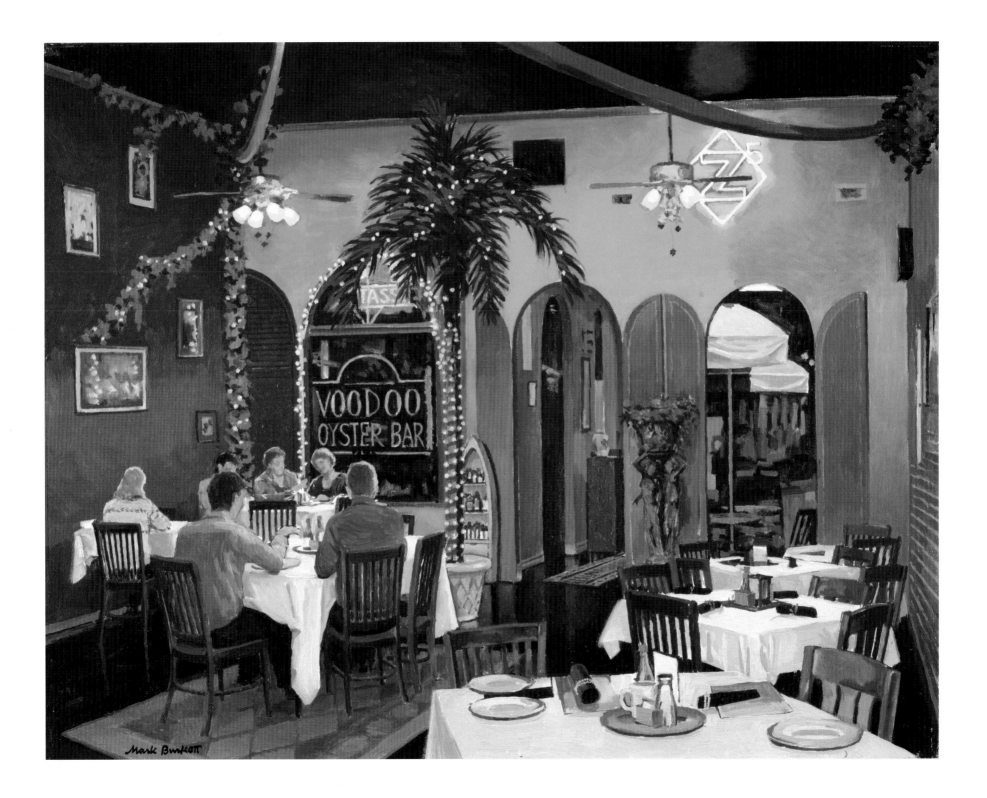

The Cattlemen's Club tent at the Indiana State Fair provides city dwellers a delicious taste of agricultural product.

CAROL STROCK-WASSON
The Cattlemen's Club, Indiana State Fair, Indianapolis
Pastel on board 12 × 16 inches

"*I found this scenic view of Benaire Farm near Monrovia. Dr. Bennett raises trotters here that compete at local horse tracks.*"

MARK BURKETT
Benaire Farm, Monrovia
Oil on canvas 16 × 30 inches

PORTFOLIO

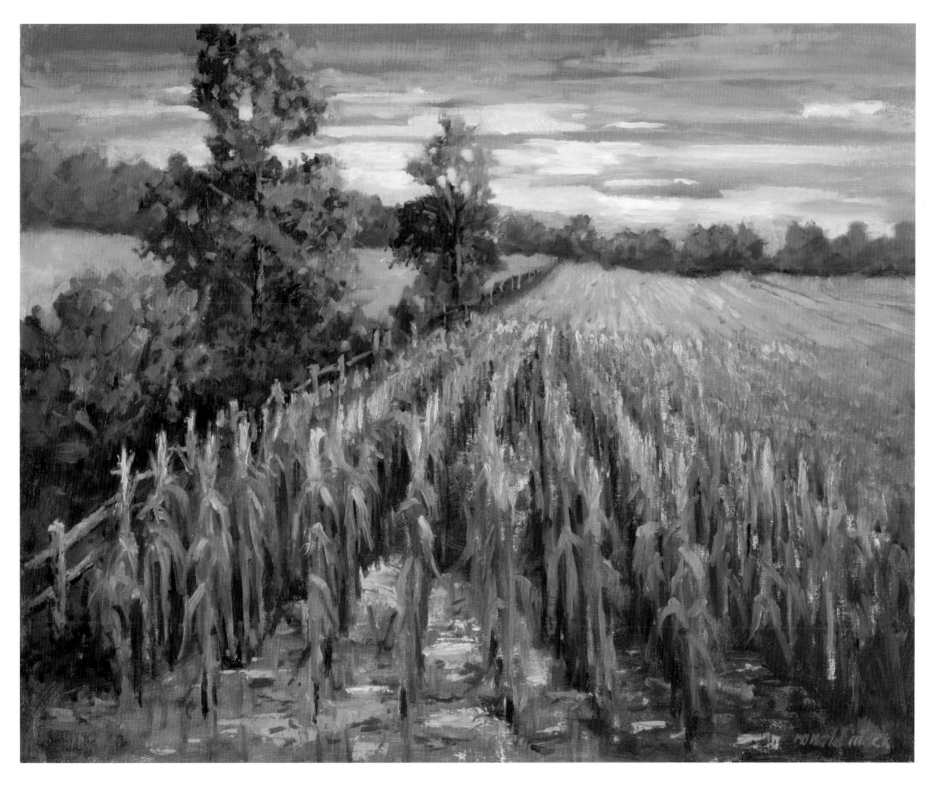

RON MACK
Winter, Southern Marion County
Oil on linen 16 × 20 inches

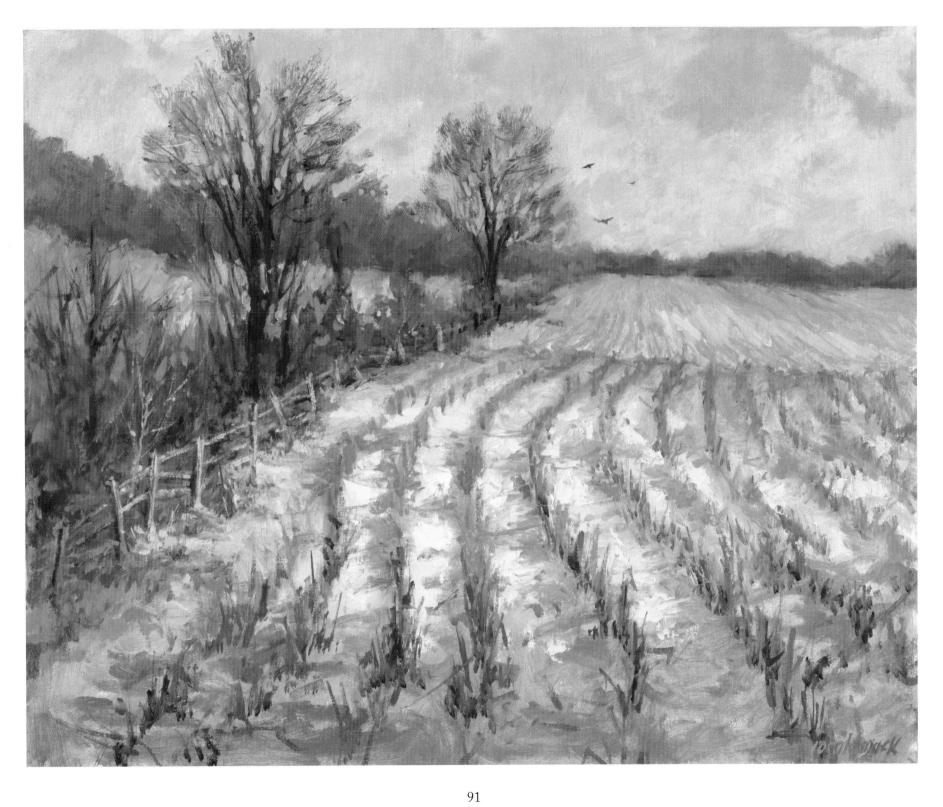

91

NANCY MAXWELL
Four Seasons, Southern Marion County
Oil on canvas 16 × 20 inches

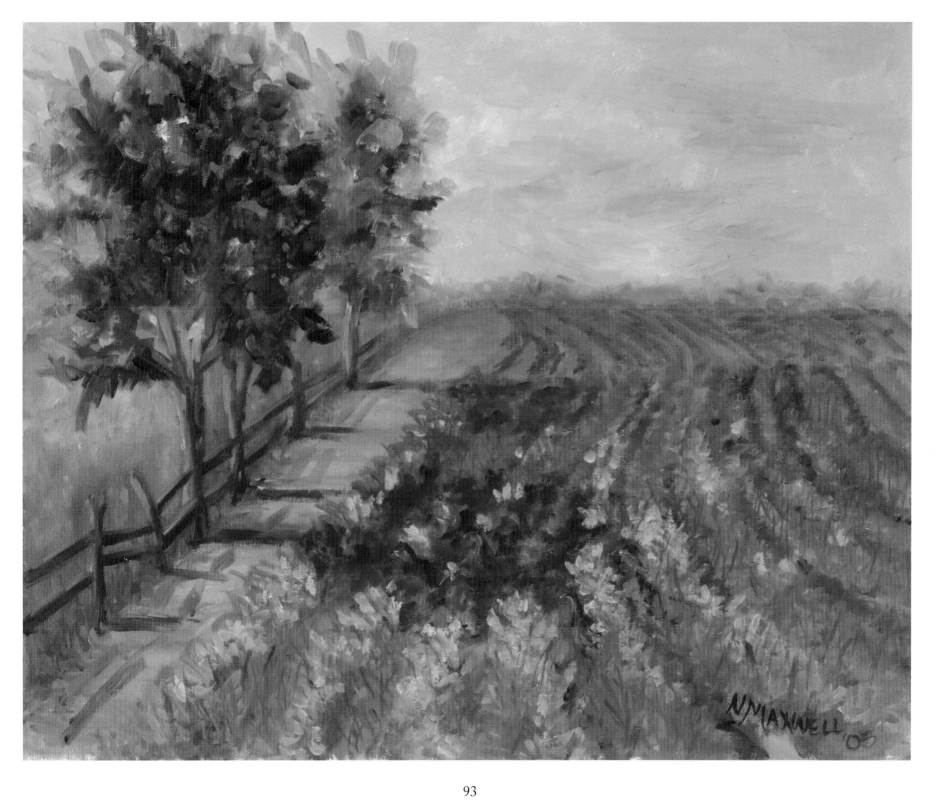

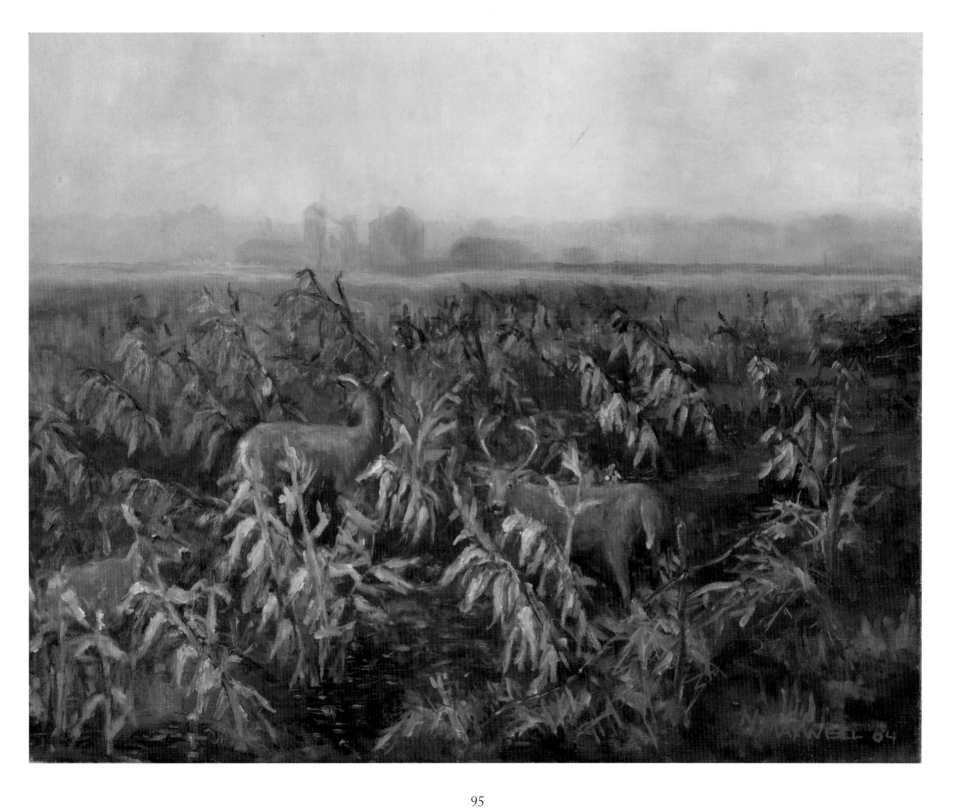

BOB FARLOW
Two Delights, Winchester
Oil on canvas 24 × 30 inches

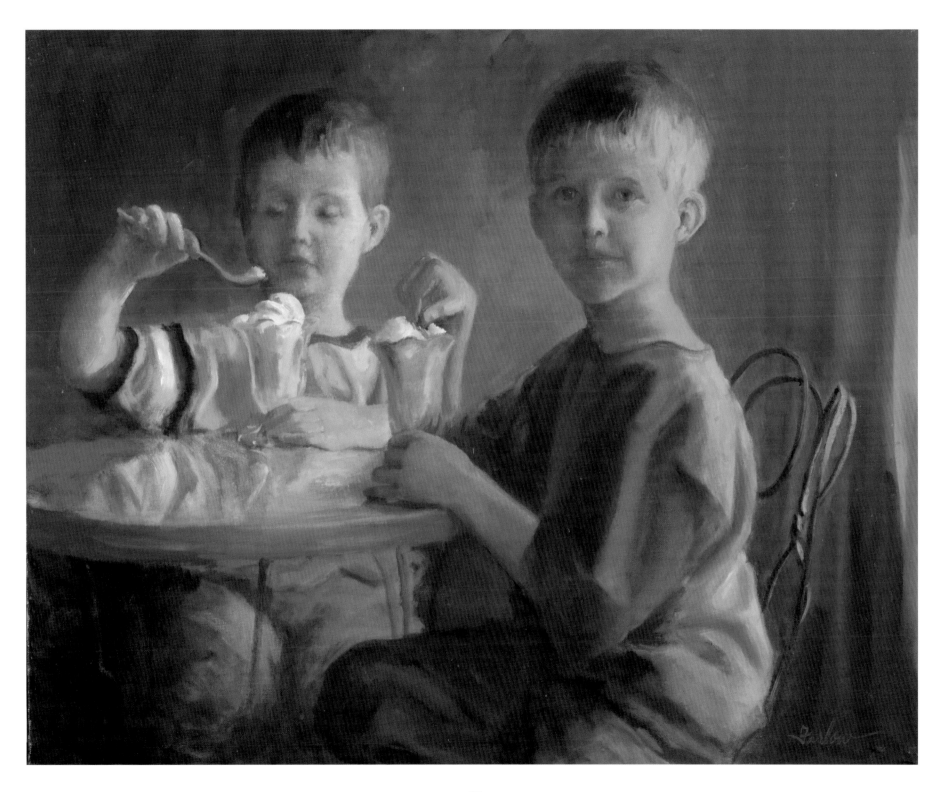

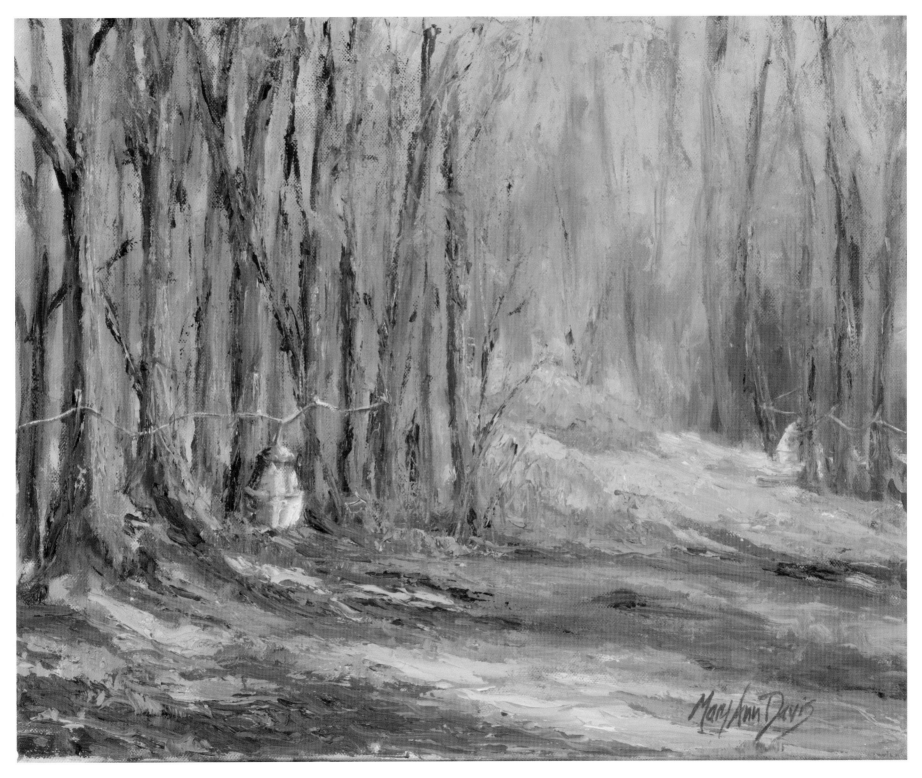

99

CAROL STROCK-WASSON
Finch Food, Prairie Creek, Delaware County
Pastel on board 24 × 18 inches

BILL BORDEN
Mild to Wild Pepper & Herb Co., Franklin
Watercolor on paper 22 × 28 inches

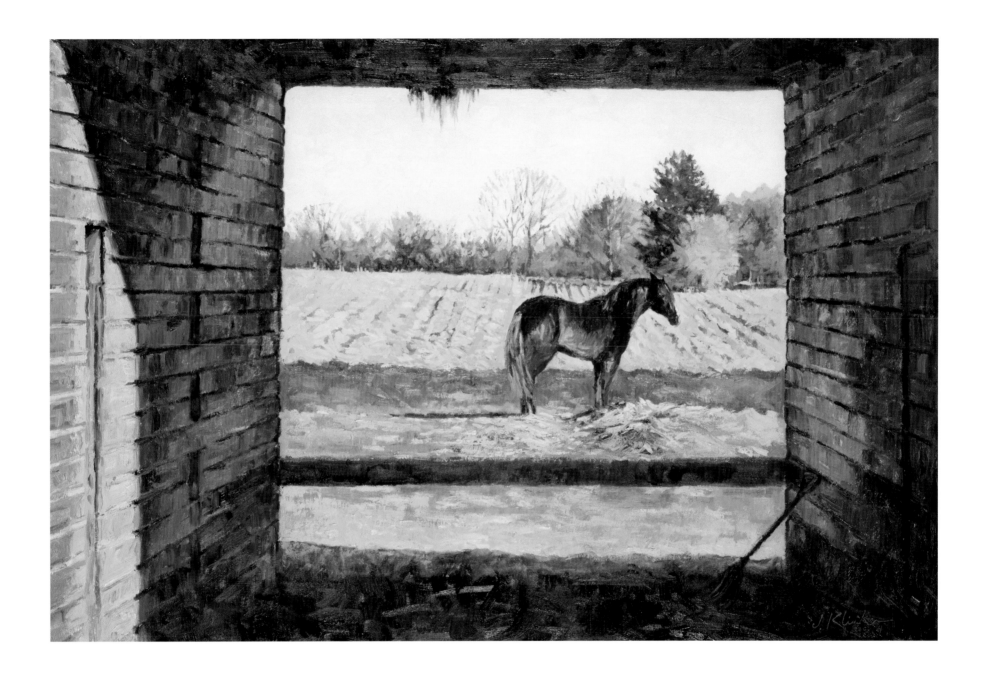

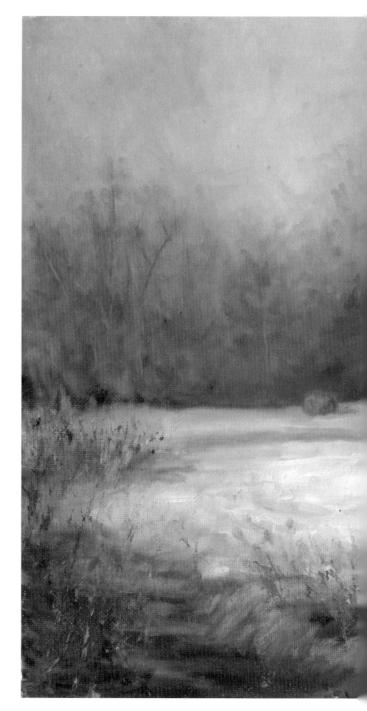

NANCY MAXWELL
Winter Silence, Godsey Road, Martinsville
Oil on board 12 × 24 inches

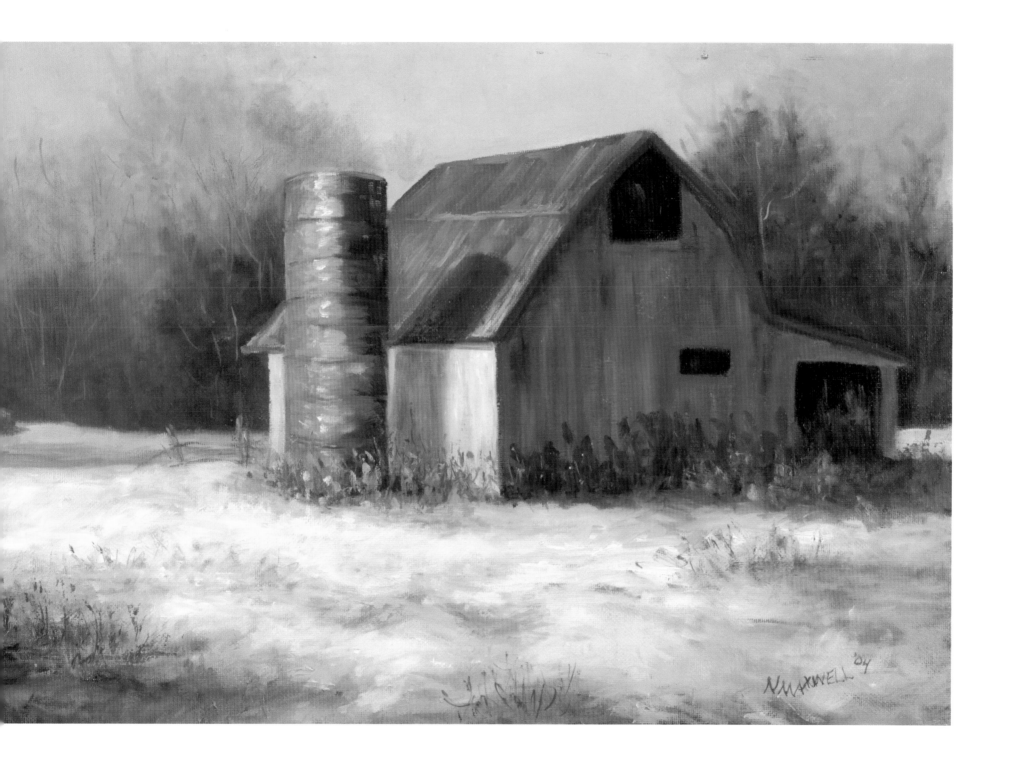

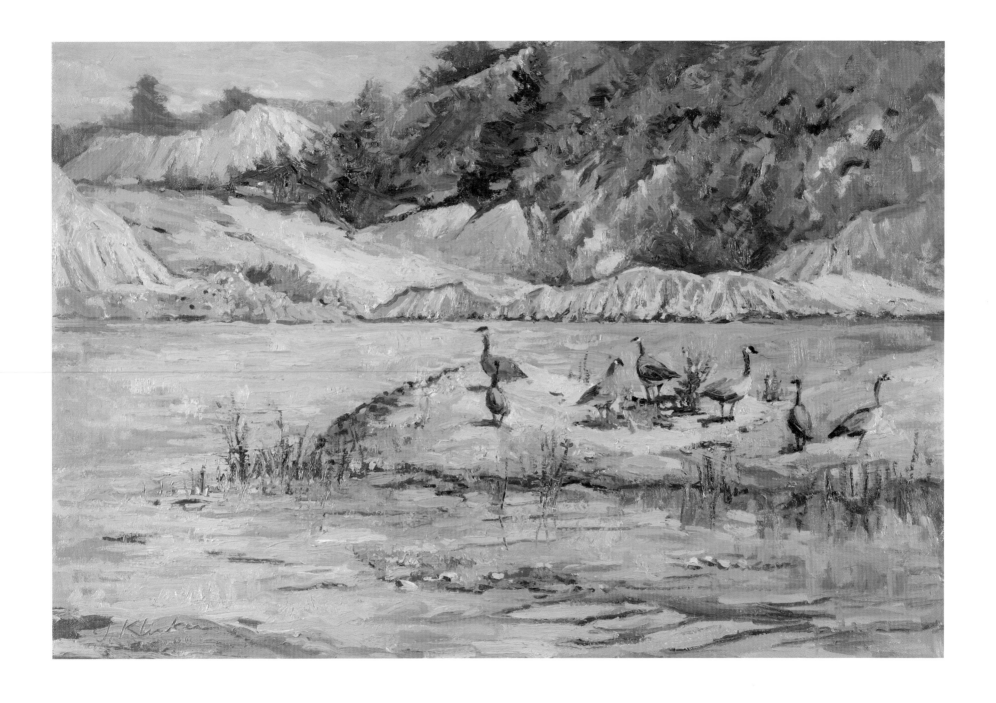

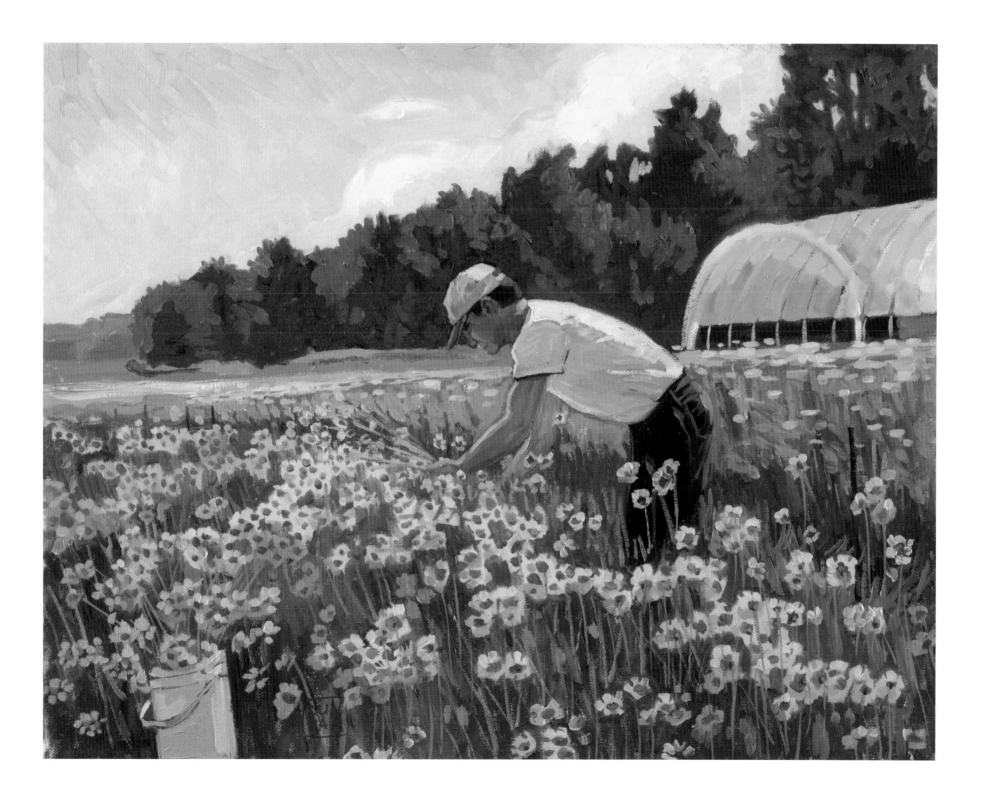

MARK BURKETT
Pond for Wildlife, New Harmony
Oil on canvas 16 × 12 inches

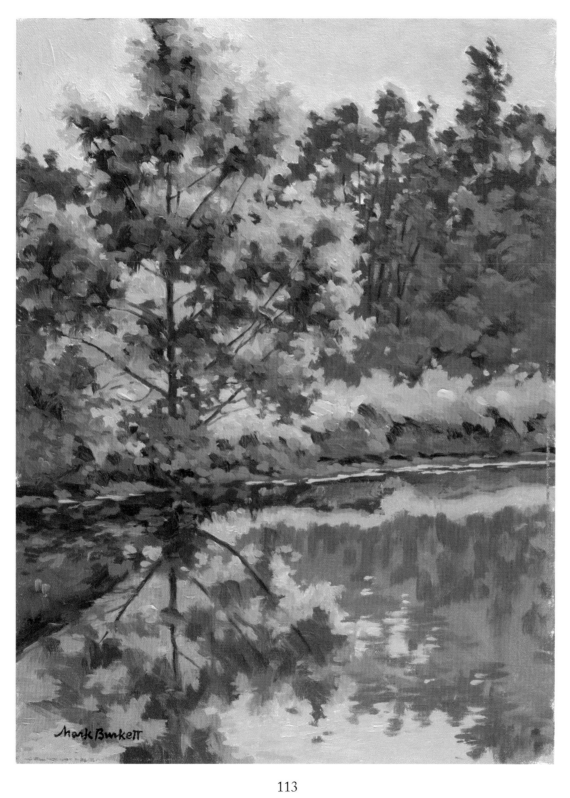

113

MARK BURKETT
Willowfield Lavender Farm, Mooresville
Oil on canvas 20 × 30 inches

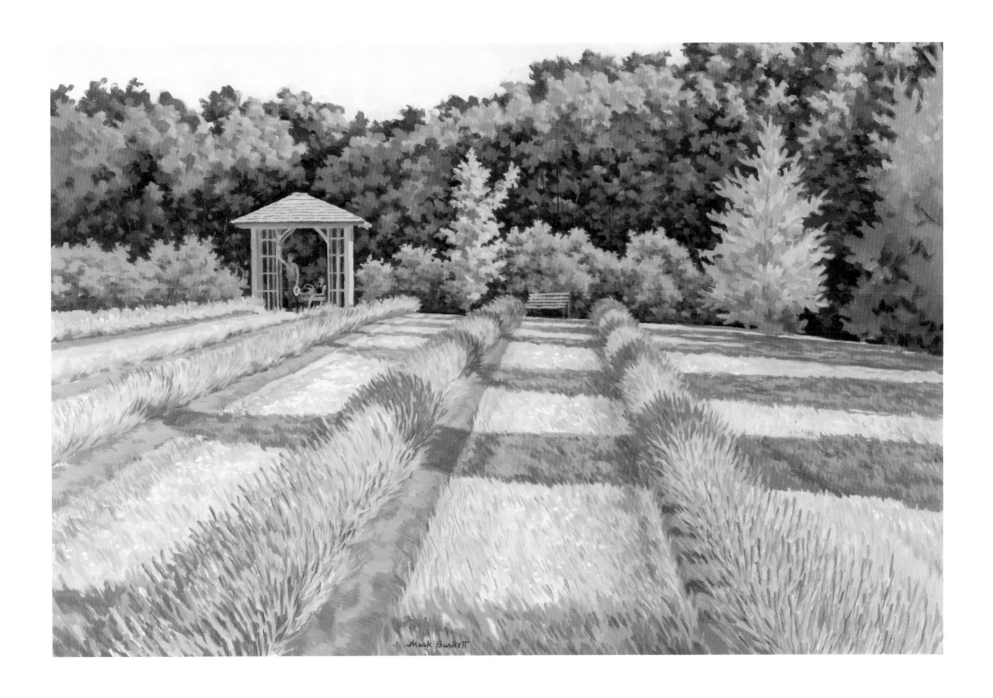

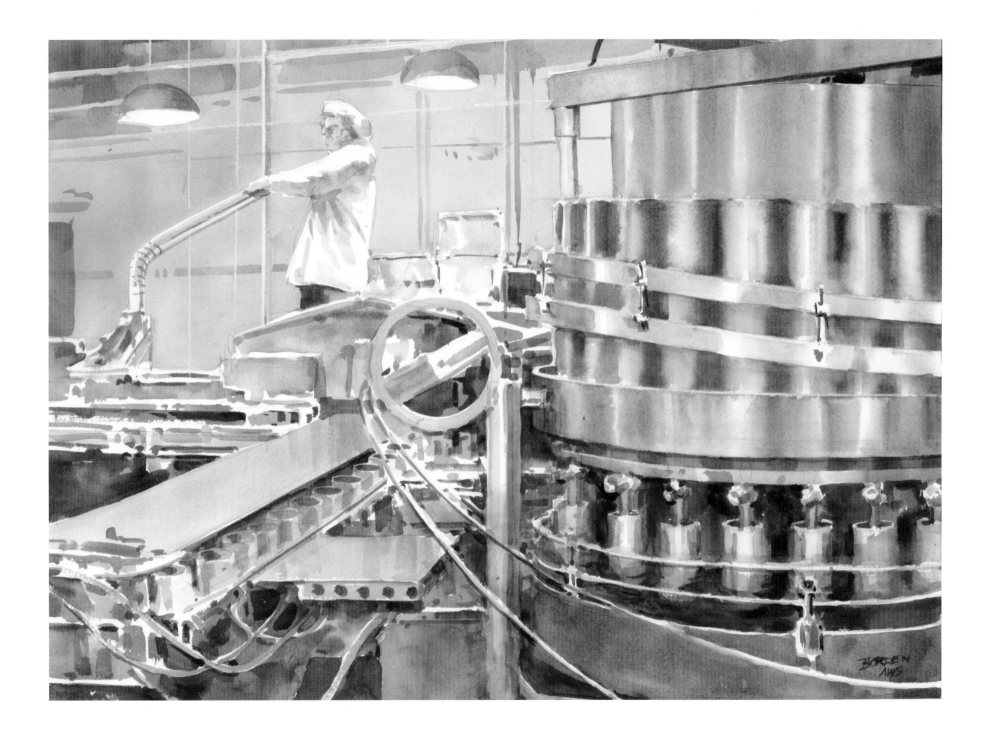

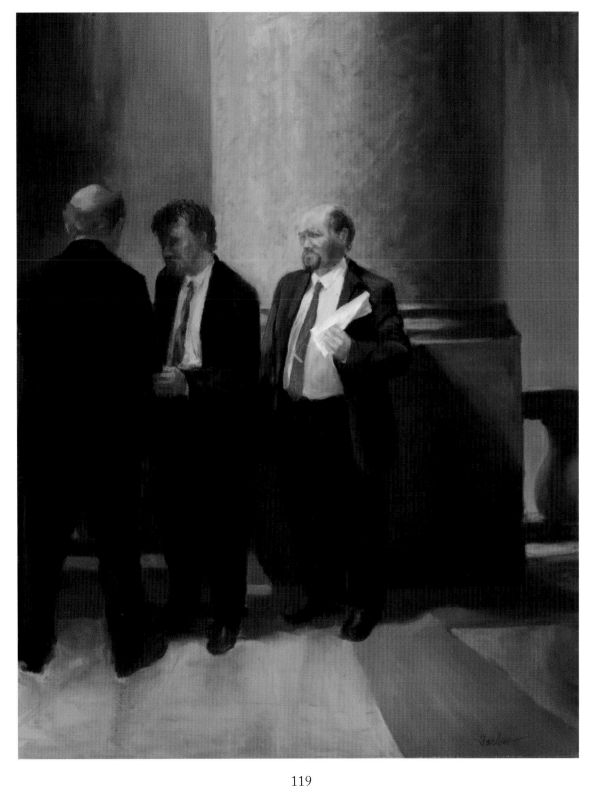

119

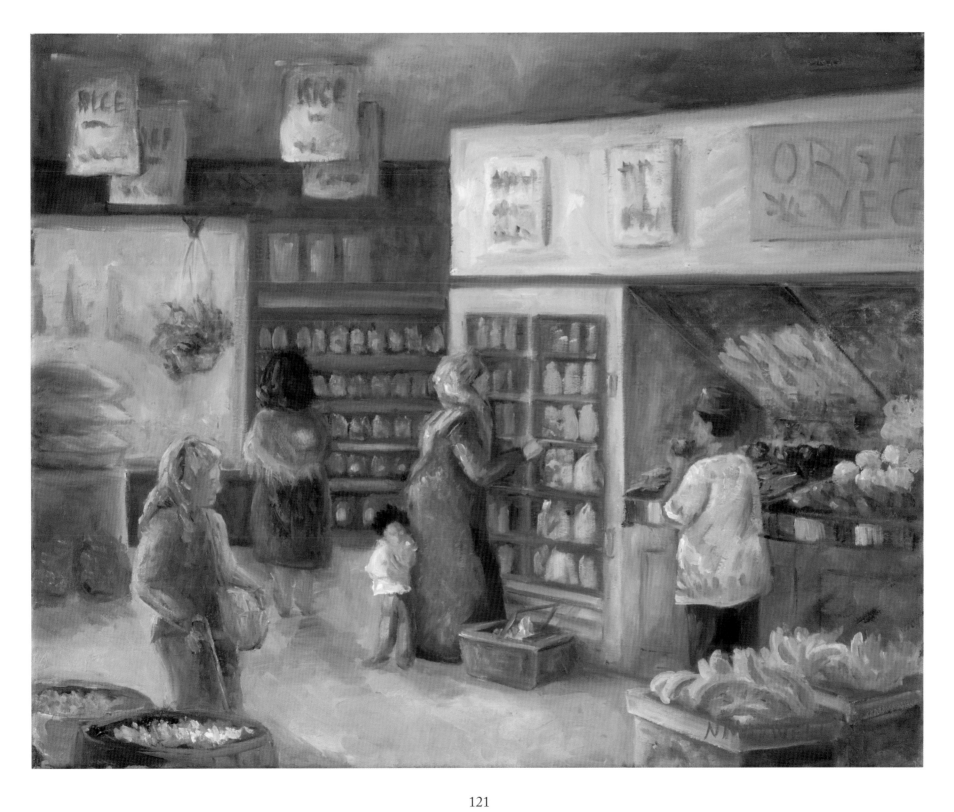

121

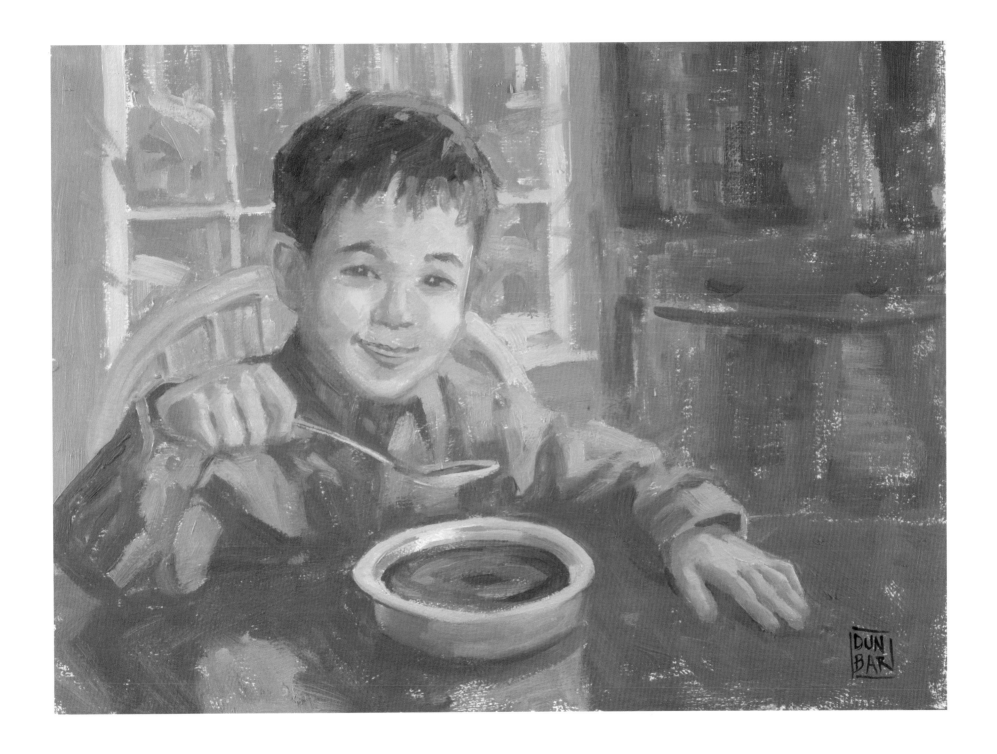

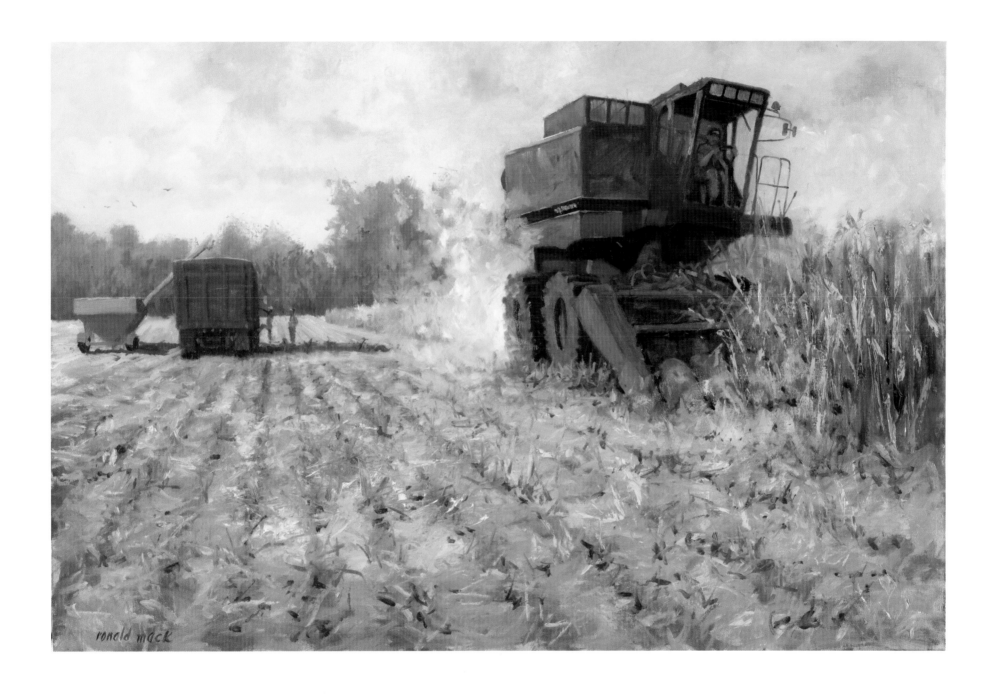

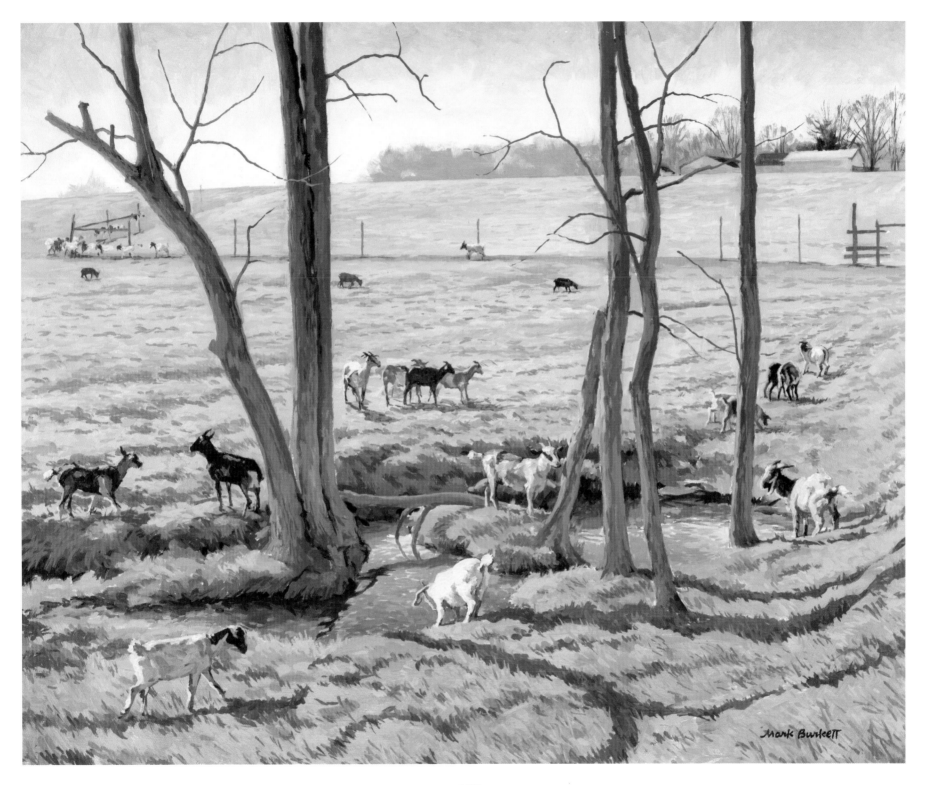

NANCY MAXWELL
Down, Come By to Me, Morgantown
Oil on canvas 15 × 30 inches

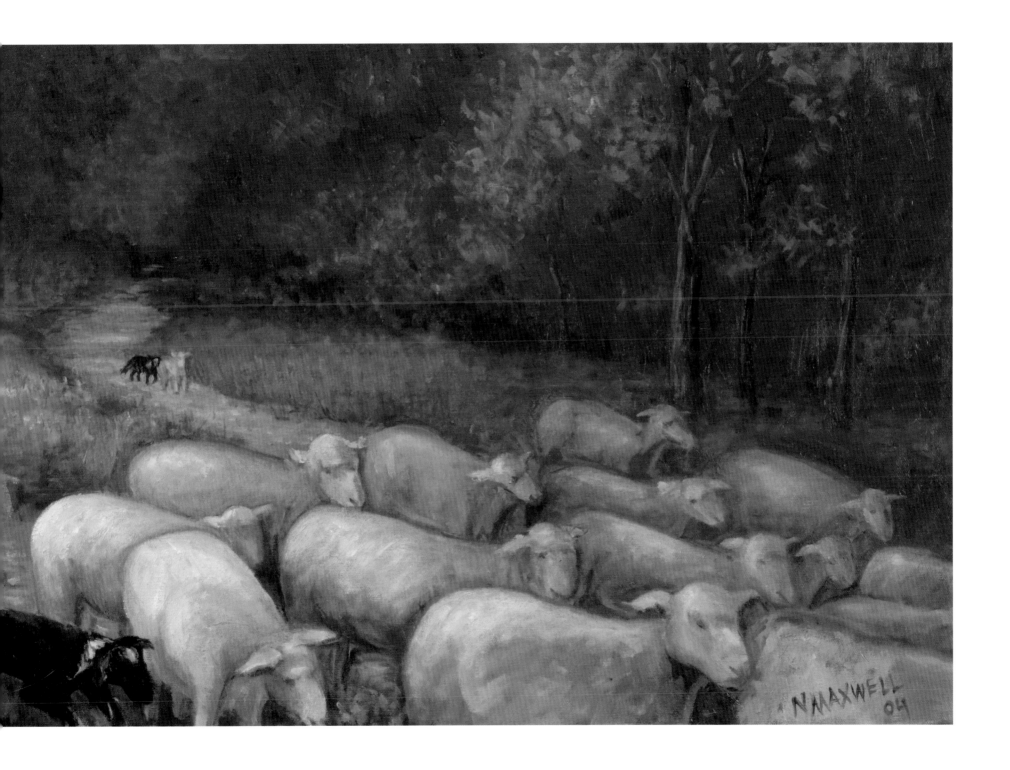

129

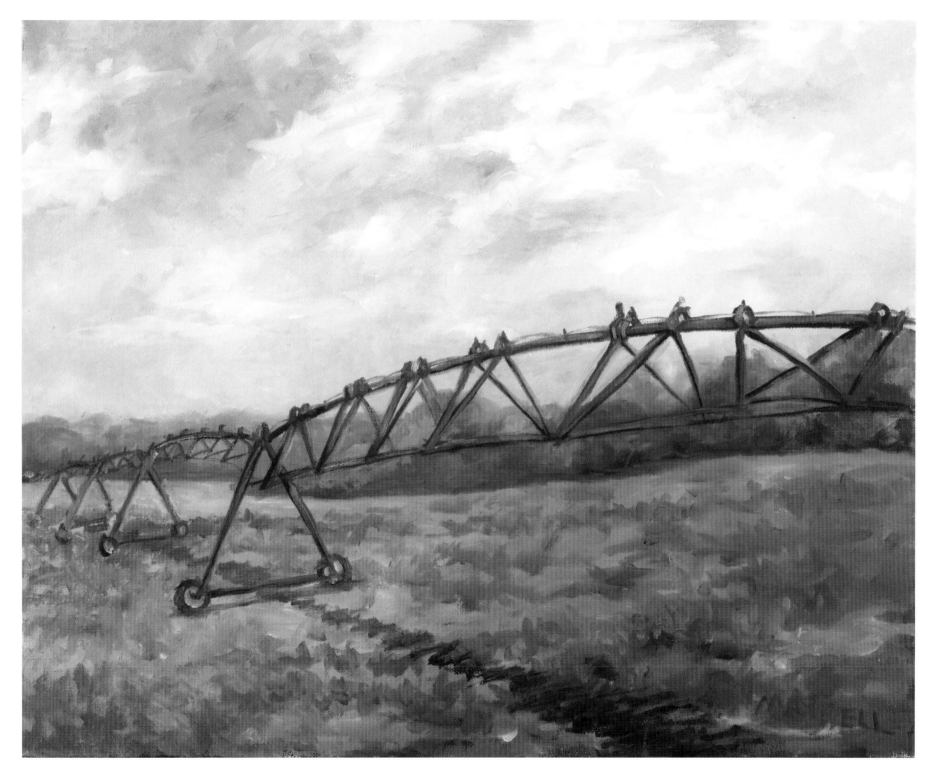

131

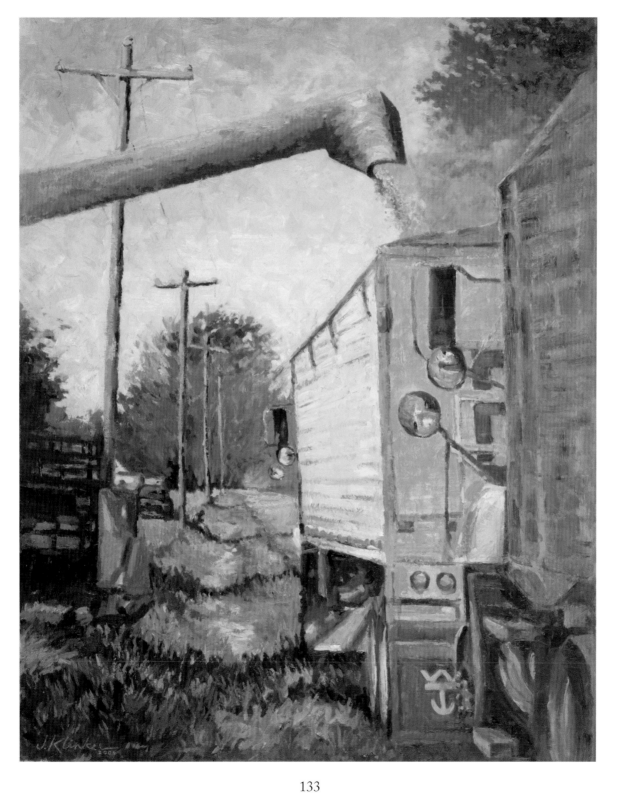

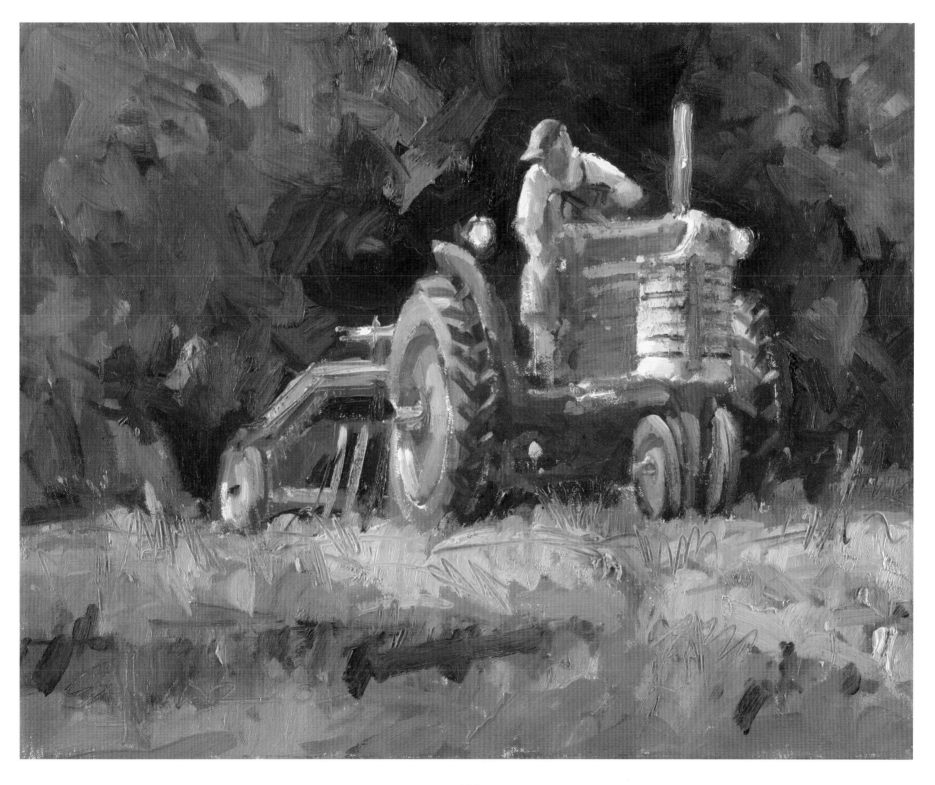

RON MACK
Rain Delay, Hancock County
Oil on linen 16 × 20 inches

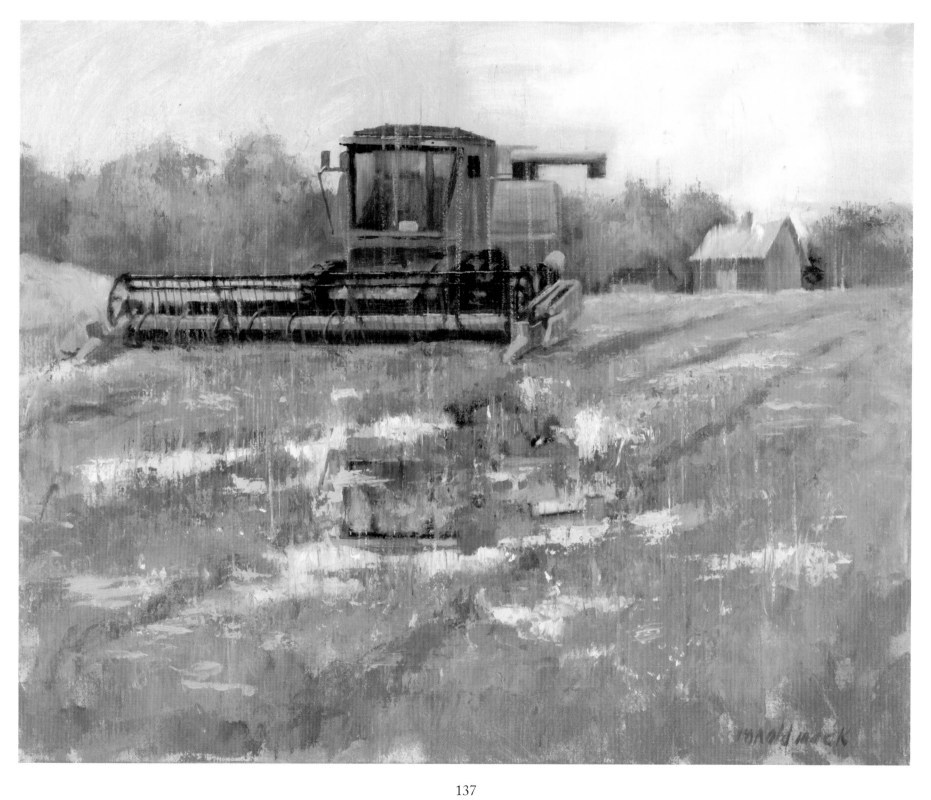

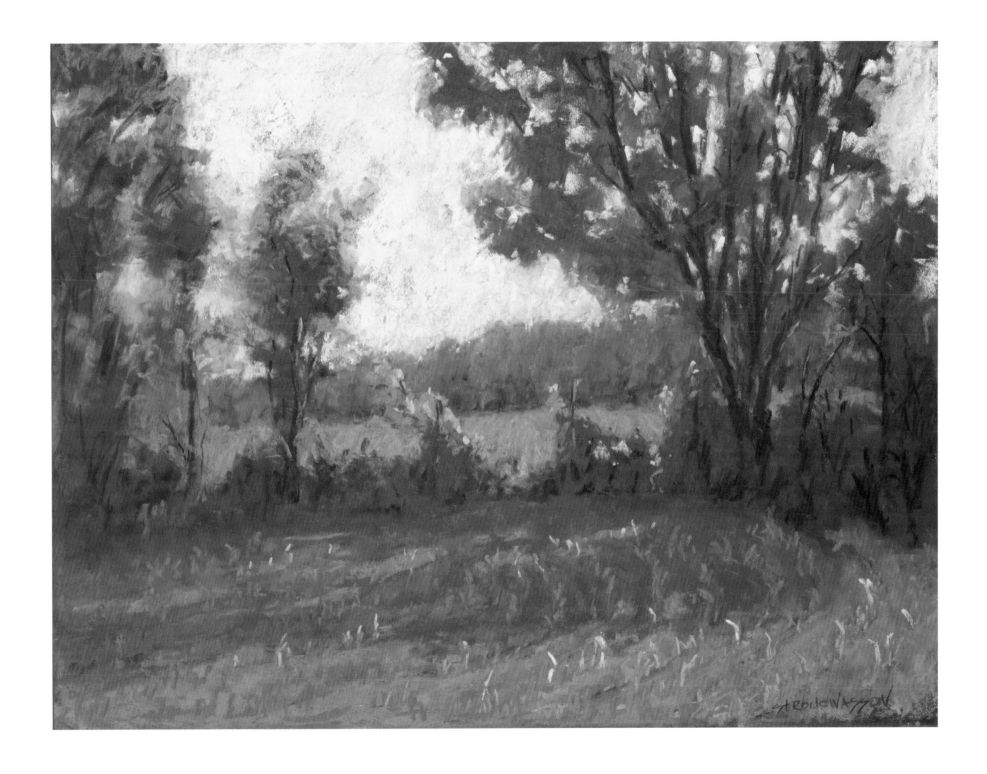

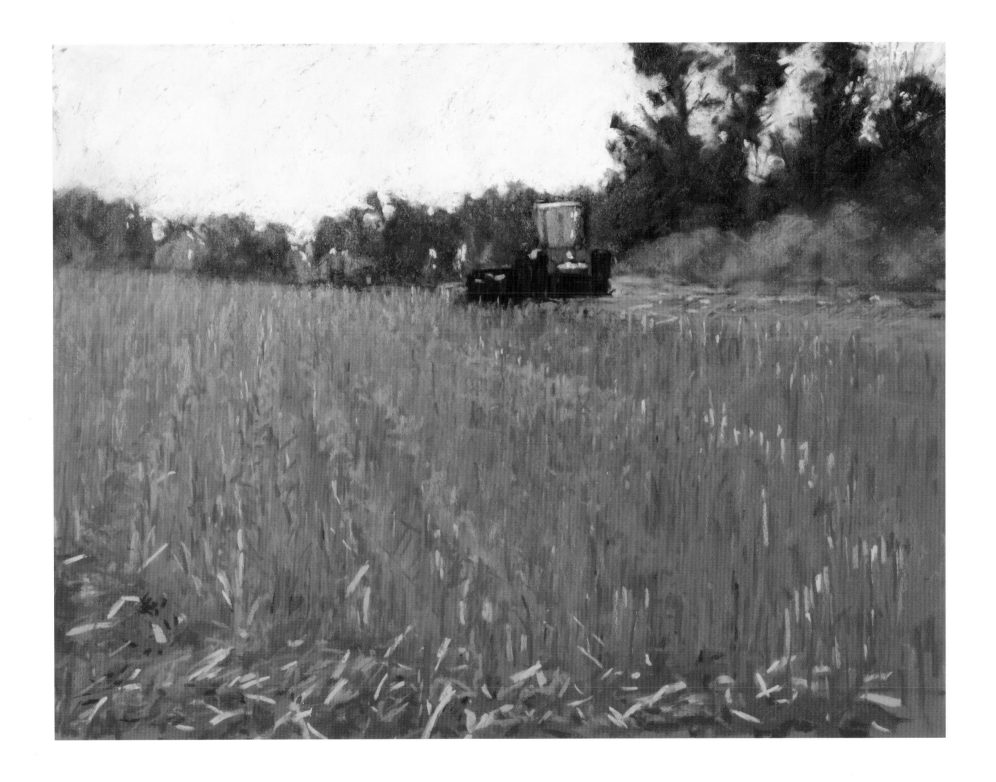

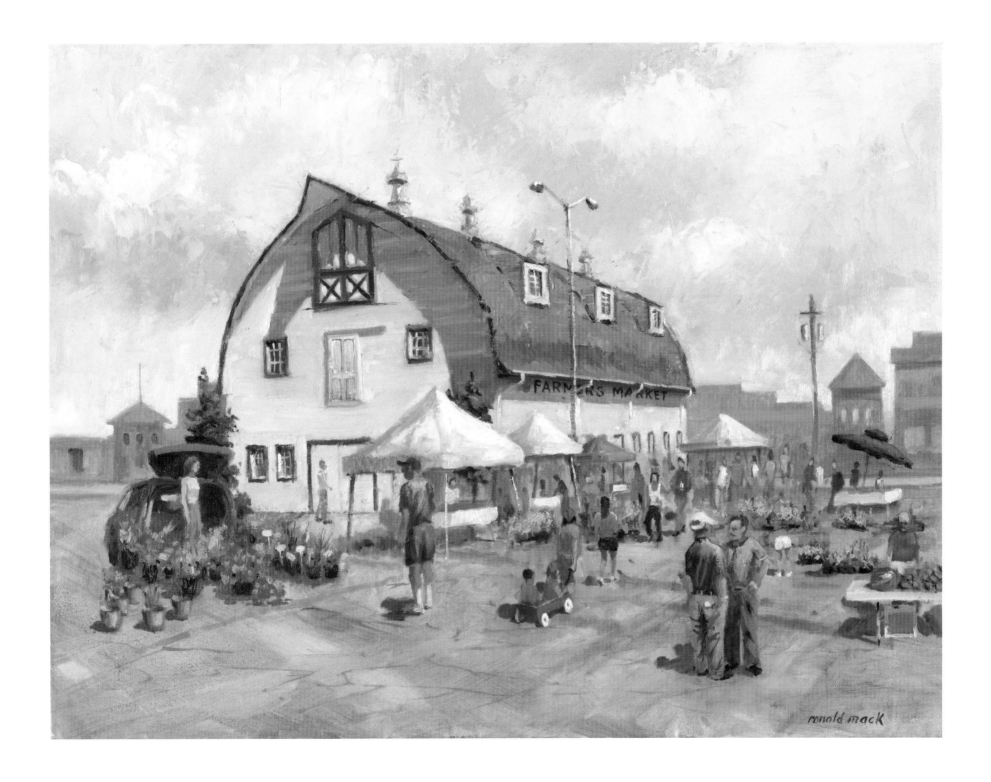

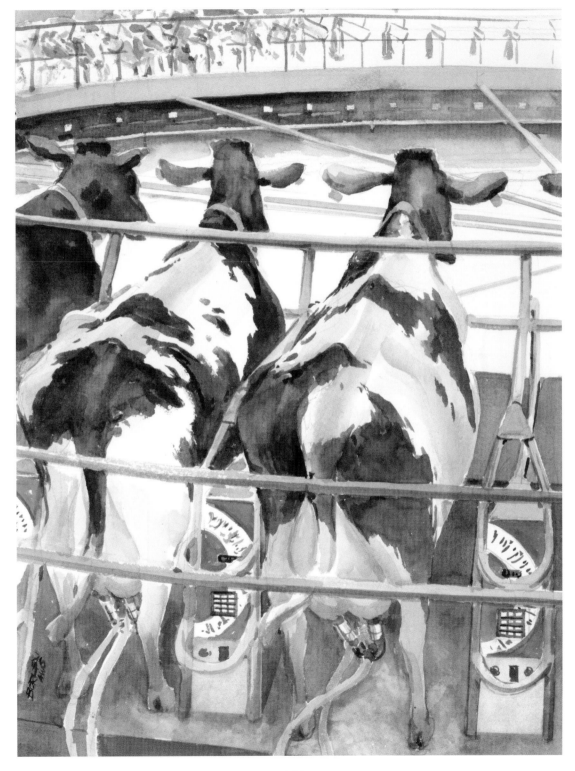

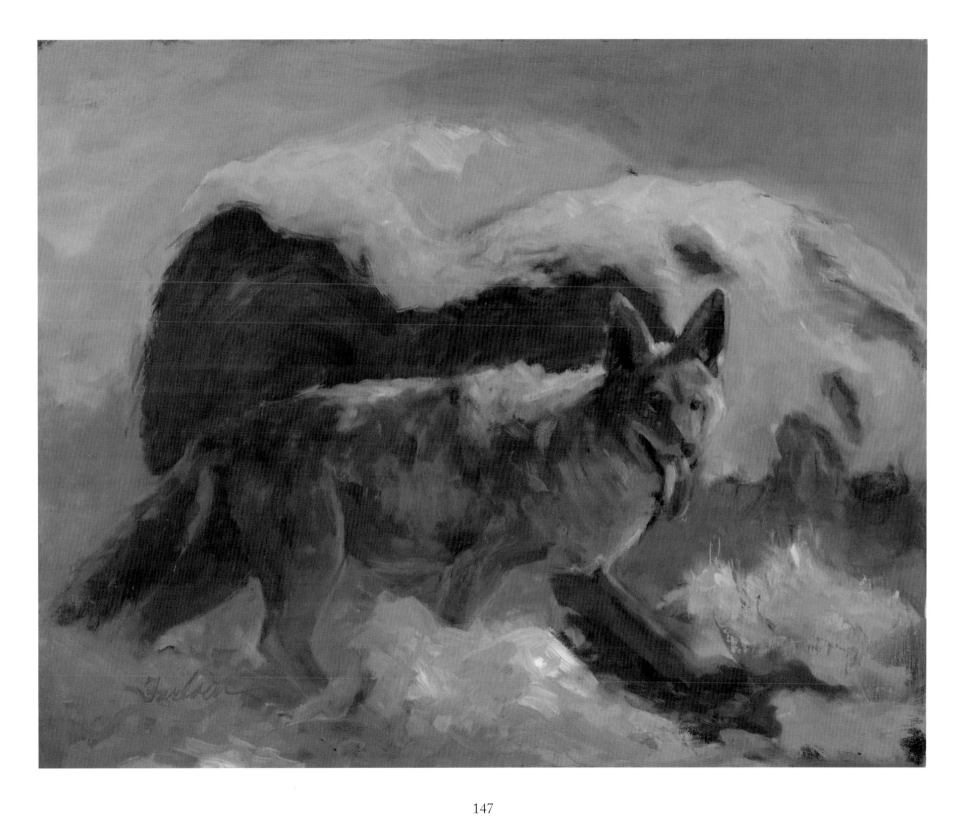

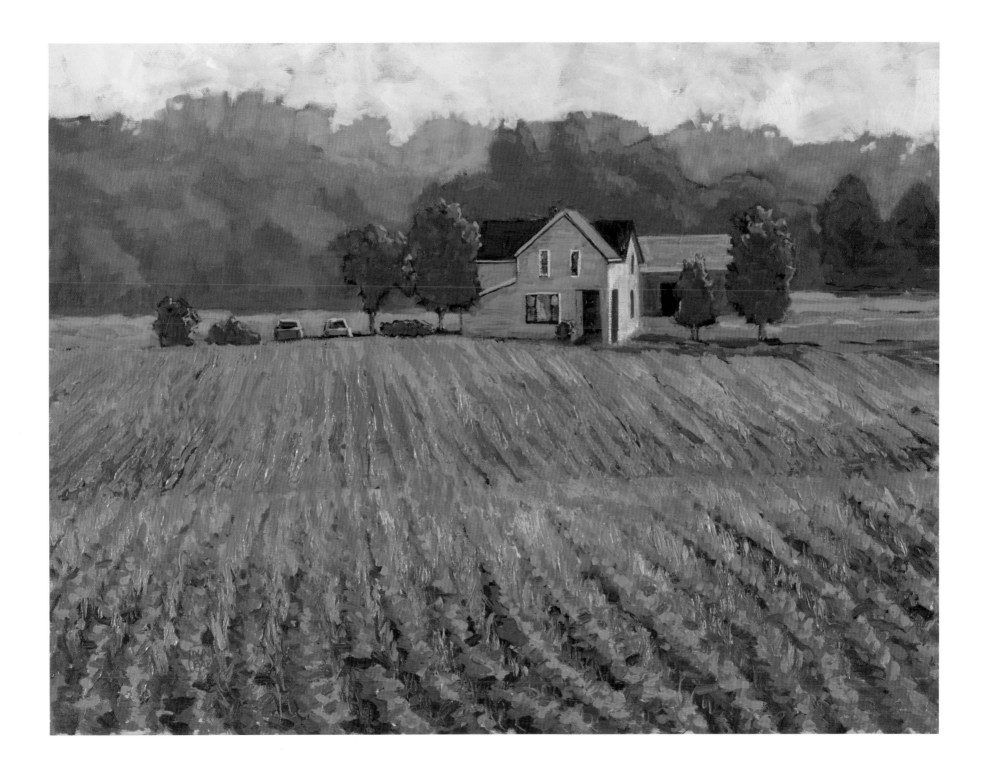

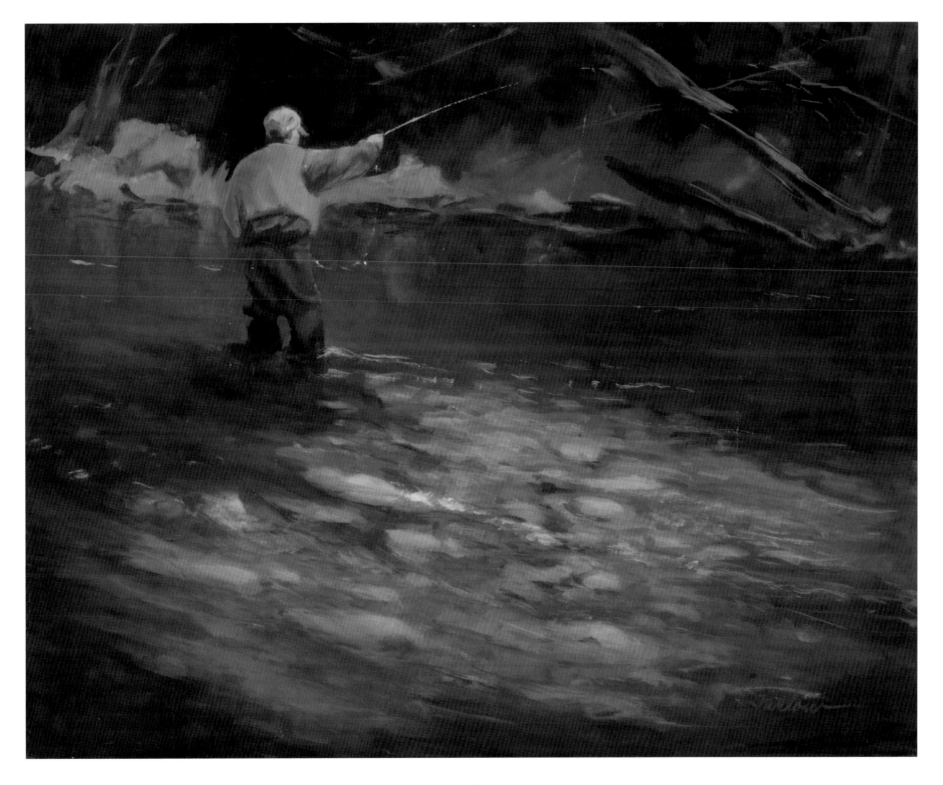

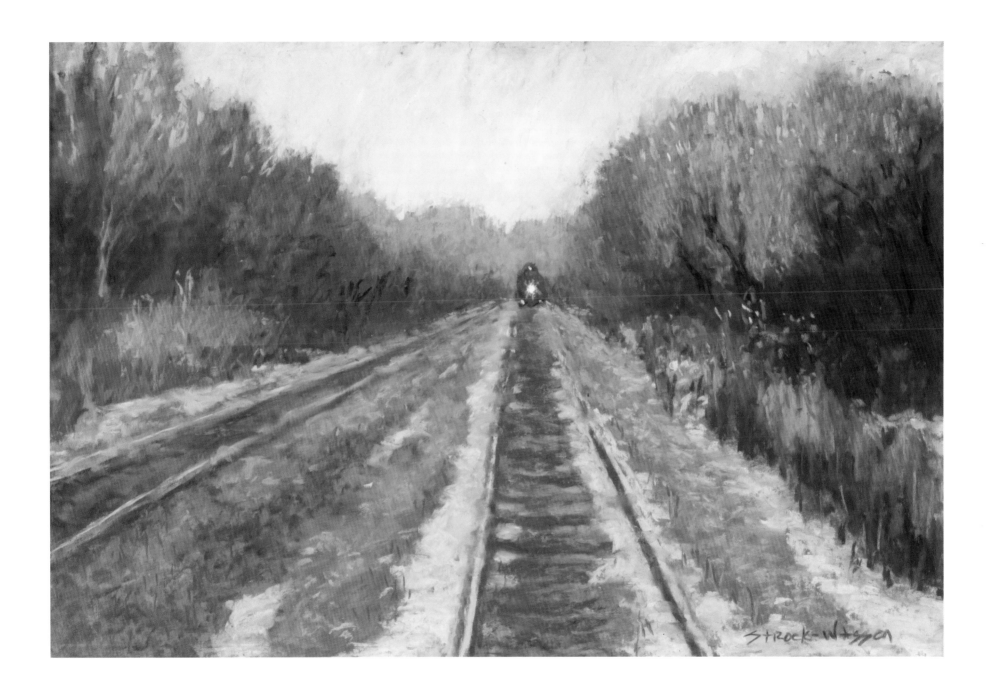

153

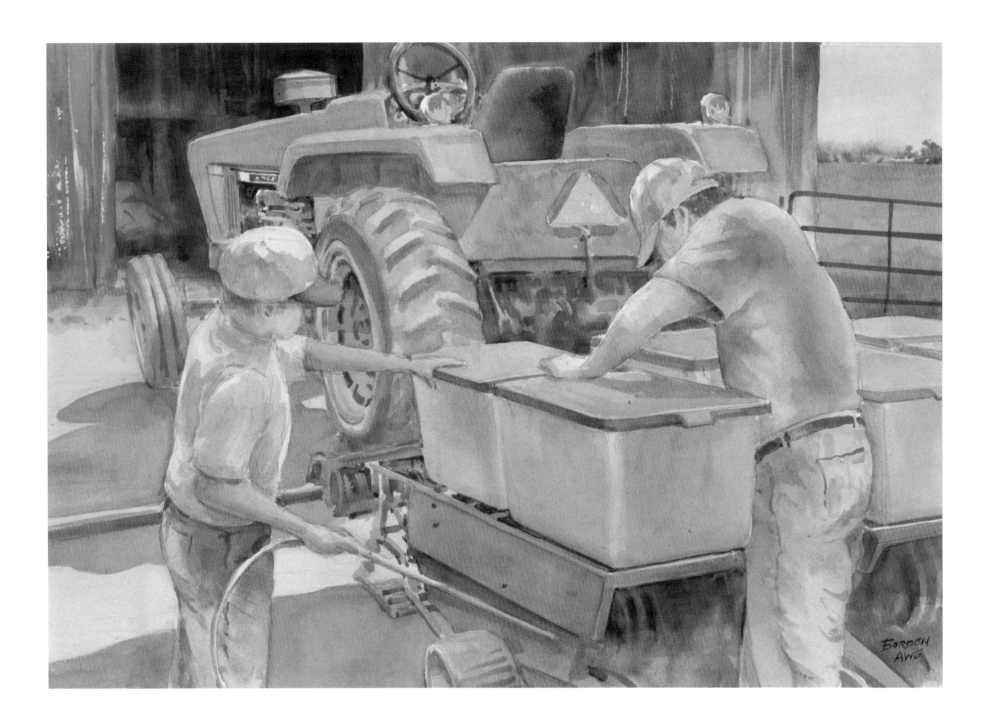

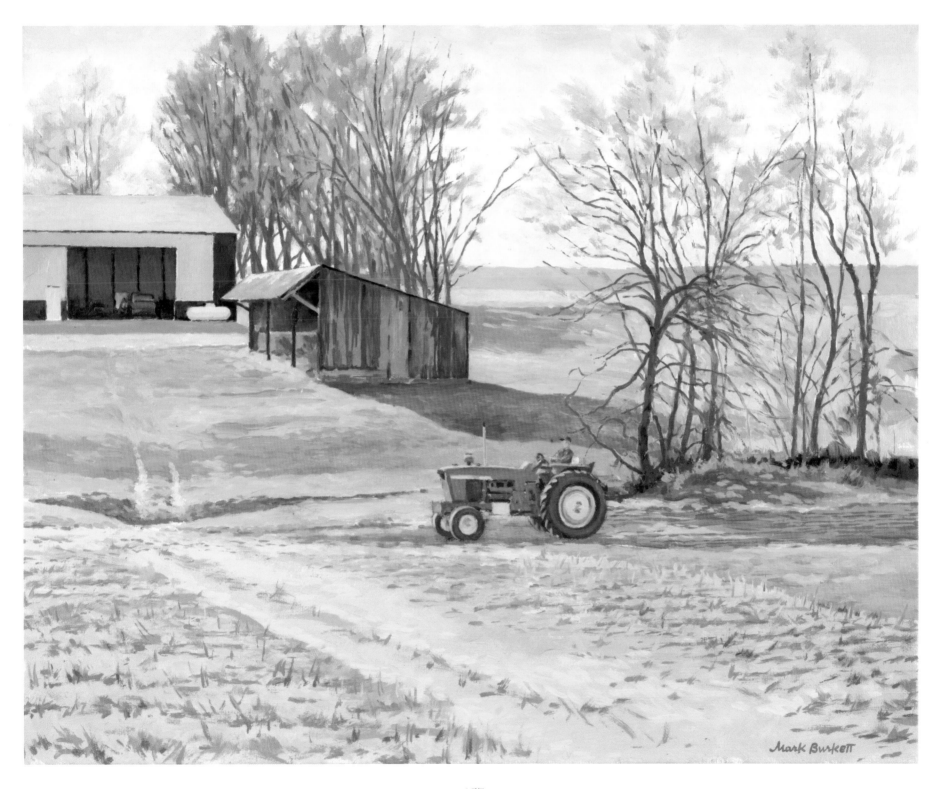

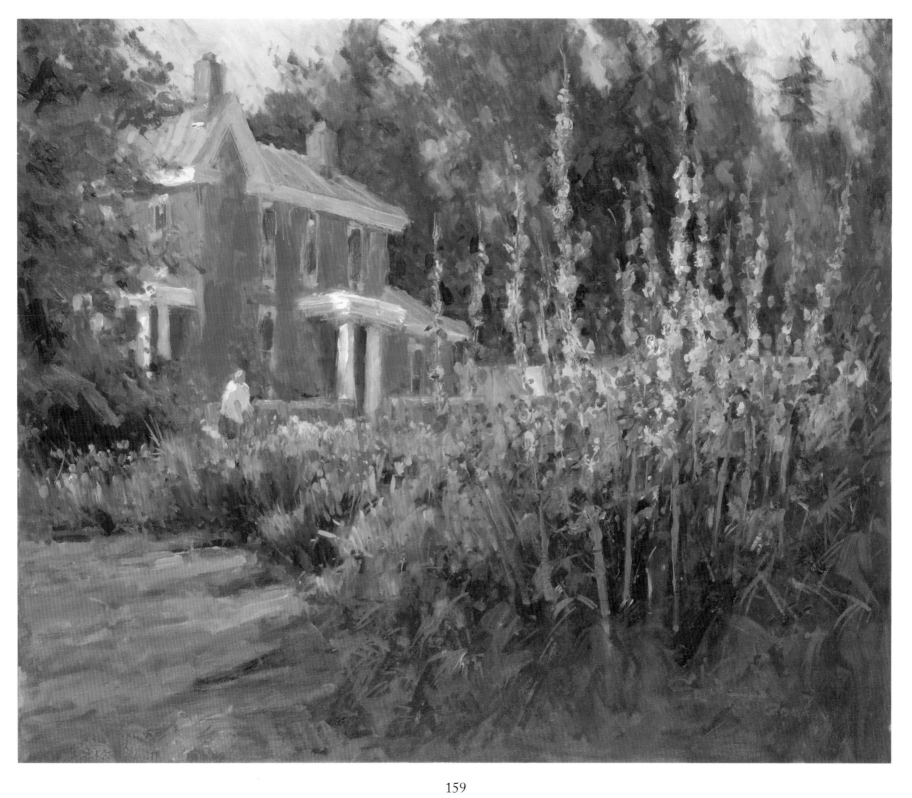

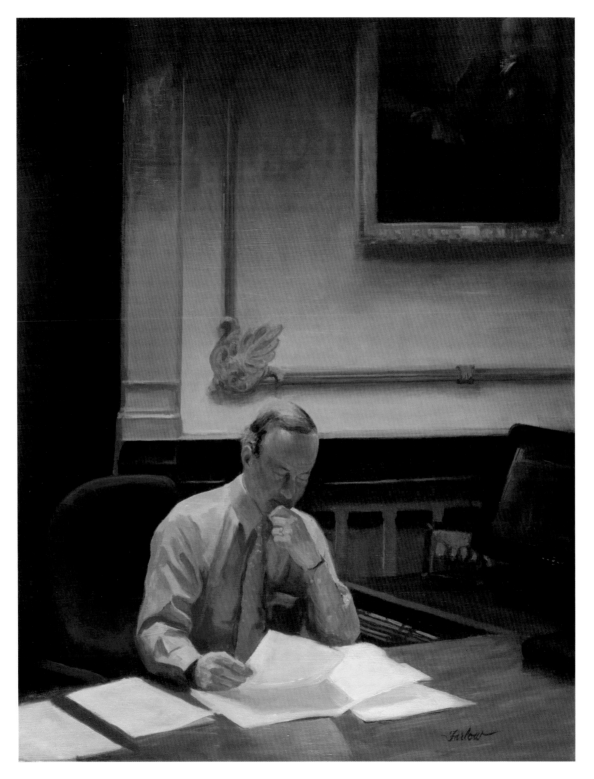

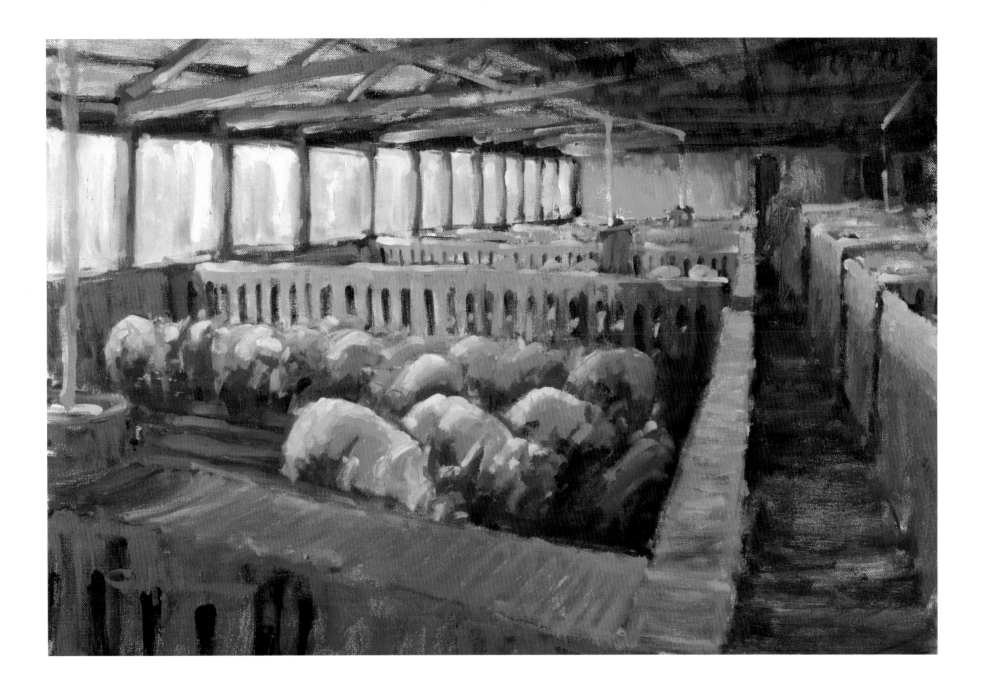

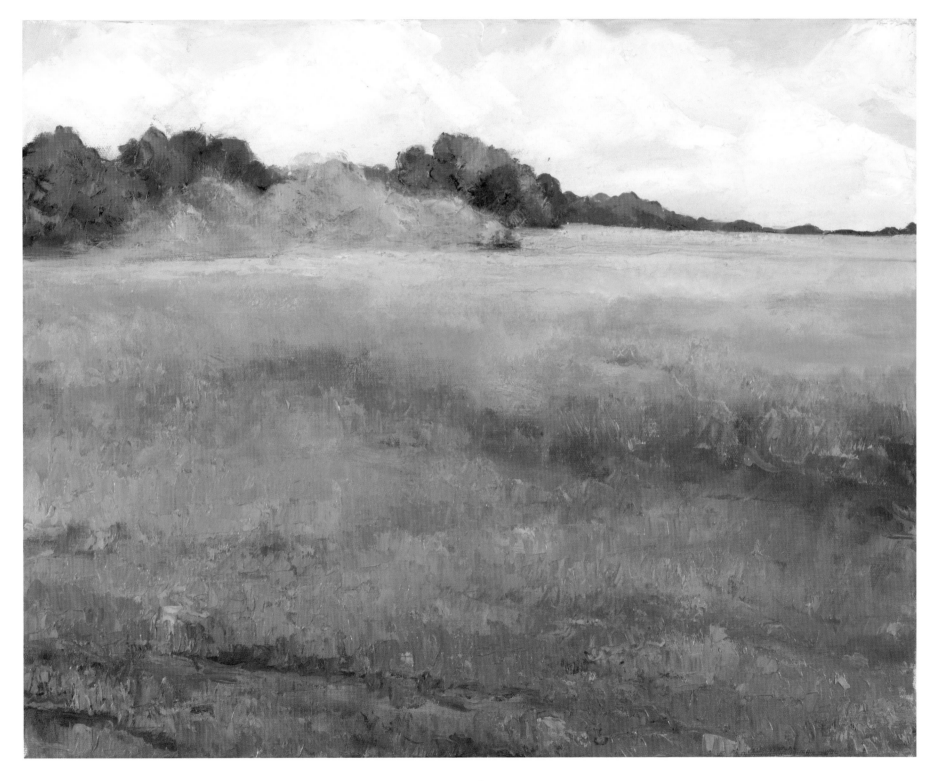

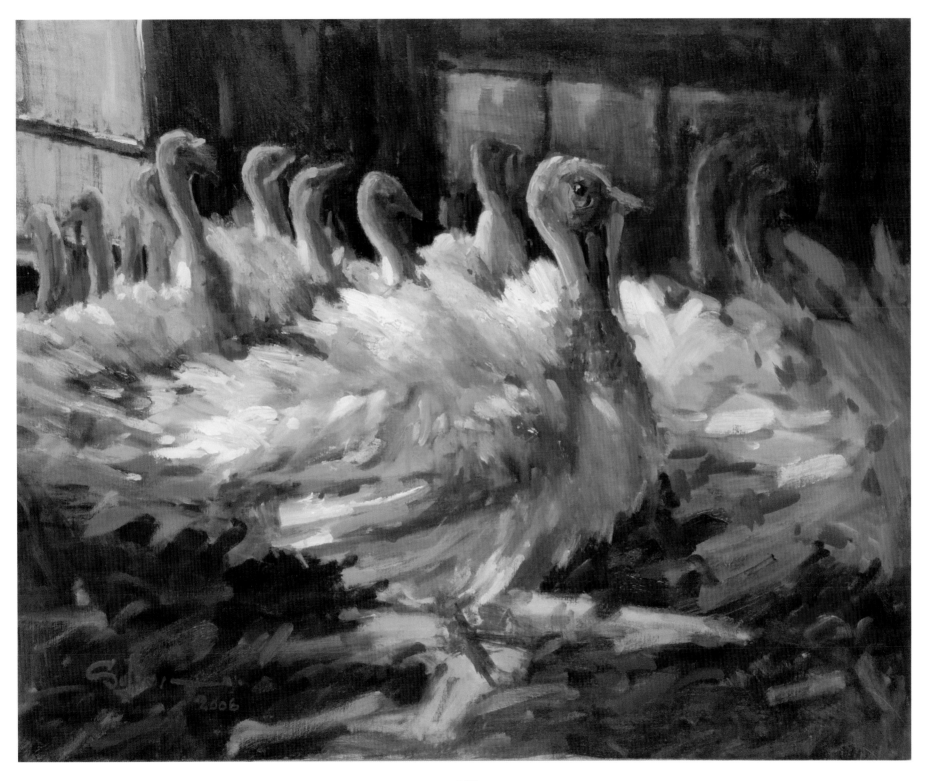

169

173

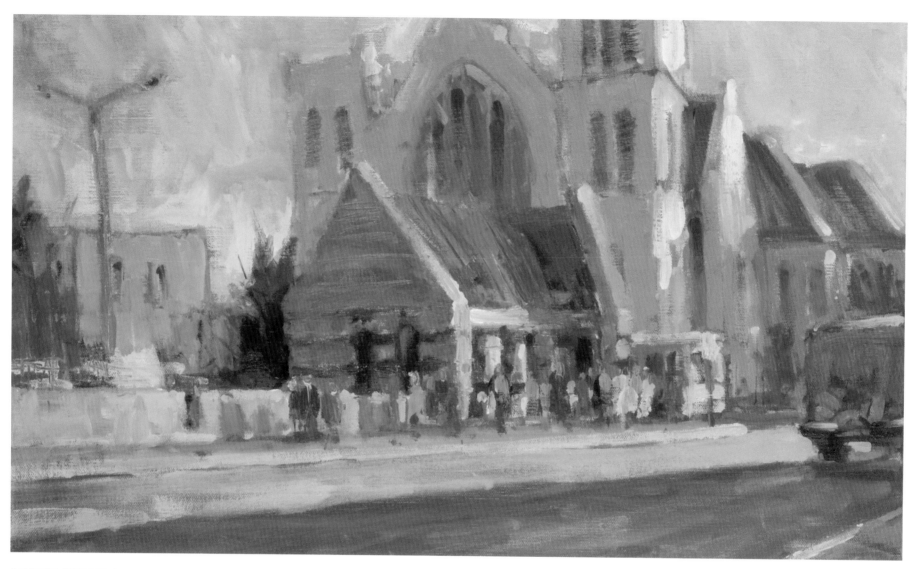

SCOTT SULLIVAN
Bus Stop, Bloomington
Oil on linen 12 × 24 inches

JEFF KLINKER
Greenhouse at Dow AgroSciences, Zionsville
Oil on canvas 16 × 20 inches

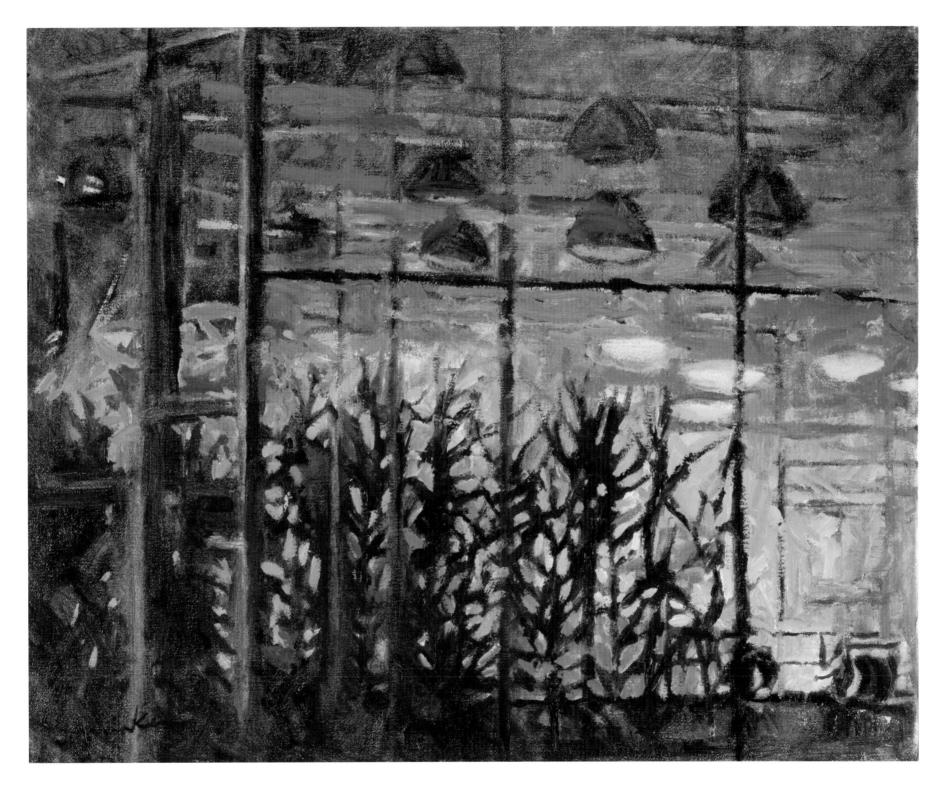

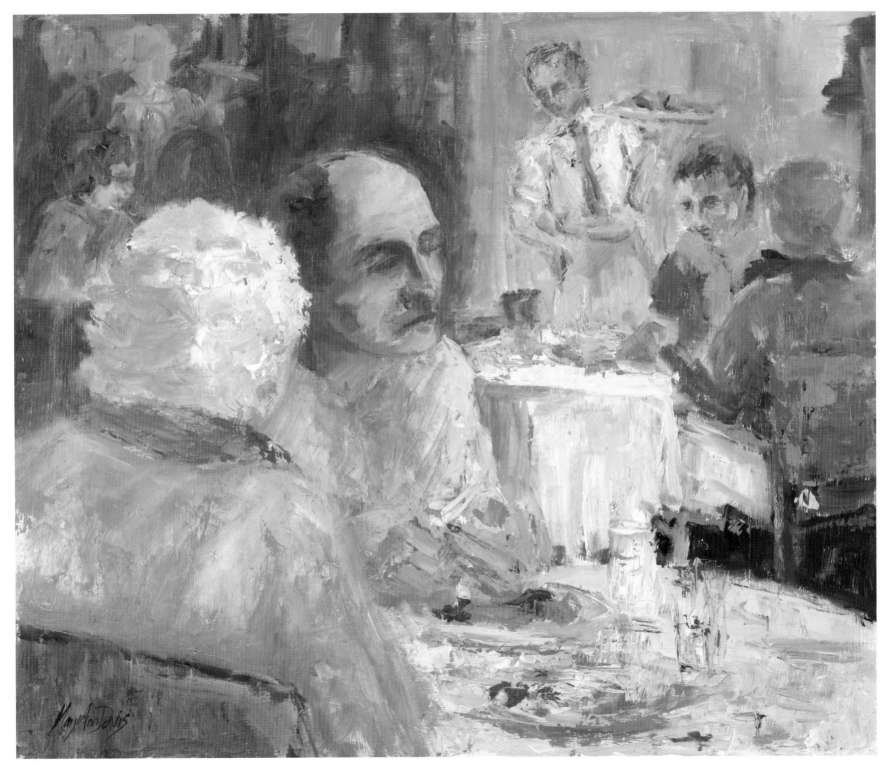

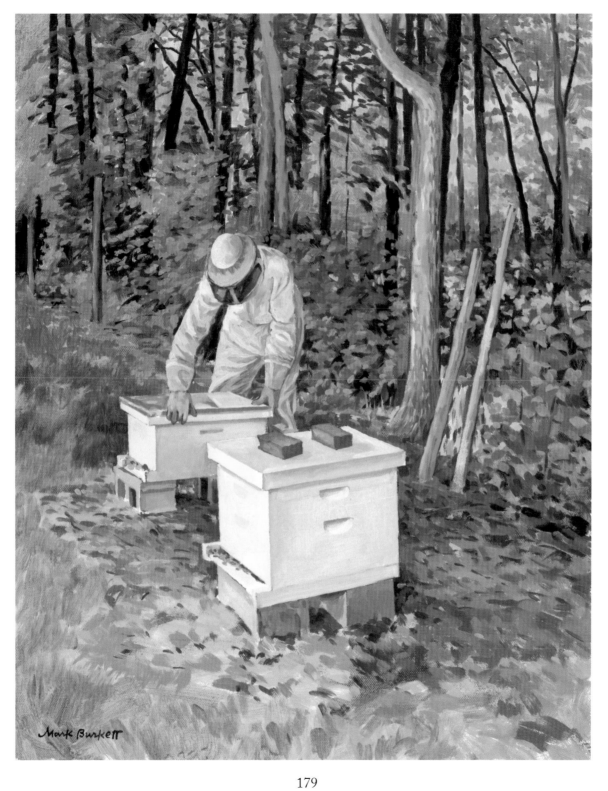

Bill Borden

Transparent Watercolorist

Watercolor painting is considered by many artists to be the most difficult of mediums. Unlike oils or pastels, watercolors do not allow for much reworking of existing painting, so the artist must either begin with a strong composition or be able to "go with the flow" of the work's first layers. Ironically, acceptance of watercolor paintings as viable investments has never equaled that of oil paintings. Respect for the medium by collectors has yet to meet the level of admiration shown to watercolorists by fellow artists.

Borden's pathway to his present career involved years of putting fine art on the back burner. Born in Indianapolis and a graduate of Manual High School, Bill Borden pursued art at an early age and never gave it up. He attended the Cleveland Institute of Art, where he majored in industrial design. He landed a job with the Ford Motor Company in Dearborn, Michigan, where he worked for thirty years in the field of automobile design.

"I did a lot of (fine art) painting as therapy for my day job," Borden laughs. "I consider myself a Hoosier and wanted to come back. Indianapolis was too close to being like Detroit. I told my wife (Sharon) that when I retired I wanted to live in a place where I could walk out the door and start to paint."

When Bill retired eight years ago, he and Sha-

ron found a place in Hanover, Indiana, overlooking the Ohio River, where he could live his dream. The Bordens' home is located near the historic preservation mecca of Madison, Indiana, where possible painting subjects range from historical buildings to floral still lifes and atmospheric landscapes. From his converted basement studio, the artist can paint indoors or out, depending on the weather. When working on location, says Borden, "I paint 85 to 90 percent outside, then bring the pieces back and look at them. I always find something that can be made better.

"I felt from Day One that Madison is where I should have always been," he adds. "I paint as much as I can, which isn't as much as I want to. The number of grandchildren keeps growing. Some weeks I paint all week, and other weeks I can't get to it at all."

Due to his medium, Borden's technique seems more premeditated than that of many of his plein air colleagues. "I can't really go over (my work) if something is very wrong. That's why I do a careful value study beforehand," he says, indicating a drawing book filled with miniature compositions. "I do a value study in the same proportions as the watercolor paper and then transfer the sketch onto the watercolor paper."

A participating member of the Indiana Plein

Air Painters Association (IPAPA) from its formation, Bill Borden initially served on the board. "The IPAPA experience is just fantastic," he declares. "There was nothing like that in Michigan." When he learned of the *Painting Indiana II: The Changing Face of Agriculture* project, he wanted to be a part of it and submitted his work for consideration.

"The first project (*Painting Indiana: Portraits of Indiana's 92 Counties*) was so successful, and everybody thought they wanted to be part of a project like that. I wanted to be, and it's been great," he says. "I think we've had a real camaraderie among all the people involved. There have been some problems, but there always are. People say, 'I wish we'd known that when we started,' but it's like anything else you do. It would always be nice to begin with the knowledge that you have when you finish."

"It has taken quite a commitment. I have a certain number of things I need to get done. Some of them I feel real good about doing, and others, I'm wondering, 'How in the world am I going to make that work?'

"It's important to do a good job," continues Borden. "You keep thinking, 'Well, gee, it's going to be in a book! Everybody's going to be looking at it and asking what was he thinking when he did that?' You want it to be a useful tool for the agricultural people and also be a decent painting.

"We're grateful to the first group for all the effort they put into *Painting Indiana: Portraits of Indiana's 92 Counties,* and we're trying to build on what they've done and take it to the next level. We're adding an educational component to this project. I think it's a tremendous opportunity for all of us, and I think it's very worthwhile."

181

Mark Burkett

Rigorous Oil Painter

A careful and analytical artist, Mark Burkett creates work that is easily identifiable in an exhibit or gallery. Using oil paint thinned to smoothness and applied with subtle brush strokes, he creates landscapes that stand out for their accurate perspective and detailed compositions.

Admired by many, his works are in such public collections as the Rose Hulman Institute of Technology and the Sheldon Swope Art Museum in Terre Haute. Burkett's artwork also has been included in annual juried exhibits of the Hoosier Salon, Wabash Valley Annual, and Indiana Heritage Arts. A member of the Brown County Art Guild and the Indiana Artists' Club, he won the "Masterpiece in a Day" competitions in 1998 and 2001 in Indianapolis.

"For years I used acrylics and did not do plein air painting," comments Burkett. "Mostly what I did was paint with acrylics and copy photographs. And I did some commercial illustration as well. Acrylics were what I started to paint with in college, and I kept using them. When I did commercial illustration, I used them because they were more versatile. I was more focused on the precise reproduction of a photograph—almost like photo-realism.

"But in the last five years or so, as

I've gotten involved in plein air painting by being a member of the Indiana Plein Air Painters Association (IPAPA) and enjoying plein air painting more and more, I no longer like to use photographs. I will use them as a last resort, but the pleasure I get from painting is responding to what's in front of me. That's one reason I switched from acrylics to oil, because you don't have to fight the paint drying out too quickly. I think my technique's getting a little broader as a result of plein air painting, but I'm still a pretty tight painter."

Burkett grew up the oldest of three children and went to high school in the small farming community of Monrovia, Indiana. "I was always drawing," he recalls. "I don't ever remember not drawing, and I think that's how my brother and I were encouraged to entertain ourselves. We were both allowed to take (private) art lessons when we were 8 or 9 years old. My mother really encouraged us. There was a woman in Bridgeport, Indiana, named Gracie Senter. She would give art lessons to adults, but she would give lessons to children on Saturday mornings. It seemed like there would be a dozen kids in this enclosed back porch, and we'd be there for a couple of hours. She always started us out in pastels and you'd do pastels for a year

or so. I was allowed to move to oil paints when I was 10 years old. Just to be encouraged to do that at that age, I think, was real important. Gracie Senter died when she was 39 years old, but I think she influenced a lot of people."

Burkett attended Indiana State University in Terre Haute and simultaneously worked at the Sheldon Swope Museum of Fine Art as a student assistant. "I probably learned more about art working there than taking classes at the university," he declares. He majored in printmaking, graduating in 1977. "There was an instructor, David Erickson, who was head of the printmaking department. I took one of his figure drawing classes, and he encouraged me to get into printmaking." The printmaking majors were a small group, however, and when Mark graduated, the lack of available art printing presses pointed his career in other directions.

After an unsuccessful business venture in Jackson, Wyoming, Burkett worked at landscaping and got into commercial illustration, including architectural illustration. "I got some awareness and practice in rendering perspective, which probably has helped me since then," he recalls. "I always tried to paint easel paintings also, and periodically I'd sell a painting. I didn't belong to any organizations and didn't know how to market myself. The illustration work was really long hours, and I was stuck doing things the way they wanted it. It got to be not very pleasant and also took so much of my time and energy that I didn't do my other painting. So I finally got brave and quit doing that (illustration work), and decided to concentrate more on doing fine art (early 1990s).

"Little by little, as I got to be more involved in art organizations through my association with Jeanne (McLeish, a fellow artist who is now his wife), we started hearing about IPAPA. I did a T. C. Steele paint-out (the annual Great Outdoor Art Contest) about eleven years ago, and that was the first I'd ever done—and it was fun. After that, I got more and more involved in plein air painting.

"I saw the first exhibit associated with the *Painting Indiana: Portraits of Indiana's 92 Counties* project, and I knew some of the painters involved with that," he continues. "When this project was floated, people talked to me about it, and I decided it was something I wanted to get involved in. I thought it would force me to paint more, which it has done. I think it's been a good opportunity. It's given me a chance to meet some people and see some things that I wouldn't have done otherwise. It's given me a chance to be more visible, so it's been positive, and I look forward to seeing what's going to happen when the exhibit comes together. I think it's just going to get better and better.

"I think as part of this group we are trying to communicate to people what's going on in Indiana agriculture—maybe show some aspect that they hadn't thought about or didn't know existed. If we do that, it's a good thing. We want to make paintings that are interesting, and we want to make paintings that people will look at. I think we're all serious about trying to create art. If I can share my response to something through painting, I would consider that my objective."

Mary Ann Davis

Plein Air Enthusiast

Mary Ann Davis is driven to paint. "If I do a bad painting, it affects my whole outlook on life until I'm able to get back to the easel and paint something decent," she reveals. Her growing proficiency with oils and pastels, however, has all but eliminated disappointing results.

Balancing her duties as president of the Indiana Plein Air Painters Association (IPAPA), vice-president of The Portfolio (an arts-related social club), and owner/designer of Davis Graphic Design, she makes time to paint or sketch something nearly every day. Twice each week, she goes to Herron School of Art to practice drawing a live model, and weekends invariably find her driving to a rural area to capture seasonal landscapes.

"The figure studies keep up my drawing skills and are a good way to study light and color in a controlled environment," she says. "But I don't do sketches as much as I should before painting. I look through a camera viewfinder or sometimes through a small square to figure out my composition. Paintings come out better when you figure them out. When I'm painting with someone and I explain what I'm going to do, it's the same as organizing it on paper. That's what painting is—organizing."

A native of Indianapolis, Davis attended Arlington High School. "Art has always been a part of my life. My mom was an art major in college, so art was available. She'd let us get messy. I have four brothers and a sister. One brother was pretty good, but not passionate about it (art). He was more into cars," Davis laughs.

The exposure to auto mechanics later facilitated a chance meeting. "I used to change people's oil to make money in art school," she discloses. "With all those brothers, I knew how to work on cars. One day I saw this guy's legs sticking out from under a car and asked if he needed help." The guy, Charlie, eventually became her husband.

Davis earned her bachelor of fine arts from Herron School of Art in 1976, but her major was lithography, and she did not take any painting courses. The choice to major in lithography turned out to be a practical option when Davis pursued a career in graphic design. "It started me in the old-fashioned way of offset printing," she explains. "When I began my career with printing companies, I understood the technical side. In college, my first job in a printing company was as a floater—I did all kinds of jobs, including darkroom, typesetting, and bindery work. I loved it because there were so many different solutions and ways you could do things. I don't like it when there is only one way to do things."

During the 1980s, graphic design professionals experienced revolutionary changes with advances in computer programs. At the time working for Meridian Insurance, Davis was able to keep up with the rapid changes because the company used computers for much of their business. But when Meridian downsized in the early 1990s, her job was eliminated.

In 1991, Davis took a leap of faith and started Davis Graphic Design. "I had always wanted to have my own business, and leaving Meridian Insurance gave me the opportunity to do that. At all the jobs I applied for, (the interviewers) said I was overqualified," she recalls. Her auspicious timing led to the winning bid to repaint new logos on all 2,000 trucks belonging to Indiana Bell, which had been purchased by Ameritech.

"When I first started my business, I was working 100-hour weeks, and I did not do any art," Davis remembers. "It's only been in the last four or five years that I have had time to do art. I figured if I could start a business in graphic design and make a success of it, I would be able to do that with my art."

As her desire to paint became more focused, Davis had the opportunity to study with Antonius Raemaekers, a Dutch painter related to her husband, Charlie. "He lived in Martinsville when Home Lawn was there and made his living painting from the clientele there. We moved to Martinsville and worked on a farm, and I told him that I wanted to study art with him. He told me to go buy a sketchbook, so I did. He said, 'When that's full, come back.' So I did 100 drawings before he finally let me paint," Davis smiles. "His purpose was to teach me to observe."

The rigorous training combined with an insatiable appetite for creating art has paid off for Davis with many awards and sales of her work. Her pastel and oil landscapes have won first place at the T.C. Steele State Historic Site's 2004 Great Outdoor Art Contest, first place in the 2003 Will Vawter Art Competition, and second place in the 2003 Southside Art League Member Show, among other awards. Included in numerous juried shows, including the 2001 Hoosier Salon, 2004 Indiana Heritage Arts, and 2003 Oil Painters of America, Regional Exhibition, her work was also hung in the invitational exhibition of Indiana women artists at the Indiana State Museum in 2005.

A good match for the *Painting Indiana II: The Changing Face of Agriculture* project with her farming background and passion for painting, Mary Ann Davis is one of the driving forces behind the logistics of the venture and camaraderie of the ten artists. She acknowledges, "The *Changing Face of Agriculture* concept is geared toward emerging artists—creative painters whose work is progressing and getting salable. One reason I wanted in the project was to paint with these guys whose work I respected and to learn from them. And while doing that I can see a lot of change in my work."

Lynn Dunbar

A Passion for Painting

"Painting is a passion, as I choose subjects that have meaning to me," says artist Lynn Dunbar. "Whether it is the rolling vistas of southern Indiana and Kentucky, the flowers I just picked from my garden, or a member of my family, I find inspiration in the connection I can feel with a painting. Ask me which is my favorite painting, and I will usually reply with, 'The last one I completed.'"

A resident of Louisville, Kentucky, Dunbar was born in Gary, Indiana, and raised in nearby Hobart with a sister and two brothers. "I always took art in school. Van Gogh, Norman Rockwell, and a high-school teacher were early inspirations," she says. "We took field trips to the Art Institute of Chicago." (One of Dunbar's monoprints won an art award in high school.) Later, she earned her bachelor's degree in visual design at Purdue University in Lafayette, where she worked for a few years designing books for the school's publications department.

For many years following her Purdue job, Dunbar worked as an advertising art director. She then enrolled at the University of Louisville to study for a master's degree in social work. "I thought I was going into art therapy," she remembers. "Then I took a class in oil painting and loved it!" She decided to pursue oil painting when she completed her degree.

Dunbar has been oil painting seriously for the past seven years and is well known in her area. Her work has been included in Kentucky Plein Air Painters' annual group shows; in "Language of the Land," an exhibit of contemporary landscapes that traveled throughout Ecuador and Kentucky; in the Water Tower 2004 Annual exhibit; and in the Indiana Heritage Arts and the Hoosier Salon annual juried exhibits. She has won numerous awards at the yearly T.C. Steele Great Outdoor Art Contest and is a member of Oil Painters of America.

"*Painting Indiana II: The Changing Face of Agriculture* is right for me," she declares. "I have maps in my car, and I go on the back roads and paint in Indiana all the time. When I saw the call for artists for this project, I just knew it was right for me. Although a native, I was concerned that I do not currently live in Indiana, even though I paint there. So I was really glad to be allowed to participate. I've learned a lot and enjoyed interviewing farmers for the project. The work was similar to my experience as an art director."

To research her landscape possibilities, Dunbar probably went to further extremes than the typical artist. She kayaked around the Ohio River looking for the best vantage point and even went up in an airplane to do aerial studies. "Bob Farlow (another

artist in the project) invented a special box that has a palette and room for paints and small paintings," she said. "I want to take it out in my kayak." After examining scenes from air and water, she concluded that the best views were from land.

"I have a busy schedule with two children at home, but I have to paint," says Dunbar. "I don't feel good unless I paint at least three times a week. I love it! It's me. I do other things, but that's the essence of me.

"Painting has been therapeutic for me in dealing with the loss of my son to childhood cancer," she adds. "I donate a portion of my proceeds from the sale of each painting to Childhood Cancer Research."

A self-described "eternal student," Dunbar continues her art studies through painting workshops. "Today my favorite painters are William Wendt, Nicholai Timkov, and Sergei Bongart," she says. Over the years, she studied with Wolf Kahn in Vermont (2001) and Skip Whitcomb in Colorado. "I was lucky to get accepted as a resident artist at The Vermont Studio Center," adds Dunbar. "Almost every waking moment was spent painting. They had a figure class in the mornings, and I went out and painted plein air at lunchtime. In the afternoon, I would take a bike ride and hike, looking for places to paint, and then in the evening I'd paint in the studio."

Dunbar has absorbed a few individual techniques that work well for her.

Like several plein air artists, she often paints on location to get the composition, atmosphere, lighting, and color, and then takes photos to finish the work in the studio. She often primes the canvas, using an underpainting of red. Occasionally, she favors using an extremely horizontal support, creating a panoramic effect.

Although Dunbar does some portraits and still lifes, she says, "I'm inspired by the landscape, and I want to be outside. I enjoy hiking, biking, and the natural beauty of the landscape. Painting allows me to interpret the beauty of nature. I enjoy painting on location with the sun on my back and the wind in my hair. My patrons often tell me that my paintings remind them of a place in their childhood."

"I want to record the landscape for posterity," she continues. "When I die, my paintings will live on. And I hope that my children can enjoy them. I want to record beauty. My (adult) daughter says to me, 'Why do you always paint pretty scenes?' I'd rather have the beautiful positive energy from a lovely painting than something negative. Even if I have anxiety or anger in me, I don't want to look at that on the wall."

Lynn Dunbar's upbeat philosophy is reflected in her joyful contributions to *Painting Indiana II: The Changing Face of Agriculture*. Her passion for painting ensures fresh and appealing landscape paintings in abundance for the future.

Bob Farlow

Painter and Sculptor

Dr. C. Robert (Bob) Farlow has been creating art professionally for half a century, and his wisdom and views on the subject are prudently considered. A recognized painter and sculptor, he has won accolades too numerous to list. But recent honors include Best of Show at the Richmond Art Show; the Indiana Heritage Bronze Medal of Honor; Best of Show Award at the Hoosier Salon/Indiana High School Athletic Association exhibit in 2003; and Best of Show at the Art Association of Randolph County in 2004 and 2005. His artwork is included in private and corporate collections in Germany, Romania, Japan, England, Canada, and Grand Cayman.

Discussing *Painting Indiana II: The Changing Face of Agriculture,* Farlow is not averse to expressing his opinions. Disconcerted that many of the subjects for the project's paintings became "more like commissioned pieces," he has worked diligently to fulfill his obligations while creating some subjects on the side to communicate his views.

"I had a different tack on things," he says, adding, "I somehow find myself thinking differently than other people. One of the pictures I did was a take-off on Grant Wood. I did one painting of a lady (his wife, Judy) ironing, and it was rejected by the project.

When you're talking about the changing face of agriculture, you're talking about the domestic side too. The wives were not just tucked away someplace. They were very much a part of it. When I did this (painting), I was saying there is a domestic side, even if it's nothing more than encouragement to the husband. If he doesn't have that kind of encouragement from the house, then he's got trouble. And that's changing, but it's still there."

Perhaps coincidentally, Grant Wood played a major part in Farlow's background. "I had a great opportunity," he recalls. "I taught school at Elkhart (Indiana) with a gentleman who was a studio boy for Grant Wood. Grant Wood took him under his wing and half raised him because his father had died. So he picked up all of his concepts of design. And I had the opportunity to spend time with him. So that's where many of my concepts about art come from."

Farlow grew up on a farm in Decatur County with two older brothers and various younger siblings who were adopted for periods of time. "My dad had about 300 acres, and back then you did everything," he comments. "You had hogs, you had cattle, and it was general farming. Soybeans really hadn't come on the market yet. I remember when they first came on,

188

they were used for hay. You mowed it and put it up in the hay mow. (People) really didn't realize it was a grain crop.

"We were still farming with horses," he continues. "I remember when Dad bought our John Deere tractor in 1936. I wasn't quite 3 years old, but I remember quite clearly. Then he got an Allis Chalmers Combine in 1937, and that broke up the threshing ring. I watched the changing face of agriculture for a long time," he chuckles.

Commenting on his artistic past, Farlow says, "When a kid, I drew all the time. My teachers were always telling me to put my stuff away. Drawing was far more interesting than reading. My mom was encouraging—she loved art. There was no discouragement from my dad, but he was very practical. You had to have a job that paid and be a productive person."

Farlow transformed his father's pragmatism into a bachelor's degree in art from Anderson University, two masters degrees from Ball State University in art and psychology, and eventually a doctoral degree in education from Ball State. He began teaching in the public school system and ended up in Winchester, Indiana, where he met his future wife, Judy. After serving two years in the service, he returned and married her. They purchased land in Winchester where they raised their two daughters after a one-year stint as missionaries for the Church of God in the Grand Cayman Islands and four years teaching in Elkhart.

Farlow stopped teaching in 1988. He became the founder and designer for Briercroft, Inc. for the next seventeen years, designing all of their displays and figurines, which were marketed throughout the United States and abroad. For several summers, he worked with German sculptor Georg Keilhofer in Frankenmuth, Michigan, eventually returning to oil painting in the mid 1990s.

"My first love has always been painting," he declares. "I decided I wanted to get back to it, so we closed the figurine business and I started painting. To get back into the swing, I took several workshops with different artists, including Mark Daily, Michael Carter, Tom Browning, and Ralph Oberg."

Although he'd always been a studio painter, Farlow initially got involved with the Indiana Plein Air Painters Association (IPAPA) for the camaraderie and interaction. "When I was teaching school, there were no artists around," he says. "I was completely by myself. I found myself really needing to get acquainted (with other artists) and that's why I got involved. I had not been a plein air painter so I felt this was something I needed to explore."

Jeff Klinker

Capturing the Essence

Jeffrey Joseph Klinker, a lifelong artist, only discovered painting on location seven years ago. "My first experience painting outdoors was in 1998, at the T.C. Steele State Historic Site (as part of the annual Great Outdoor Art Contest). I ended up getting a merit award," he remembers. "A few guys saw me and asked how long I had been doing this. They said I needed to get involved with the Hoosier Salon. So I did. I got best piece for first-time exhibitor (2001) and it was like a shot in the arm. Just like when I was a kid in kindergarten.

"I got involved with the Indiana Plein Air Painters Association (IPAPA) in the late 1990s," Klinker continues. "I was approached to submit slides of my work for this (*Painting Indiana II: The Changing Face of Agriculture*). . . . I knew agriculture and also knew painting. . . . So I got involved. I think it's going to be a wonderful project. All the artists are putting their hearts into it. These 'paint outs' have a lot of camaraderie. . . . Art is a journey, and this project is a part of my journey."

The journey has been a long and varied one for Jeff (known as "Klinker" to his artist friends). Born in Lafayette, Indiana, into a family who farmed in the Linden area, Klinker first displayed artistic talent while in kindergarten in Montgomery County. "My kindergarten teacher called my

mother, and she said, 'Mrs. Klinker, you need to come in to school right away and see what your son has just drawn,'" Klinker laughs. "I did a life-sized drawing of this cowboy—I still love western stuff—and it had his wrinkles, his rhinestones, and his holsters."

He continued to astonish his elementary school teachers with his artistic abilities, and they showered praise on the youngster for his work, particularly his portraits. "So I always had the desire to do this," he says. "Because when somebody says it's good and they like it, it encourages you. So I knew I had a gift—and I consider it a gift."

Despite family expectations to spend most of his time working on the farm, Klinker discovered oil painting while in high school. One of his teachers, Steve Swagerle, recognized Klinker's talent and arranged to teach him during study-time periods. "He showed me how to oil paint," Klinker said. "He helped me work through some things like going from thin to thick and dark to light."

The budding artist's college career at Purdue University was cut short when his father began having health problems in 1978. Klinker dropped out of school to raise hogs and row crops with his brother and dad. He

190

recalls, "I was 20 years old and still in love with my high school sweetheart, so I decided maybe I was supposed to get married and settle down to a life on the farm."

After a little more than a year, though, Klinker sold out his part of the farming business, and took his wife (Betty) with him to pursue his dream of attending Herron School of Art in Indianapolis. But the elusive art career was still not to be. Enrollment for the full course at Herron occurred only in the fall, so Klinker decided to get a job while waiting. "A food store was advertising for five stockers and received 3,000 applications," he explains. "When they saw my application that said I was a farm kid all my life, they hired me. They figured I was a hard worker."

From stock boy, Klinker quickly rose to a position of managing his own store (ALDI stores) and working sixty-five to seventy hours each week. With the arrival of the couple's first child, Klinker's dreams of art school dimmed. After several moves to open and manage new stores in Illinois for the company, Klinker gave up the grocery business and returned to Montgomery County.

The Klinker family expanded to include three babies, and although Jeff was always employed, his jobs changed periodically. He worked in a confinement hog operation, became a regional salesman for a feed company, then stocked groceries at a Marsh grocery store, and later worked twelve-hour shifts at a corn processing plant (Staley's). "When you have kids to feed, you'd do anything," he says. Eventually, he took some welding classes at Ivy Tech to qualify for a maintenance job at Staley's.

Klinker moved to Lafayette after he and his wife divorced. He landed a job as Master welder for the Eli Lilly laboratory in Tippecanoe County, where he is still employed. Throughout his ups and downs, Klinker managed to continue painting, with studio spaces in spare bedrooms. "It was one of those dreams I didn't want to get rid of," he says.

His successes have been numerous. A regular participant in most of the regional annual juried exhibits and major outdoor art contests, he has won numerous honors, including Best of Show awards at the 2001 First Brush of Spring in New Harmony and the 2002 Postcards from the Rising Sun, as well as the Dale Bessire Memorial Award from the 2003 Indiana Heritage Arts Annual and first place in the oil-painting division of the 2003 First Brush of Spring. His artwork has been purchased by private collectors throughout the state as well as by Ivy Tech State College in Lafayette.

About plein air painting, Klinker says, "When I paint outdoors, I try to capture the essence of being there. Not so much the representation of what it is, but the feeling of being there."

Ron Mack

Freezing a Moment in History

Of the ten artists selected for *Painting Indiana II: The Changing Face of Agriculture*, Ronald (Ron) Mack is the only one who has direct prior experience with a major Indiana Plein Air Painters Association project. A veteran of the highly successful *Painting Indiana: Portraits of Indiana's 92 Counties* exhibit, book, and sale in 2000, Mack is a proven artist whose credentials are numerous.

Well known in his home state of Indiana, Mack has received awards and purchase prizes from the Hoosier Salon and Indiana Heritage Arts annual competitions; won Best of Show at the Indiana State Fair; and is represented in the Brown County Art Guild and the TOP Gallery in Bloomington, among other places. He has been a popular painting teacher at the Southside Art League in Greenwood for several years.

"Painting is my life," Mack declares. "I've had students that are just beginning, and once they get started, it's a lifelong desire. If your work is accepted by other people, that's a big boost, too."

Mack grew up with one brother in Indianapolis and attended Southport High School. After serving in the U.S. Army for a couple of years, he got a job doing architectural drafting in the engineering division of Eli Lilly and Company, where he worked for thirty-eight years.

Ronald P. Mack

Lilly also depended on Mack to implement other visual projects. "Whenever they had anything to do with art, they came to me. They'd say, 'Now, we need to have this by tomorrow morning, immediately.' What bothered me was when they had something really interesting to do, they'd send it to New York and say, 'We don't need this for a month,'" he laughs.

Mack became interested in honing his easel art skills around 1972 while still working full time. "(My wife) Dottie decided to go out and buy some things to hang on the walls. And she said, 'Why don't you get busy and paint something?' So that's when I really got started.

"I didn't know beans about it," he continues. "I'd seen people do paintings down in Brown County, so I loaded up my car with all this stuff and went to Brown County. I went to Ogle Lake in the state park. And I set up looking across the water to some pine trees on the other side. I put some green on the canvas and then I noticed the light. I was aware enough to notice the light color on all these shapes over there, so I painted light and dark and light and dark, one tree after another. In about two hours, I was looking at that and I thought, 'Where'd the light go?' And I realized that the sun was moving around and the light and

shadows were all changing. And I thought, 'There's something I don't know about this!' I chased the sun for about two hours, and packed up and came home. Dottie said, 'You need to take some lessons!'"

At that time, Myron Fincham was teaching at Beech Grove with fellow instructor Harold Buck, and Mack began taking lessons with Fincham. "Harold was a good artist," Ron says. "I loved his work because it was honest. He didn't fake anything. He basically put it down like he saw it and still made a beautiful painting out of it."

Mack concentrated on still-life paintings and applied a detailed technique in his early work. But years of workshops and countless paintings later, his skillful landscapes have become his trademark. Always experimenting, he recently changed to using only three basic tubes of oil paint colors to complete his paintings. "You can just about cover the whole color range with those three," he explains. "You have to realize your range. Everything relates to the colors, making it harmonious."

When Mack heard of the new project, *Painting Indiana II: The Changing Face of Agriculture,* he decided he'd like to participate. "I like goals," he says. "I'd much rather be doing this project than coming into the studio in the winter and looking through photographs to find something to paint. I loved the *Painting Indiana: Portraits of Indiana's 92 Counties* project."

One part of the project, the "360 degrees," called for all ten participating artists to position themselves in a circle, looking out on a field, and then paint only what was in their direct field of view. The artists drew straws to determine who would paint what view. "What is interesting is this 360-degree painting," says Mack. "What you'll see is how different artists perceive things. Some people just go off the chart with what they paint. They don't really paint what's there very much. We had to have the same horizon line and the same size canvas. Some people were unlucky because all they had was a line of trees and it was hard to make it interesting."

"What's exciting to me about painting is capturing what is there—to see if you can do that," he continues. Ronald Mack's paintings for *Painting Indiana II: The Changing Face of Agriculture,* including the "360," are all sensitive and strong. Now a veteran of two major art projects, Mack brought to each an indisputable discipline and a genuine devotion to his art.

Nancy Maxwell

Sharing a Moment

"I just try to create a little space where someone will stop and take a look for just a minute," Nancy (Barbara) Maxwell explains about her colorful oil paintings. "If for just a minute they feel something, see something, or go somewhere other than the 'here and now' before moving on, then I've accomplished my goal."

Maxwell, who taught art in the public school system, began devoting her full attention to fine art upon retirement. "I paint some every day, but not for long stretches, due to health limitations," she says. "I teach class one night each week in Martinsville and paint with a couple of friends every week, both inside and outside.

"One of the things that this project (*Painting Indiana II: The Changing Face of Agriculture*) has done is move me more toward a direction of finding subject matter anywhere," comments Maxwell. "The project has been good on lots of levels for me—pushing me to think about the message I'm trying to get across in the painting. It's causing me to stretch, doing figures and architecture. I wanted to try to paint to someone else's standards, and was ready for a project when this came along."

The endeavor is a good fit for an artist who continues to be immersed in farming through her husband's family tradition. "We have a midsized farm in Martinsville," she explains. "The Maxwells have been farming for hundreds of years. We farm a lot of acreage and do processing for other people.

"I love living out in the country. . . . I would have thought it almost too late for the midsized farm," she adds. "But this project has made me realize that there is a strong mid-level farm business in Indiana and people who are interested in seeing that continue.

"I'm a big supporter of the Heifer International project," comments Maxwell. "It is a worldwide nonprofit organization based on sustainable agriculture using the concept of teaching people how to fish instead of giving them the fish. After World War II, they started training people all over the world how to raise livestock. When families raise livestock, they are required to give some animals (and training) to other people—llamas some places, chickens the next. I just think farming is the only way the earth is going to survive. I know farms are getting bigger and more complex, but there is a movement in Indiana to encourage smaller, family-owned farms. I think that's what

Nancy B Maxwell

it's going to take to survive: family farming for a sustainable economy and for families to stay together."

Maxwell's mother, also an artist, was born on a farm near Evansville, Indiana, and her family moved to Martinsville in her youth. "My mom painted with Antonius Raemaekers," she remembers. "When I was little, she would let me go along, but I was not allowed to say a word. So I'd just sit there and watch." When older, Maxwell took her first art instruction from Mr. Raemaekers.

Maxwell is one of five children, all of whom have remained Hoosiers in their adult lives. She graduated from Martinsville High School and attended Indiana University in Bloomington. After receiving her bachelor's degree in fine arts in 1977, she married her husband, Chris, and began a public-school teaching career that lasted almost seventeen years.

"I did a lot of textile work in college," recalls Maxwell. "We were doing photo silk-screening when it was a cutting-edge technique." She earned her master's degree in art education in 1984.

Four years later, Maxwell was the recipient of an Eli Lilly Creative Fellowship Grant to study design and textile work in Japan. "I always loved textiles," she declares. "My grandmother was a quilter and started me designing with fabric and color at a very early age. I have always been very interested in oriental design."

Although Maxwell has been participating in the T. C. Steele State Historic Site's Great Outdoor Art Contest since its inception in 1988, time for pursuing fine art has been elusive. "A long time ago, I knew I was going to be a painter," she states. "But you get side-tracked. When you're teaching public-school art, you don't get to do your own artwork. I thought about painting. But it's only in the last ten years that I really started looking at it seriously." Maxwell adds that she finds support in her family, saying, "My husband and children, Rachel and Adam, have always been my strongest advocates and critique all of my work."

Maxwell's studies with artists Ron Mack, Nancy Cupka, and Ned Mueller have strengthened her painting skills to a level that has resulted in inclusion in such exhibits and galleries as the Southside Art League Regional Show (Indianapolis), New Harmony Hoosier Salon Gallery, TOP Gallery (Bloomington), the Indiana State Fair, and the annual Morgan County Fall Foliage Art Show.

Currently, Maxwell owns and operates the art gallery ArtWorks of Martinsville. She's a board member of the Indiana Plein Air Painters Association and stays active with the Hoosier Salon Patron's Association, Indiana Heritage Arts, the Southside Art League in Indianapolis, and the Morgan County Artist Colony.

Nancy Maxwell's involvement in *Painting Indiana II: The Changing Face of Agriculture* has given her work new energy and direction. Her passions for family farming and for capturing moments on canvas unite in this dedicated advocate of both.

Carol Strock-Wasson

Rural Midwestern Pastel Painting

Pastel paintings by Carol Strock-Wasson stand out for their distinctive style and aesthetic quality. Her layered textures and integrated colors create a harmonious visual effect while revealing the artist's application of the medium. The successful results stem from years of seeing her surroundings through an artist's eye, experience with the medium, and a passion for her subjects.

A native of Union City, Indiana, Carol Strock and her siblings (one brother and one sister) were encouraged by their mother, a painter herself, to be artistic. Carol studied art in high school, using every medium available, including woodcuts, drawing, watercolor, and oils. She enrolled in some art classes at Vincennes University but majored in chemical engineering.

Carol's career plans were interrupted when she became ill with Type 1 diabetes. At the time of her diagnosis, the relatively primitive treatment for this condition mandated that her life become highly regulated, with meals, exercise, and medications the focus of her days. "After I was diagnosed, I felt like my life kind of slid down hill," she laughs.

Carol returned to Union City and enrolled in art classes at Ball State before marrying Dan Wasson, owner of Wasson Nursery. The thriving landscaping and plant business, with its five large greenhouses,

dominates the south entrance to her hometown. Carol works for the family business, managing the perennials, in addition to pursuing her fine art. Many of her horticultural paintings are displayed in the offices, and her detailed knowledge of flowers and plants no doubt adds to the accuracy of the art.

"I got into pastels when my kids were little," she says, "because you always have to go back and forth, taking the children to different events. It's hard to put down your oils, get cleaned up, clean your brushes, and leave. With pastels, you can just put them down and go do what you've got to do. And when you come back, it's all there. You don't have to worry about drying paint or wet paint or any of that." Her two sons are now grown.

Strock-Wasson began entering local art exhibits about twenty years ago. "I've always had my own special space to do art," she says. "A spare bedroom upstairs, then down in the basement, and now I'm in a reconstructed garage." As her paintings became increasingly acclaimed, she augmented her training with workshops from William Schultz, Master Pastelist with the Pastel Society of America. She later participated in workshops with Albert Handell, David Dale, and Nancy Foureman, and tries to attend two workshops each year.

Carol Strock-Wasson's diligence has paid

off. For the past decade, her paintings have been included in juried exhibits throughout the region and the nation, and her awards list continually grows. She has won merit and purchase prizes in the state's annual Hoosier Salon, Indiana Heritage Arts, and the Art Association of Richmond's annual exhibits, among others. Nationally, she was honored as a finalist in the 1996 *Artist's Magazine* competition, won honorable mentions in the 2003 Fourth Annual Pastels 100 and the 1996 Grand Exhibition National Show, and took the Fostport-Yarka Award in the 23rd Exhibition of the Pastel Society of America. She was also juried into the Arts for the Parks Mini 100 exhibition in Jackson Hole, Wyoming, in 2004. Her work is included in the collections of the Indiana State Museum, Richmond Art Museum, and the Minnetrista Cultural Center. She is an Associate Member of the Pastel Society of America and a member of the Pastel Society of North Florida, the Indiana Artist Club, and the Randolph County Art Association.

Just recently, Strock-Wasson has been converting her talents to oil painting. "Everybody tells me how I should be painting in oils. Why can't they paint in pastels? I don't understand why oil paintings are more respected when pastels are actually more permanent," she comments.

About her work for *Painting Indiana II: The Changing Face of Agriculture,* the artist comments, "I'm excited to be in this project because I live around these people (farmers). You come into a place like this (the local restaurant) and you hear the farmers talk about the weather, crop failures, the ice storm we just had. . . . The farm scenes are a part of it. But this project has made me look at the local landscape in a different way. Before, I never would have gone out to the field with a friend of mine and watched how he plowed the fields while I was painting. I probably would have just gone out and taken a photograph, and maybe not even put him in the painting.

"I don't think I would have done the McDonald's (restaurant) scenes if it hadn't been for this project. Why would you do something like that? But that was a lot of fun. It has opened my eyes to the many different ways of seeing the landscape."

The work of Carol Strock-Wasson was highly praised prior to the *Painting Indiana II: The Changing Face of Agriculture* venture. She has expanded her repertoire to include subjects and compositions completely out of her comfort range for the project. And she has risen to a new level of proficiency in the process.

Scott Sullivan

Painterly Landscapist

"I don't have much time to paint," Scott Sullivan admits. "So whenever I paint, I want it to be a success." Despite the interference of his full-time management of a heating and air conditioning business, Sullivan is an artist who, by most standards, has definitely succeeded. An award winner at his first Great Outdoor Art Contest at the T.C. Steele State Historic Site in 1998, he has since won numerous prizes at the annual Indiana Heritage Arts and Hoosier Salon exhibitions.

"As far as the 'changing face of agriculture,' I think I'm probably a cynic," Sullivan says. "I see agriculture going in two different directions. I see it going toward technology and science. There are marvelous things they can do, but at the same time, what's happening to the quality of our food? What's happening to our environment? . . . They think you have to do more with less. You have to make the cows fatter and the chickens grow faster.

"And then there's the other side," he continues. "People are going to farmers' markets because they want to buy food that has no additives. So I see two different directions. I see the dark side of it, like people losing their farms.

"I painted the saw mill at Knight's Corner Lumber because I wanted to

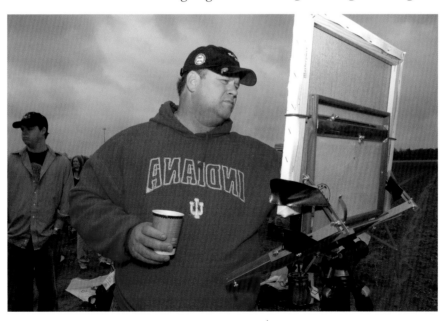

document the small, family-owned business. I appreciate the *Painting Indiana II: The Changing Face of Agriculture* project because I've gone out and met the farmers and done things I would not normally have done."

Sullivan grew up in Champaign-Urbana, Illinois, until he was 13, and then his family moved to Washington, Indiana. "I had always drawn as a kid," he remembers. "If I wanted paper or paint, my parents always bought them for me. The one regret I have is that my dad died before I really got into painting. He would have loved that."

After graduating from high school, Sullivan attended Vincennes University, where he took two years of courses in drafting. He then went to work for an engineering firm in Loogootee, Indiana, and later took jobs with Haynes-Tabor Architectural Firm and Bynam-Fanyo. He moved to Bloomington, Indiana, in 1980 and married Lisa while employed with Haynes-Tabor and Associates.

Drafting was different then because everything was done by hand, Sullivan recalls. "I remember the first computer program I ran was Fortran, I think, and it was a joke. You had to write the program. Everything else was done with ink and pencil, and you had to have talent. You had to be able

198

to draw. It was a job, and you didn't have unlimited time to get it done. I had a high-school teacher who was very big on lettering. I'm grateful to him because my handwriting is horrible."

When Lisa's father retired from running his business, Quality Heating and Air Conditioning, Sullivan took over its management. But his yearning to paint never really left him. "I carried oil paints in the back of my truck for about a year and a half. We travel a lot, and I always wanted paintings from the places we went, but they were so expensive or poor quality. I think I started painting because I wasn't drawing any more (in drafting jobs) and I didn't have that outlet," he said.

After about a year and a half of painting on his own, Sullivan took a workshop with Bob Hoffman. He painted at the 1998 T.C. Steele State Historic Site's Great Outdoor Art Contest and received third place, behind *Painting Indiana: Portraits of Indiana's 92 Counties* artists Robert Eberle and Dan Woodson.

Sullivan had seen the work of artist Don Stone in the magazine *American Art Review* and considers himself fortunate to have been able to sign up for his week-long workshop on Monhegan Island, off the coast of Maine, that same year. "I walked into Don's studio, and there were all these banjos hanging on the wall, so I felt at home," Sullivan relates. "The workshop was a real eye-opener. Everyone had been there before—it was a real social thing. We did all outside painting except one day when it rained and (Stone) did a demo. . . . At that first workshop, I met fellow Hoosier Fred Doloresco and benefited greatly from his knowledge and experience.

"The instructor, Don Stone, would not be easy to take if you aren't willing to listen and learn," he continues. "He is very straightforward with his critiques. At the first critique, he looked at my lighthouse and said, 'Scott, do you have any green left for the rest of the week?' and I just started laughing. He was right. The whole painting was green. And that endeared me to him because I was able to laugh instead of taking myself too seriously. I wanted to learn, and Don was a good teacher." Sullivan has attended workshops since then in France (2000) and Italy (2001).

"The most important thing Don Stone shows is how to see values," Sullivan continues. "He had us do thumbnail sketches to see values and shapes and then transfer it onto the canvas with complementary colors. Once you have the value study and a good design, you can do almost anything with color. It's so hard to get people to see values—it was like a light bulb went on in my head."

Judging from Scott Sullivan's paintings, the light bulb has never dimmed. Known for his loosely rendered plein air paintings with architectural elements, his work is coveted by private collectors and is included in museum collections. His pragmatic view of representational painting sums up the competitive world of contemporary realism. "The closer you paint to reality, the harsher your critics will be," he states, "because they're judging against reality. An artist must interpret what he sees. Only then is it art."

Rivers are the arteries of Indiana's agriculture.
Our communities have grown up around them
because of their importance to agriculture; their
value goes far beyond transportation.

MARY ANN DAVIS
Wabash River, Looking toward Illinois
Oil on canvas 12 × 24 inches

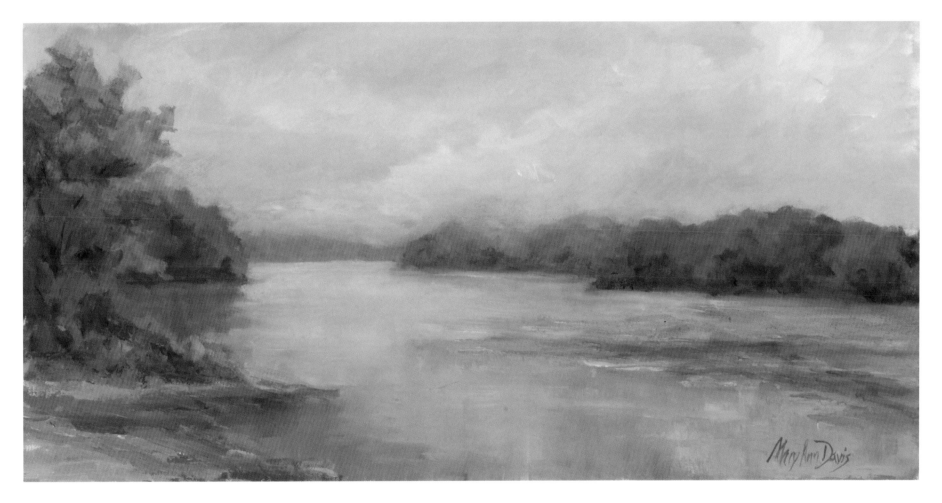

GARY R. TRUITT and **KATHLEEN STUBBE TRUITT** have been writing about Indiana agriculture for more than twenty years. As a farm broadcaster, Gary has traveled extensively across the state and has interviewed farmers and farm leaders. He also writes a weekly syndicated newspaper column. Kathleen has edited numerous print and online publications. Gary and Kathleen have collaborated on several articles for regional and national publications about the changes taking place in agriculture and rural America. Gary and Kathleen are the parents of three children: Jonathan, Anne, and Nathaniel.

RACHEL BERENSON PERRY is Curator of Fine Arts at the Indiana State Museum in Indianapolis. In addition to organizing exhibits of historical and contemporary Indiana artists, she has written numerous articles for *American Art Review, Traces of Indiana and Midwest History, Outdoor Indiana,* and *Southwest Art Magazine.* She provided the introduction to *The Artists of Brown County* by Lyn Letsinger-Miller (Indiana University Press, 1994) and wrote *Children of the Hills: The Life and Work of Ada Walter Shulz.*